The Complete Photo Guide to

# CREATIVE PAINTING

**Creative Publishing international**

Library of Congress Cataloging-in-Publication Data

Greenman, Geri.
  The complete photo guide to creative painting / Geri Green-man and Paula Guhin.
      p. cm.
  "More Than 500 Large Format Color Photos."
  Summary: "Techniques in step-by-step format for painting with all types of craft and fine arts paints, including acrylics, oils, tempera, watercolor, and pastels"–Provided by publisher.
  ISBN-13: 978-1-58923-540-3 (soft cover)
  ISBN-10: 1-58923-540-1 (soft cover)
  1.  Painting–Technique.  I. Guhin, Paula.  II. Title.

  ND1473.G74 2010
  751.4–dc22

2010016771X

Photographer: Paula Guhin
Photo Credits: Len Bielefeldt: 152 (top), 153 (bottom), 207 (top and bottom), 216 (top); C. M. Cernetisch: 28 (top and bottom), 216 (bottom); Jessica Fine: 32 (bottom), 33 (top and bottom), 217 (top); Gordon France: 208 (top): 210 (top and bottom), 211 (top and bottom), 217 (center); Jacqueline France: 146 (bottom), 147 (top and bottom), 217 (bottom); Leonard Fumarolo: 202, 203 (bottom), 218 (top); Marge W. Hall: 150 (top and bottom), 151 (top and bottom), 218 (bottom); J. Anthony Kosar: 48 (top), 49 (top), 50 (bottom), 219 (center); Randie Hope LeVan: 29 (top), 30 (bottom), 121 (bottom), 211 (bottom); Rebecca Mulvaney: 30 (top), 31 (top and bottom), 220 (top); Daniel Sheldon: 144, 145 (top and bottom), 220 (bottom); George Shipperley: 117 (bottom), 120 (top and bottom), 221 (top); Thomas Trausch: 48 (bottom), 51 (top), 148, 149 (top and bottom), 204 (top), 205 (top and bottom), 221 (center); Kay Wahlgren: 203 (top), 208 (bottom), 221 (bottom)

Photo Coordinator: Joanne Wawra
Cover Design: Kim Winscher
Page Layout: Kim Winscher
Copy Editor: Ellen Goldstein

Visit www.Craftside.Typepad.com for a behind-the-scenes peek at our crafty world!

## Dedication

To my loving husband, Jerry; wonderful daughters, Laura and Jennifer; and terrific grandchildren, Maddy, Ally, and Jonah. You are the masterpiece that is my life. – Geri

I dedicate this book to the wild, wonderful women who have been my best friends for life: Liana, Ruth Ann, Cecile, and Coni. – Paula

## Acknowledgments

Geri sends loving applause to her husband, daughters, and grandchildren (for putting up with her and for loving her as unconditionally as she loves them). She is also grateful to former art department colleagues, English teacher buddies, and other educators whose talent and willingness to collaborate on assignments allowed their students to see the vital connection to art in all areas of study.

Paula and Geri have taught and mentored a dozen art teachers, animators, writers, illustrators, cartoonists, musicians, and a few creative lawyers, too, all of whom have been a boon to the spirit. So, a big, affectionate thanks to all their former students, whose talents and uniqueness have always been inspirational. Their incredibly creative artwork still motivates the authors to continue to improve their own skills and to keep learning.

Geri and Paula are proud to have been a part of their students' lives and to have been a tiny spark in their artistic growth. Both authors realize what a privilege and gift it is to teach.

Their everlasting gratitude goes out to CPi editor Linda Neubauer and to the CPi design and production staff for making the book so beautiful.

The Complete Photo Guide to
# CREATIVE PAINTING

**Creative Publishing**
**international**

# CONTENTS

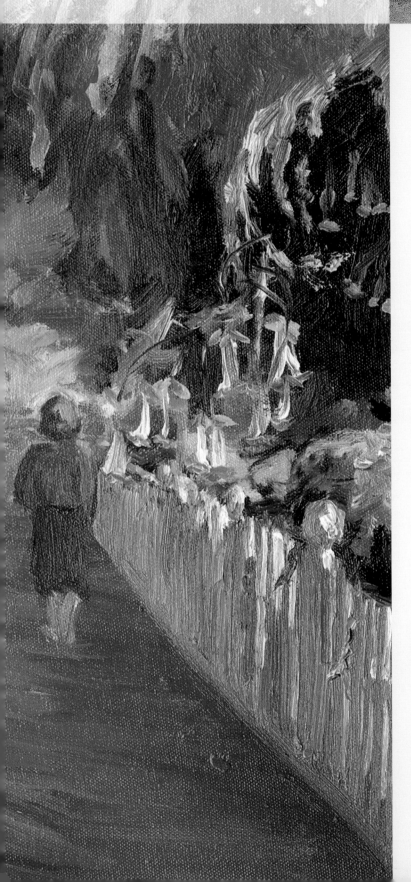

# Introduction

Acrylic paint, oil paint, pastel, tempera, gouache, and watercolor: All are made of pigments and agents in which the colored powders are mixed. Each medium has its own capabilities.

Painting is one of the oldest of the visual arts, and one of the most important. Whether you're new to painting, an experienced artist, or somewhere in between, practicing the techniques detailed and pictured in this book will help you explore the possibilities in a variety of art paints.

You'll discover, through our examples and step-by-step instructions, the unique qualities of each painting medium and what it can do for you. This will allow you to build your skills and to gain proficiency with various mediums, for whatever style you develop and refine.

Each section features a different painting medium and its characteristics, as well as the numerous types of substrates (papers and surfaces), the tools of the trade, and other art materials and equipment that complement that particular medium.

You'll learn how to create many exciting effects with each medium, and a wealth of full-color photos will give you a better understanding of how to achieve such results.

Every section of the book ends with a painting project. It's easy to follow the clear, step-by-step directions and accompanying photographs. The completed painting utilizes the skills learned in the section.

We hope, too, that you'll use the book as a springboard for further investigation and experimentation, combining mediums in creative ways. For example, try an underpainting with acrylics, then glaze or scumble with oils. Due to numerous variables in methods, materials, and conditions, of course we cannot guarantee results that are satisfactory to each artist. But mistakes are how we learn, and mistakes often generate ideas!

Throughout the book, there are tips to aid you still further and handy Budget Boosters to save money on art supplies. And fuel your creative fire with the inspiring artworks in the Artists' Galleries—discover extraordinary examples of each painting medium. Consult the helpful Glossary anytime to clarify terms, and be sure to check out the Resources page, too.

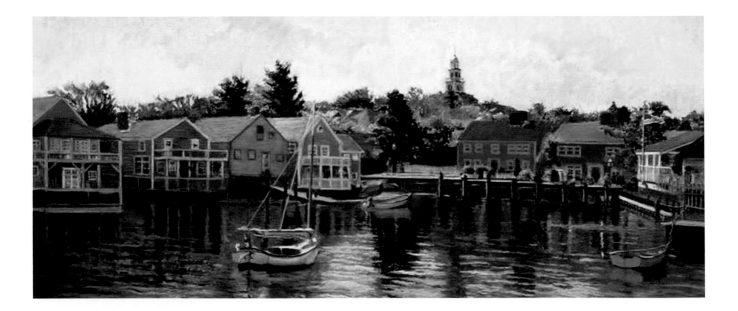

## A Word about Color

The color wheel is a very useful tool for seeing relationships between colors. It's made up of three basic colors (the primary colors), three secondary colors, and six intermediate colors. Learning the color wheel is one way to choose pleasing harmonies for your paintings.

A limited palette in a painting can be a very good thing! Any one of the following suggestions makes an excellent color scheme.

- Try complementary colors, which are found directly across from each other on the color wheel. Because they're opposites, consider using one of the pair predominantly and the other as an accent.

- Analogous colors, three or four colors found beside each other on the color wheel, are always delightful together because they're related.

- All warm or all cool colors in a single painting also make for a lovely color scheme.

- Experiment with a monochromatic artwork, which employs various tints, shades, and intensities of a single color.

- Check out a neutral palette, which consists of hues not found on the color wheel. Black, gray, white, brown, and beige are neutral (another description for the latter two is "earth colors").

# Safety Note

When using powders, solvents, or sprays, work in a well-ventilated area, read safety information on the packaging, and keep combustibles away from open flame.

SOFT PASTEL

**P**astel is the perfect medium with which to begin this book, because it's a direct, immediate material. It's also portable and convenient. Pastel imparts a rich, glowing vibrancy to the artwork, which is considered to be a painting although it is produced with a dry medium. With pastels, one can work quickly with decisive, visible strokes, or take time and build a more detailed, highly finished piece. This section of the book leads you through the fundamentals as well as the many special effects one can create with vivid, buttery pastels.

## ABOUT SOFT PASTEL

Pale or bold, velvety or firm, pastels come in a vast array of appealing colors and textures—a pleasure to the senses! They are ground pigments mixed with a binder, and are usually round or square sticks. One can buy boxed sets or individual sticks.

High-quality soft pastels can be very expensive (and fragile—they break easily), but their smooth, thick quality is a tremendous asset. Many manufacturers produce affordable selections.

Pastel pencils are clean and easy to use, but they're not as soft. Since they offer greater control, they're best for drawing preliminary sketches or for adding sharp accents, crisp lines, and details.

Hard pastels, which often come in slender square sticks, contain more binder than soft pastels, and so lend themselves to sketching rather than painting. Many pastelists use both soft and hard pastels, often combining both (and more) in a single work.

Various manufacturers of pastels use different names for their colors, so we cannot suggest specific colors to buy. The beginner should start with a basic boxed set, usually containing twelve to twenty-four sticks. Forty-eight colors is a good number to aim for eventually. Numerous art and craft suppliers sell a range of pastel sticks individually, so the artist can supplement or restock a basic palette in time.

For those artists who specialize in portraits or landscapes, manufacturers make boxed sets of skin tones and scenery colors.

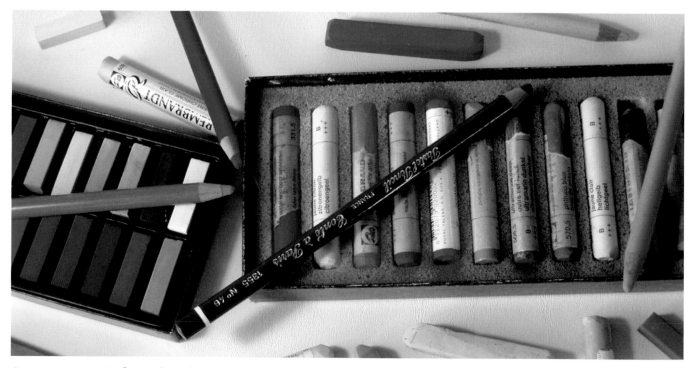

**An assortment of** pastels and pastel pencils

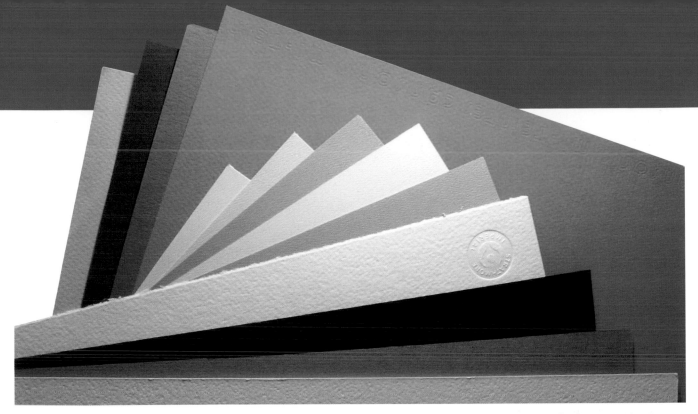

**From the bottom to top:** pebbled illustration board, two sheets of charcoal papers, watermarked watercolor paper, five assorted colors of Strathmore pastel papers, and four colors of Canson Mi-Teintes papers

## SUPPORTS FOR SOFT PASTEL

Ingres and Canson papers are available in individual sheets and in spiral-bound pads. Pastel boards are rigid and very good to use with harder pastels.

**Pad of charcoal** paper and three colors of sanded pastel boards.

# Budget Booster

Matboard is suitable for pastel too. Ask your local framer for free scraps in various colors and textures!

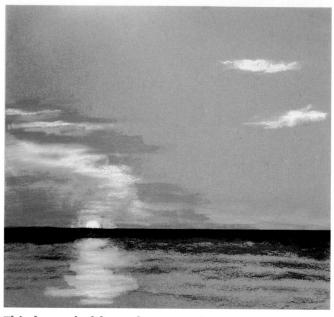

**This household sandpaper** (still showing in much of this unfinished scene) is extra-fine-grit, 9" x 10" (22.9 x 25.4 cm).

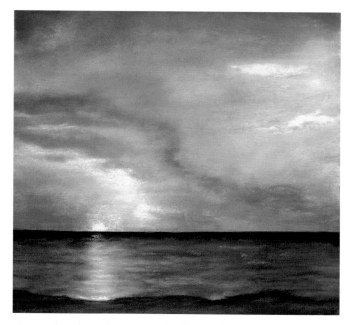

**A work of** art done on a lowly product

## Colored Backgrounds

Because the graininess of soft pastel often allows the support to peek through in places, colored paper can add warmth or coolness to a work. It can even substitute for a key color in the subject! For example, you can use gray or buff paper in a cityscape, or a warm green or yellow paper for a sunny summer landscape.

On the other hand, tinted paper can contrast with the overall color scheme. Blue-gray paper can further enhance that warm, summery scene, too!

For the beginner, we suggest mid-toned paper in gray, buff, blue-gray, beige, or cream. Both dark and light pastel colors show up nicely on any of these. Charcoal papers also work well with pastel.

The paper color has a definite effect on the appearance of pastels. White or light-tinted paper adds luminosity to a work, while a dark background boosts color brilliance. Bright, vivid paper has a very strong influence on the image.

# Budget Booster

Fine grades of sandpapers purchased at the hardware or home store may be smaller than those made especially for pastel, but they're much cheaper. Try working on rough brown wrapping paper, too!

## Textured Backgrounds

All pastel paper has some grain (called tooth), but some surfaces offer pronounced texture. Some papers have a flocked surface, and others are gritty. The latter is best for thick, heavy applications.

Watercolor papers are quite suitable for soft pastels. Some artists tone watercolor papers with an ink or watercolor wash to eliminate the stark whiteness. Then they apply pastel after a thorough drying.

Other textured substrates include some boards and fine sandpapers manufactured specifically for pastelists. Sanded pastel papers come in a variety of grits (degrees of granulation).

Artist's canvases work as textured substrates for pastels, too! Finally, velour papers have a soft, velvety nap.

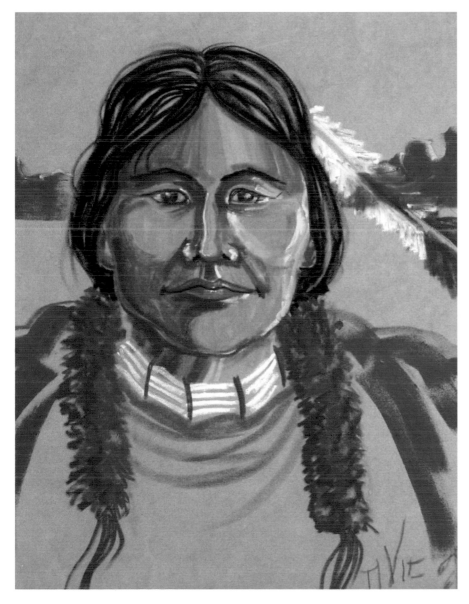

**The artist, Vic Runnels,** left much of the golden-colored velour paper showing in and around his subject.

## Precautions

Be sure to protect not only the work surface but also the floor of the work area from the inevitable chalk dust! A painter's drop cloth works great. Avoid inhaling pastel dust. Wear a protective mask if desired (this is important for anyone with a lung ailment). Another idea: At the base of the painting or drawing board, attach a strip of masking tape as a "shelf," sticky side up, to help catch dust.

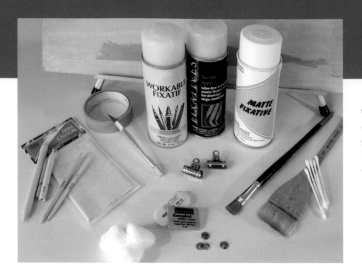

**Clockwise from right:** cotton swabs, Hake brush and a firm brush, thumbtacks, two erasers (one is a gray kneaded eraser), cotton balls, chamois, tortillons, blending stumps, painter's tape, craft knife, fixatives, and clips. In back is a smooth drawing board (on easel).

## TOOLS AND OTHER MATERIALS

Pastels are the most immediate of painting mediums since they are applied directly to a surface. And yet there are many tools and materials that can greatly benefit the pastelist. For example, a craft knife is handy for sharpening a point or an edge on hard pastels.

Blending stumps, used to smooth pastels and blend colors, are made of soft felt paper. They have two tapered ends, while torchons and tortillons are spiral-wound paper with one tapered end. Use an artist's sandpaper block (a small pad of tear-off sandpaper sheets stapled together) to clean and refine the point on these blending tools. Sandpaper also sharpens pastel pencils nicely.

A tissue, soft deerskin chamois, or soft cloth is also useful for blending when a finger won't do. Cotton swabs and cotton balls are helpful, too.

A large, soft Japanese Hake brush is effective for delicate blending. Some artists use a stiff brush to push colors around or to flick away excess pigment.

Attach pastel paper to a large, smooth board with painter's tape, tacks, or clips. Some artists place a second sheet of same-sized paper under the first, to serve as padding. The board or panel should be at least 1" (2.5 cm) larger all around than the largest papers the artist plans to use.

An easel is optional. Tilt the board on a stack of books if desired. A mahlstick is also optional. It's a long, narrow tool that supports and steadies the hand and helps to avoid smearing.

Fixative is a varnish that helps prevent smearing. Its benefit is controversial, since spraying may darken the artwork. Use it lightly. Another method to prevent smearing is to mat and frame the piece under glass.

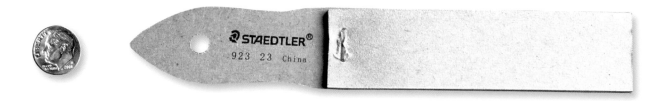

**The dime suggests** the size of this artist's sandpaper pad.

## SOFT PASTEL TECHNIQUES

Try all these methods and more—but not all in a single work of art! Develop a unique style employing your favorite processes.

**Vine charcoal is very soft** compared to charcoal pencils. Charcoal is also available in compressed sticks (not shown).

### Underdrawing

Ready for undercover ops? Make a basic sketch with the tip of a pastel stick, a pastel pencil, a hard pastel stick, or soft charcoal. (The advantage of soft charcoal is that it's easy to make corrections in the drawing.)

If you use pastel to draw the preliminary sketch, select a color in the same color family as the paper. Or use a neutral color or one that is predominant in the subject. Outline all the essential shapes very lightly.

It is ideal to work under indirect, natural light. For night work (or when plenty of natural light isn't available), use two artificial light sources. Light both the subject and the work surface with bright lamps of the same type; that is, regular incandescent, fluorescent, halogen, or daylight tungsten.

## Clean Hands

Keeping hands—and pastels—clean while painting can be a challenge. Some pastelists wear surgical gloves or keep baby wipes nearby. Instead of baby wipes, a lightly moistened cloth kept in a plastic bag allows one to reach in and clean hands easily.

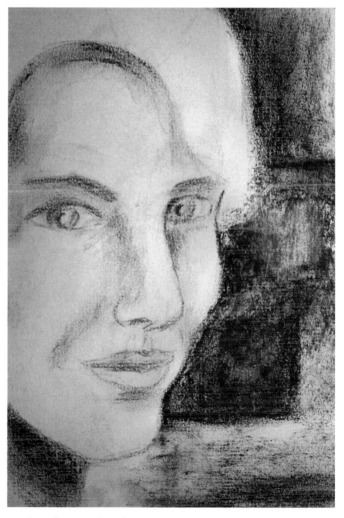

**A sketchy underdrawing** (done in charcoal) places the main shapes and lines.

## Blocking In

Actors, athletes, and knitters all block, but this art technique is very different. Many pastel artists work lightly at first, because overworking the paper will quickly fill the tooth (the grain) of the paper. A dense, solid surface resists further work.

A method called scumbling, in which a gentle new layer only partially covers the one below, lends itself to the blocking-in process. It allows the paper to show through in small patches, which adds contrast or a color connection to the whole. It's a technique common to all painting mediums.

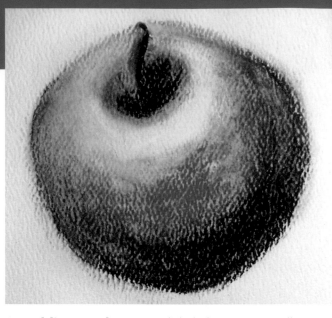

**Scumbling on the** textured, light beige paper allows bits of it to sparkle through.

### Scumbling

1   Select short, unwrapped pieces of mid-toned pastel, or peel the wrappers from longer pieces.

2   Lay in broad areas of color with side strokes, holding the pastel broadside (the flat side) to the paper. Work with one color at a time (and with minimal pressure), merely suggesting shapes and tones. This technique provides a general impression of the work—a basic structure upon which to build the artwork.

3   Then use the tip gently in smaller areas. Here, we use a tonal understructure to prepare the main elements for the next stage.

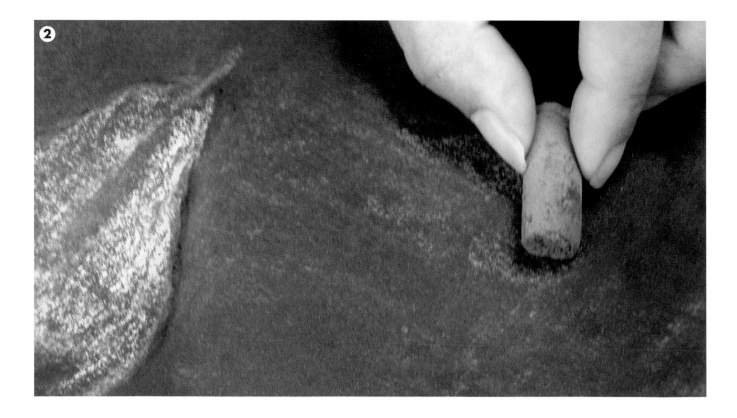

### Building Up

This process follows the initial sketch and blocking-in steps. Think of it as building muscle!

Begin to develop form (the appearance of mass) with deposits of mid-tone color. Apply successive layers of sheer color with a light hand. Mix and blend colors, and add shading for contrast. The artwork will be more unified if it progresses as a whole, so build it up overall rather than one area at a time.

### Blending

Now for a little smooth talk.

Traditionally, soft pastels were (and often still are) blended smoothly in gradations. This technique entails the fusing of two or more colors by rubbing and spreading them together on a surface. Blending lends itself particularly well to such subject matter as soft fabric, metal, glass, and skin.

It's easy to do because of the nature of soft pastels! It's also easy to go too far, so take care to preserve lovely colors and avoid muddiness. Use blending in the early steps of a painting, or just in certain areas.

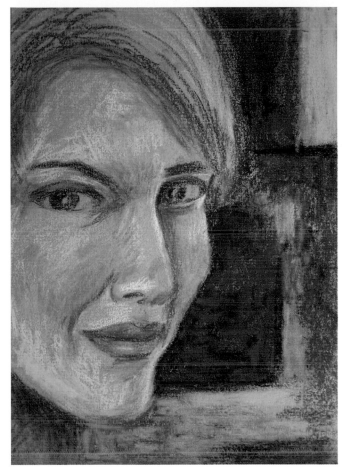

**Brush off excess** charcoal before overworking. Note the visible strokes in this still-unfinished piece.

# Planning a Painting

The artist must choose subject matter that interests him or her and that evokes a strong response. Then consider how the subject might fit on the paper. How should the composition be organized? Where will the lights and darks go? What colors will make up the palette? Set up the subject in several different ways and make small, quick studies (sketches) before settling on the best arrangement.

Work from photographs if it's necessary, but don't rely on them too much. It's preferable to use them for additional information, not as the entire inspiration.

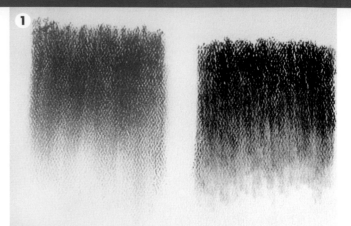

## There's the Rub

**1** The easiest method of creating a gradient or blend is to lay down some powdery color, then gently rub with finger, chamois, tissue, or soft rag. The bristles of a synthetic brush can spread color evenly and soften it to create gradual transitions, too. Other implements with which to blend include a cotton swab, a blending stump, or tortillon. The sample on the left was created by rubbing downward with a finger. The sample on the right was made by blending down with a tortillon.

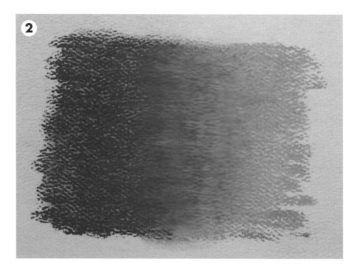

**2** When fading one color into another, merge the strokes of one into those of the other. Don't overfill the grain of the paper by using heavy pressure. When transitioning from one color to another, use a light hand to combine.

**3** Blending complementary colors together lowers their intensity. This is a convenient way to tone down an overly bright area (a "too-sweet" color), but avoid too much dullness, as well. Here are the three primaries blended with their color opposites.

# Tips for Blending

To clean a tortillon, either scrub it on sandpaper or unwind and discard some of the paper from the tip.

Overblending—mixing way too much—can deaden a pastel painting. Add excitement with vibrant, unblended touches here and there!

For portraits, flesh is not a single color! Mix yellows, pinks, reds, browns, and white. The shadows of the face can even contain a bit of blue, green, or violet!

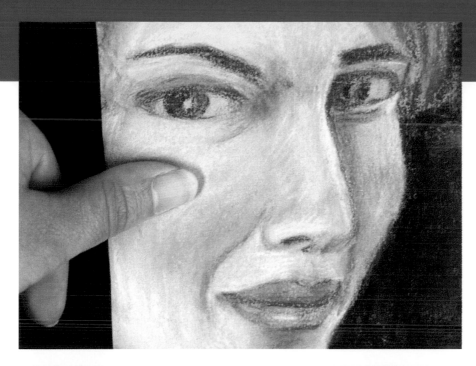

**Softening the** strokes will result in a velvety finish.

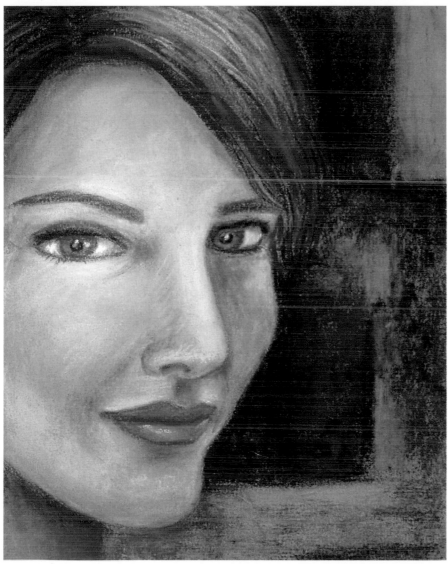

**Bright highlights** and some smooth blending complete this portrait.

## Dry Washing

No laundry talk here. A dry wash entails loose particles of pigment, used to lay down flat tints or soft gradations. It's great for sunsets and bodies of water, or for suggesting large areas of fog.

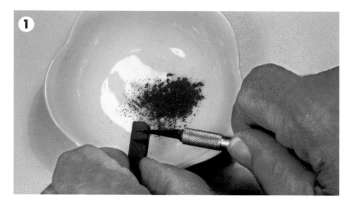

**1** Scrape the side of a pastel stick gently with a blade (single-edge razor or a craft knife), collecting the scrapings in a small dish or on a clean piece of paper.

**2** Dip a cotton ball gently into the powder and dab it across the paper. Build up nuances slowly with thin applications of more powder, even a different color if desired. Cotton balls pick up a lot of fine powder, so work carefully. (Keep different powder colors separate and don't contaminate them with a dirty cotton ball.)

## Using Broken Color

This term refers to an unblended, lacy layer that allows whatever is underneath to show through. Building up areas using short strokes of different colors is an Impressionistic technique that creates an energetic result. From a distance, the eye mixes the flecks to form a harmonious surface.

### Breaking It Up

**1** Begin with a light sketch, and then put down marks of color loosely.

**2** Next, overlap dabs of another color. Allow some of the color underneath to show through. Daubing splashes of color gives a shimmering effect.

# Budget Booster

Don't discard small, broken pieces of pastels! Use in small areas, or crush them and apply the powder.

**The black paper** used for this scene deliberately shows through in many places. It serves as the lowest value in the painting.

## Feathering and Stippling

Two other terms relate to broken color: feathering and stippling.

Feathering is using the tip of the pastel stick to lay in linear strokes over parts of another color. It's great for fur, hair, and enlivening or enriching bland, dull areas that otherwise seem flat.

Stippling is the application of specks or dots rather than linear strokes. Both of these techniques are just the thing for many patterns in nature.

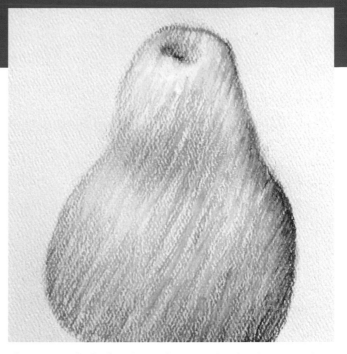

**These angled, feathery** lines might also be termed hatch marks.

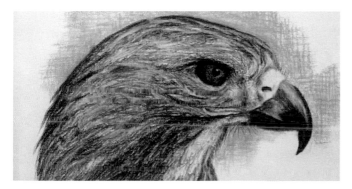

**Behind this bird** of prey are some crosshatched lines. See page 23 for more about crosshatching.

**Many light** strokes appear...feathery!

# Erasing

Avoid using ordinary rubber erasers with pastels—they'll push color into the surface and flatten the paper's tooth! Many pastelists use vinyl erasers (also called plastic erasers), in addition to kneaded ones. Some of them even use a small piece of fresh white bread rolled into a wad as an eraser! Or, one can carefully scrape a heavily worked area away with a sharp blade.

**Small dabs of** pure, unblended colors next to each other.

## Making Erasures

In the department of corrections, alterations made with a kneaded eraser (also called a putty eraser) should be done in the early stages. A synthetic bristle brush may also work to flick away excess pigment, if the pastel is still loose. Rubbing out mistakes later results in overworking because the paper grain is already filled.

**1** Massage a kneaded eraser to form a point or an edge, depending upon what is to be corrected. This eraser can now reach into small areas.

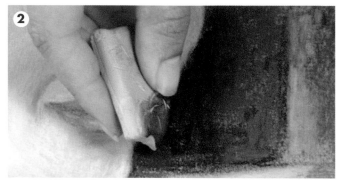

**2** Dab and lift gently on the mistake to avoid flattening the paper grain. Use this technique to bring back highlights, too. See the dark pastel on the eraser?

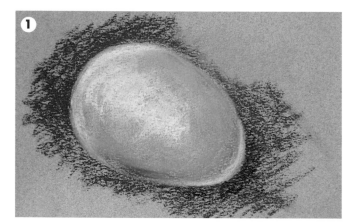

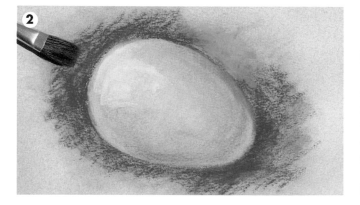

## Wet Brushing

This fun and easy technique employs a wet brush to spread previously applied dry color. It's great for modeling forms or covering the surface quickly as an underpainting.

**1** Establish the main shapes and colors with side strokes of dry pastel.

**2** Dip a bristle brush into clean water and spread the pigment in the same directions as the pastel strokes. The same egg now appears smoother and painterly.

# Cleaning Erasers

Clean kneaded erasers by pulling and folding them until they appear light gray again. If they're really dirty, you can use Geri's nifty trick: Place them in the back pocket of blue jeans and throw the jeans in the wash (but not the dryer). They truly do come clean.

## Hatching and Crosshatching

It is possible to create a variety of tones and values using only lines! Roughly parallel lines, that is. Hatch marks (a series of lines drawn fairly close together) are great for enhancing depth and form. They impart a lively surface quality, too.

Hatched strokes that are close together have a greater effect on what's underneath. They don't have to be uniform, and the artist can vary line quality from straight to curvy. So feel free to change direction, following contours as desired.

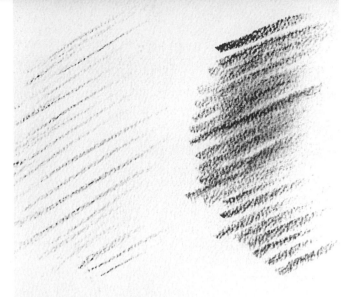

**The farther apart the marks,** the less the impact. Thicker strokes are more dense than thin ones, so they have a stronger effect. Note how the same color appears lighter or darker depending upon the hatching technique.

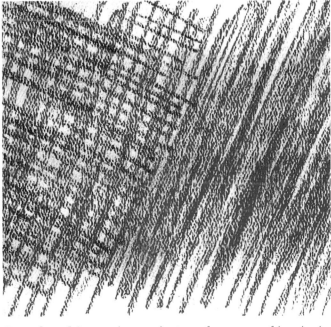

**Crosshatching** is the overlaying of two sets of hatched marks, roughly at right angles to each other, which creates a woven effect. The artist can even use different colors for succeeding layers of hatching (more than two sets of hatchings in several different directions!) On the right, hatching in two, similar colors. On the left, crosshatching in two colors.

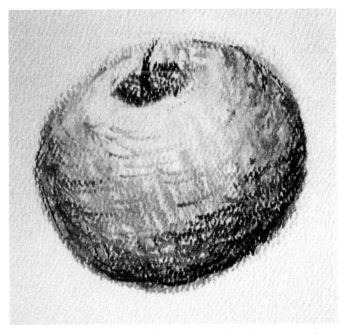

**The hatching here** has been overlaid with more strokes.

## Masking

Become a masking magician with these ideas!

A clean, precise edge is easy with a paper shape cut into a stencil. One can use it by filling inside the opening with color.

Or do the reverse! Position a positive paper shape on the surface, and rub color from its center outward. Going off the edges to color the background creates a negative shape.

**1** Hold the paper mask firmly in place while pushing color off its edges.

**2** The base paper color becomes the foundation for a vase, and the area behind it is now dark.

**3** If you wish to mask an irregular shape, such as mountains or a tree line, just use the torn edge of a piece of paper. This mask preserves blue sky on a landscape.

**4** Voilà! A quick, easy way to lay in some dark hills.

## Sharpening Edges

A sharp image is simple to achieve. To define contours and emphasize important elements, use decisive, linear strokes (light or dark). It's okay to bring only some areas into sharp focus, leaving others soft. Play down some parts and call attention to others. Save such crisp details for the final stages. As a finishing touch, sharp accents can add definition and refine the work.

**If a sharp, straight line** is required, use a straightedge. Running a pastel pencil along a ruler ensures straight buildings, windows, and more.

## Icing the Cake

Save strong highlights for last. Light reflecting from shiny surfaces, the radiance of eyes in a portrait, points of sunlight here and there—all these and more should be emphasized last. Choose pure white or a very pale color for these accents.

## Using Fixative

Some pastel artists are against the use of fixatives, but distinct advantages do exist. Read on and decide whether the fix is in!

Fixative can protect your work in progress and when it's finished. It is vital, however, to use it in moderation. Don't soak the paper! Overspraying may cause bleeding (running colors) and worse.

### Let Us Spray

1   First do a test on a piece of scratch paper (checking that the mist is even). Then position the board and art upright to assure that large droplets won't fall on the artwork.

2   Spray uniformly over the entire surface, holding the can about 12" (30.5 cm) away from the artwork and continuously moving your arm back and forth to prevent build-up of spray in one spot.

    Note: Don't hold an aerosol can of fixative too close to artwork. Always apply fixative in a well-ventilated area.

## Fixative

Some colors can become muddy if layered over others. Fixative applied lightly between layers helps prevent such murkiness. So seal the work sparingly at successive stages if necessary.

## A SOFT PASTEL PAINTING PROJECT

Still life objects, especially close up and personal, work particularly well as subject matter. Try several pieces of any fruit or vegetables, or use bottles, vases, teacups—the choices are many!

**1** Create the underdrawing softly with pastel or charcoal. Render the sketch delicately, even though we've made the lines more evident in this photo.

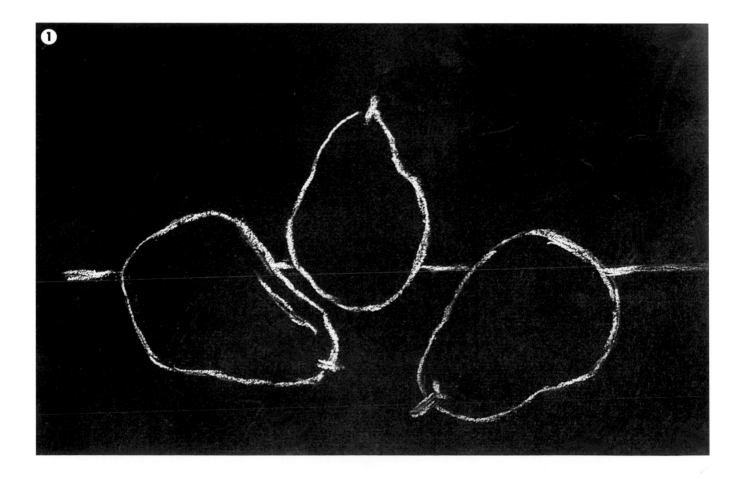

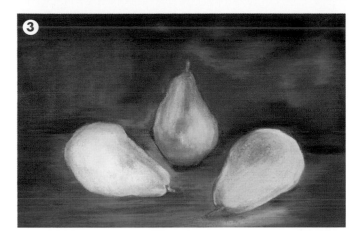

# Pastel Tips

When pastels become soiled from use, clean them by wiping with a tissue, or put them into a shallow pan filled with uncooked rice. Gently agitate the pan to clean very dirty pastels.

Don't roll up a pastel artwork when storing it. Keep it flat and place a clean sheet of tracing paper over it.

**2** At this early stage, just block in to hint at all the colors and tones of the main shapes. Look carefully at the subject to determine the lightest and darkest parts.

**3** Working all over the piece, increase detail and intensity without filling the grain of the paper. All the elements of the subject are now more refined and ready for final development.

**4** Add smaller details and accents, reserving the lightest and most intense colors for last. Strong highlights and a light spray of fixative finish the artwork.

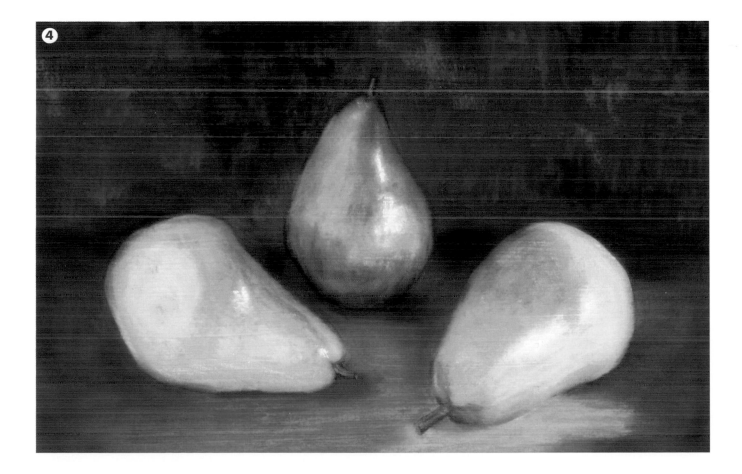

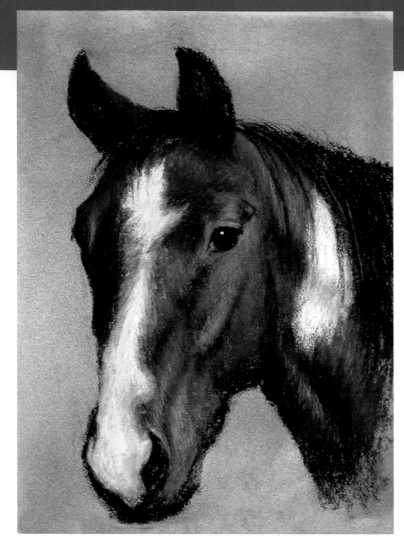

*Duke*
by C. M. Cernetisch, Private Collection
16" x 20"  (40.6 x 50.8 cm)

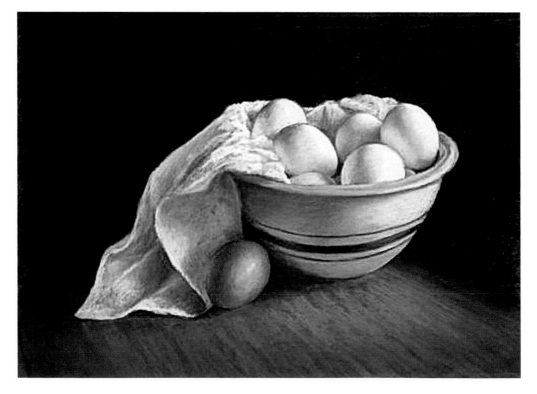

*Brown Egg*
by C. M. Cernetisch
Private Collection
11" x 14"
(27.9 x 35.6 cm)

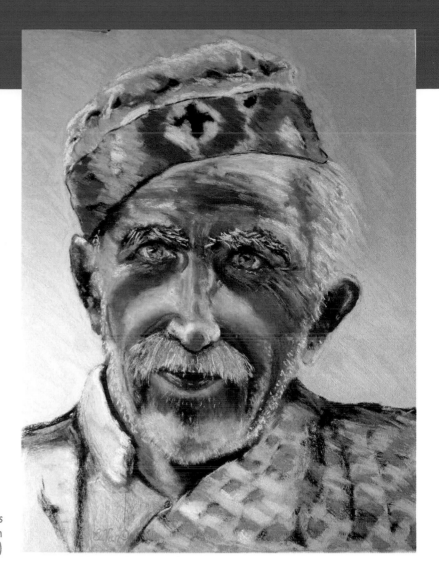

*Kashmir Kindness*
by Randie Hope LeVan
30" x 35" (76.2 x 88.9 cm)

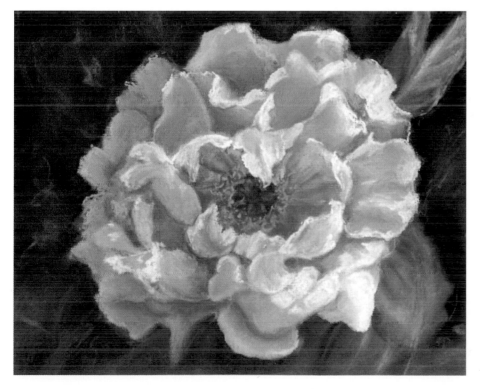

*Hanakasoi Tree Peony*
by Geri Greenman
8" x 10" (20.3 x 25.4 cm)

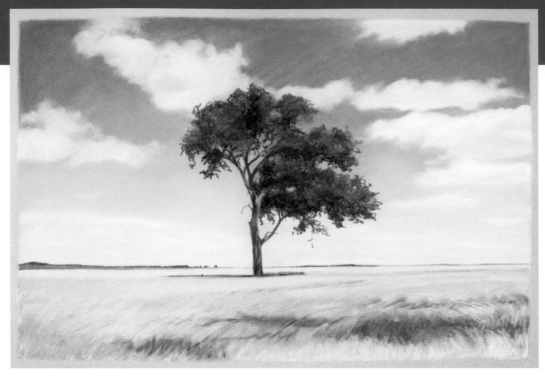

*Towering Beauty II* by Rebecca Mulvaney, Private Collection, 24" x 30" (61 x 76.2 cm)
The lone cottonwood stands proudly within a wheat field in Brown County, South Dakota.

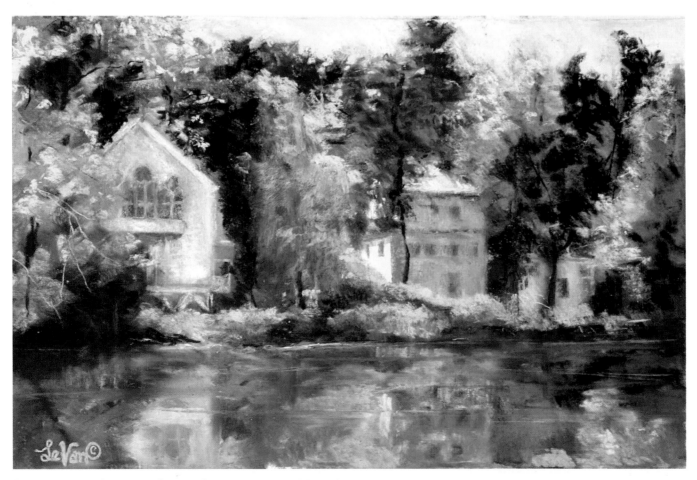

*Rendezvous with Serenity* by Randie Hope LeVan, 19" x 25" (48.3 x 63.5 cm)

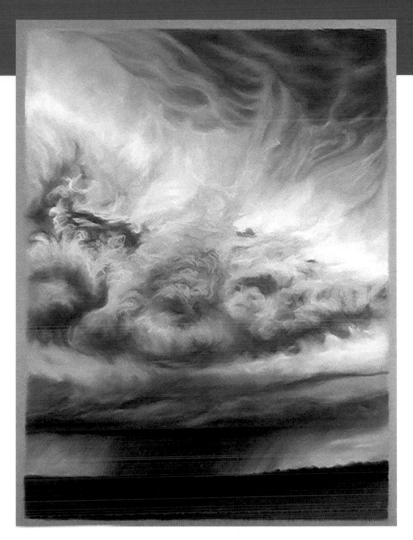

*Blaze*
by Rebecca Mulvaney, Private Collection
22" x 28" (55.9 x 71.1 cm)
Part of a series of pastels and
paintings of a powerful storm over
Lake Kampeska in South Dakota.

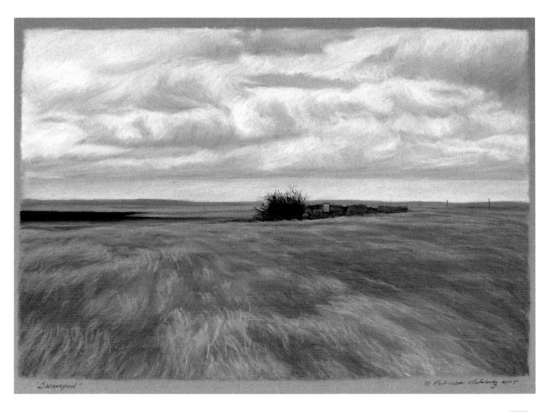

*Swamped*
by Rebecca Mulvaney
collection of the artist
22" x 28"
(55.9 x 71.1 cm)
A barn foundation
is nearly hidden in
windblown prairie
grasses behind an
abandoned homestead
near Java, South Dakota.

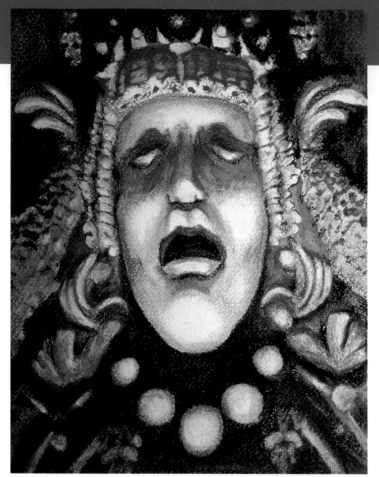

*Maudlin Mask*
by Paula Guhin
9" x 12" (23 x 30.5 cm)

*Night Moves* by Jessica Fine, Collection of Diane Garvey, 30" x 40" (76.2 x 101.6 cm)

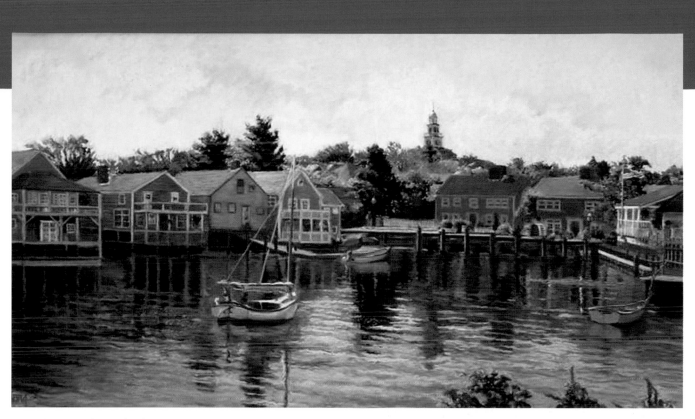

*Easy Street, Nantucket* by Jessica Fine, 24" x 36" (61 x 91.4 cm)

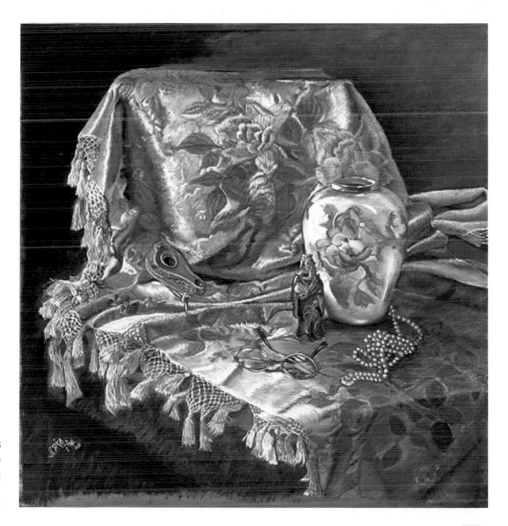

*Silk, Satin, and Friends*
by Jessica Fine
Private Collection
29" x 29"
(73.7 x 73.7 cm)

# OPAQUE WATER MEDIUMS: TEMPERA & GOUACHE

These paints are fast, direct, and convenient. Tempera and gouache are pigments suspended in water-soluble binder. They differ from transparent watercolors because the ratio of pigment particles to water is much higher, and they contain an inert white pigment such as chalk that makes them opaque. They offer the painter quick coverage and total hiding power but they also dry quickly. Experimentation is important to understanding how these two mediums work.

## ABOUT OPAQUE WATER MEDIUMS

The advantage of both these water solubles is that the artist can build up layers without much delay, since they dry so quickly. Mistakes can be easily painted over.

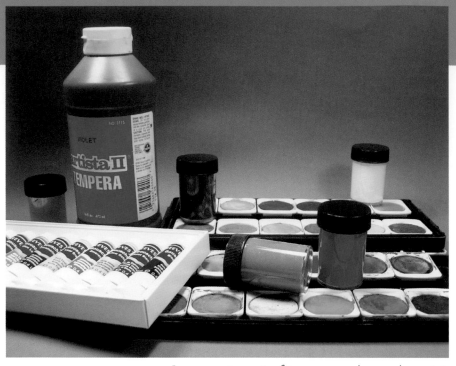

**An assortment of** tempera and gouache paints

### Tempera

Tempera is a water-based medium made from powdered pigments. Often referred to as poster paint, it dries quickly, so modeling is frequently achieved by hatching or mixing colors in darker values. Although precision and detail can be achieved with tempera, it does chip, crack, and scratch easily. Colors also turn lighter when they dry.

Tempera is available as a liquid in jars or pots, but also in powder, cakes, and pans. It comes in many forms (even glossy, fluorescent, glittery, or metallic), including liquid paint markers!

## Precautions

Don't breathe in the tempera powder. Wear a dust mask when working with it.

Egg tempera paintings can be ruined by pets that are attracted to the yolk. Cats or dogs might actually lick them clean if given the chance!

Egg tempera paintings are brittle and may crack or scar easily.

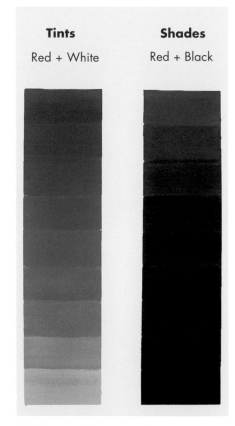

| Tints | Shades |
|-------|--------|
| Red + White | Red + Black |

**Adding white to paint** creates a tint, or higher value. The addition of black to a color creates a shade.

### Making Egg Tempera

Egg tempera (dry pigment mixed with egg yolk as the binder) was the most important painting medium in Europe between the twelfth and fifteenth centuries.

Here's how to mix this time-honored medium:

1 Make the paints from scratch using dry pigments, egg yolk, and water. (Tempera powders are available at art supply stores and online.) Add just enough water to the dry tempera to form a stiff paste. Don't mix up too much, because the amount of pigment paste must be equal to that of the yolk mixture to come! Once the paint has been made, it cannot be stored, so only make paint sufficient for a particular painting session.

2 Crack open an egg and drain off as much of the egg white as is feasible. It's important that the yolk be as pure as possible, so transfer it to a paper towel and gently roll the yolk toward the edge of the towel to remove the white.

3 Using the tip of a knife or fork, pierce the yolk sac and allow it to drain into a clean container. Then add about a teaspoon of water and stir.

4 Add the tempera paste to the yolk/water container and mix.

### Gouache

Gouache is watercolor made opaque with the addition of white pigment and, often, a glue binder. It's sometimes called designer's colors. Gouache has excellent covering power—unless it's very thin, it doesn't allow the white of the painting surface to show through. It is available in cake, tube, or liquid form, and it dries lighter, just as tempera does.

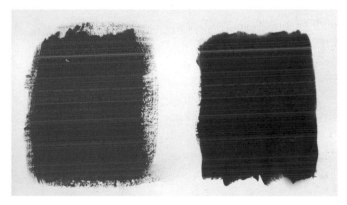

**The sample of tempera** paint on the left seems faded compared to the more lustrous egg tempera at right. Both were dry when photographed.

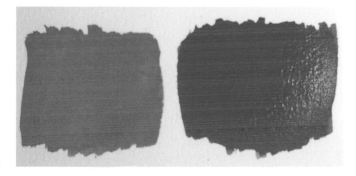

**Of these two** gouache samples, the one at right was still wet when photographed.

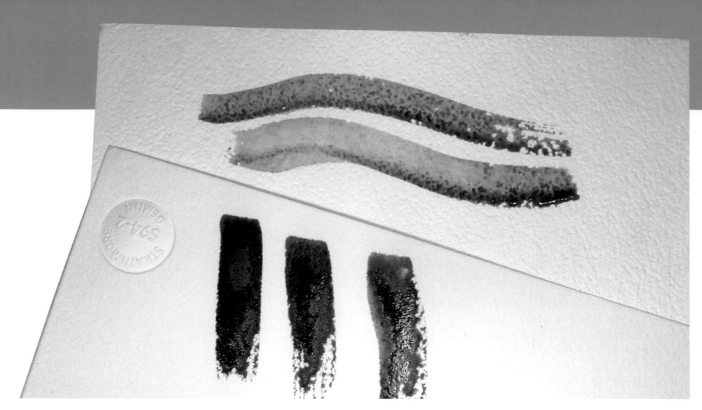

**Paint with gouache** or tempera on products like these and many others.

## SUPPORTS FOR TEMPERA AND GOUACHE

A number of surfaces are adequate to hold opaque water mediums. Both tempera and gouache can be painted on wood, watercolor board, heavy watercolor paper, Claybord panel, Bristol board, illustration board, or any support that will not curl or buckle when painted. Untempered Masonite (⅛" or ¼" [3 or 6 mm] thickness) can be used, too, but the surface needs gesso first.

**From left:** Bristol board, illustration board, and 140-lb (253 gsm) watercolor paper.

## Budget Booster

Eyeliner brushes can be cleaned with makeup remover and used as fine paint brushes. Get cheeky with old blush brushes, too!

## BRUSHES, TOOLS, AND OTHER MATERIALS

Brushes are an extension of the artist's hand and are the painter's primary tool.

**These brushes are made** with sable and squirrel. The wells in the palette are useful for water mediums.

Standard student-quality brushes work well with tempera and gouache. Brushes come in myriad types, shapes, and sizes. From the smallest to the much larger #12, they are sized in increments of two (#2, #4, #6, etc.). Some brushes are also labeled by width, for example, 1", 1½," etc.

Flats are brushes with long hairs or bristles that form a rectangular shape. Brights are flats with shorter bristles, efficient for wiping out areas of paint in a controlled manner and for dabbing paint. Filberts are rounded flats: each side is rounded though the very top of the brush is straight. The fibers of rounds are gathered into a round shape. The very tip is either pointed or rounded. Fan brushes are blenders that have fibers arranged in a fan shape.

**A rag, a segmented** paint tray, and containers of water are necessities with tempera or gouache.

Watercolor brushes have soft fibers that hold water well. They're made of the hairs of sable and squirrel, or they're synthetic. We recommend beginning with round sable brushes in #4, #8, #10, and #12 sizes. Size #4 is perfect for sharp detail in small areas, whereas the #12 is adequate for larger portions of a painting. Rounds hold a lot of paint and can make bold strokes or fine lines.

Bristle brushes work well with thick paint and expressive strokes.

It's best to use two water jars (one for cleaning brushes, and one for adding to paint when necessary). Dirty water makes for a dirty, muddy-looking painting! An easel and drawing board are optional, since many painters prefer to work on flat or only slightly inclined surfaces.

**One way to save on** paintbrushes is to use old cosmetics brushes. Sponges come in handy, too.

## TEMPERA AND GOUACHE TECHNIQUES

The methods here are easy to achieve, and most can be done in under an hour.

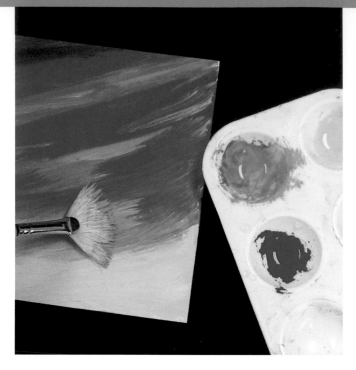

Begin with a light pencil outline of the subject on the support of choice. We recommend painting from background to foreground, and from general to specific. Save the details for last.

### Using Wet into Wet

Go with the flow, especially when painting skies or water.

**1** Place a small quantity of each color of choice onto the palette (or, if using cake pigment, dampen them with water).

**2** Starting with the lightest color first, apply it with a fan brush or a large round. This color must stay wet long enough to blend with the next color, so work fast!

**3** Promptly dip the brush into another color (having cleaned it first, if needed) and continue. This is tempera paint, but gouache can be used the same way, with similar results.

### Working Wet on Dry

Allowing an underpainting to dry and then working the area further is a great way to refine an artwork.

Simply lay down a coat of paint and let it dry. This sets the stage for coming in with new color without any bleeding. Use the type and size of brush most suited to the work. But don't overwork the second layer, as it may lift up some of the first color.

During a painting session, keep tempera and gouache paints damp on the palette by adding a drop of water now and then. But if extra paint is left over at the end of a painting session, use plastic wrap or slip the palette into a zippered plastic bag to keep the paint moist.

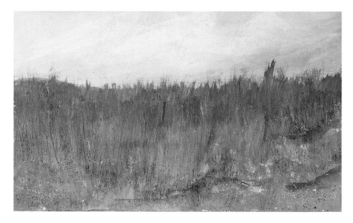

**The first layer of** blue sky and green grasses here were already dry when more shades of green and sandy colors were added.

## Drybrushing

It could be called kind of a drag. A fan brush is great for this technique, but a #4 or #6 round will do just fine. Simply dab the brush into slightly thick paint, use your finger and thumb to put pressure on the bristles to spread the bristles, then drag the brush lightly over the area to be enhanced. Hold the handle nearly parallel to the painting surface.

Use drybrushing with watercolor, acrylic, and oils, too.

**Spreading the** loaded brush by hand.

**White tempera was** drybrushed on a black painted background on one half of this surface; and black tempera was drybrushed on a white painted background on the other half.

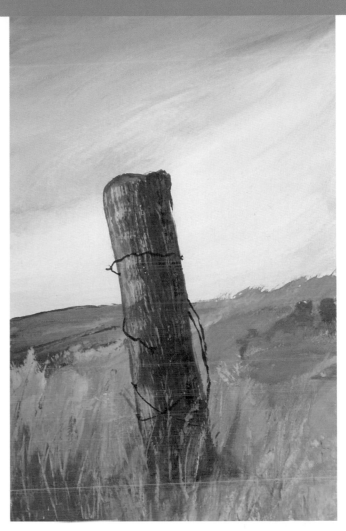

**The post was** already painted a brownish color to look dry and weathered. Then an even lighter color was applied using the drybrush technique.

# Avoid Muddy Colors

When painting unrelated colors wet into wet, it's important to clean the brush between colors so they'll remain bright and not turn muddy. For example, yellow and purple together would make a sickly green.

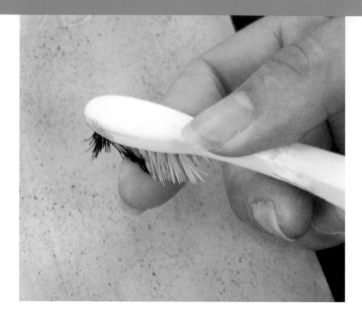

## Spattering

Spattering gives the effect of chips, mud splashes, debris, sand, and the like. Spritzing painted bricks or gravel with other colors adds a touch of realism. All water mediums lend themselves to spattering. Practice on scrap paper first.

1   Mask any parts of the artwork with paper where spots are unwelcome.

2   Dip a bristle brush or an old toothbrush into paint. Make sure the paint isn't too thin or it will leave large unwanted drips on the work!

3   Aim toward the area to be spattered, and pull your index finger from front to back of the bristles.

## Sponging

Lunge for the sponge for terrific texture!

Simply tap a sponge lightly into one or more colors of paint, and press it onto a prepainted area to make an interesting pattern. Use a small natural sponge, or tear a synthetic one into smaller pieces.

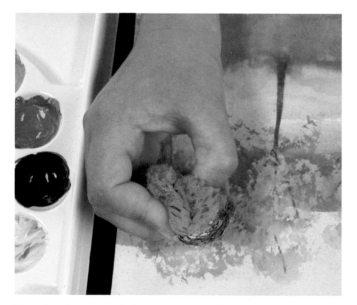

**The background,** foreground, and tree trunks came first. When they were dry, the artist used a sponge to stamp in the foliage in several green colors.

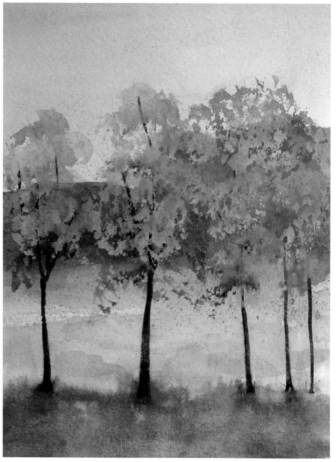

**A sea sponge** made the tree leaves simple.

# A TEMPERA PAINTING PROJECT

Many variations are possible with a tempera painted landscape.

Follow these steps to practice your techniques.

## YOU WILL NEED

- pencil
- watercolor paper or illustration board, 8" x 10" (20.3 x 25.4 cm) or larger
- watercolor brushes: #2 round pointed, #8 round, and #1 fan
- toothbrush
- tempera paints
- water in containers
- rag or paper towels

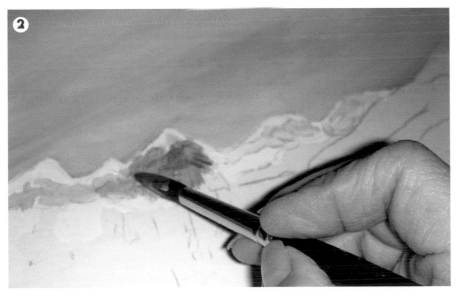

**1** Pencil in the main parts of the landscape lightly. Then start at the top of the page, and paint the sky using a good-sized brush. Use wet into wet technique with white, blue, and a bit of red. Work quickly in small areas at a time for smooth blending.

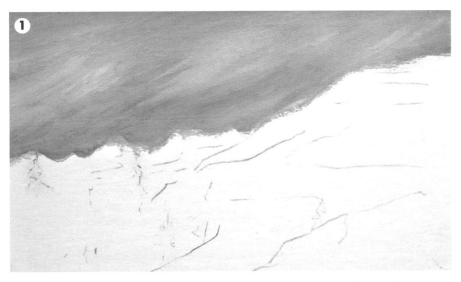

**2** Change to a smaller brush when adding small mountains or trees, to provide more control.

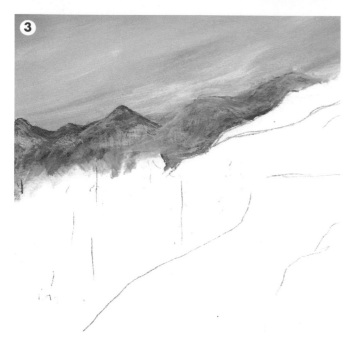

**3** Lay the groundwork by finishing the background elements first. Paint in the far mountains, mixing cool colors so they appear distant (atmospheric illusion makes cool-colored objects appear farther away. Things higher on the picture plane also appear distant). To add to the impression of depth and space, the distant mountains are without detail.

**4** Paint in areas that will become trees, and a large rock form in the middle ground. This is an underpainting for the texture and fine-tuning to come. The rocks and earth have just been started.

**5** Put in the final additions to bring the painting to completion. The trees are done and the foreground is next!

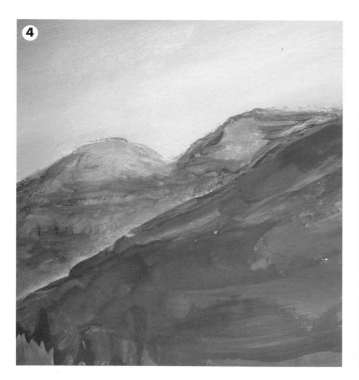

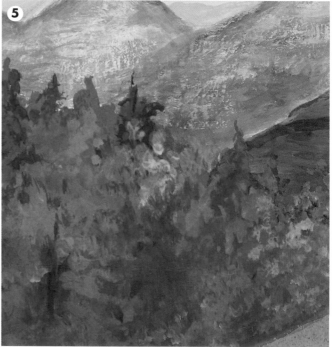

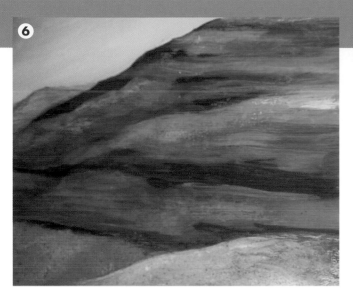

**6** Drybrush the rock formation and add crevices. Try a fan brush or spread the bristles of a round by hand. Include fissures and ridges to make the stone look more convincing.

**7** Texturize the foreground using the spattering and dragging techniques mentioned earlier. Scumble and spatter the sandy gravel and boulder in front.

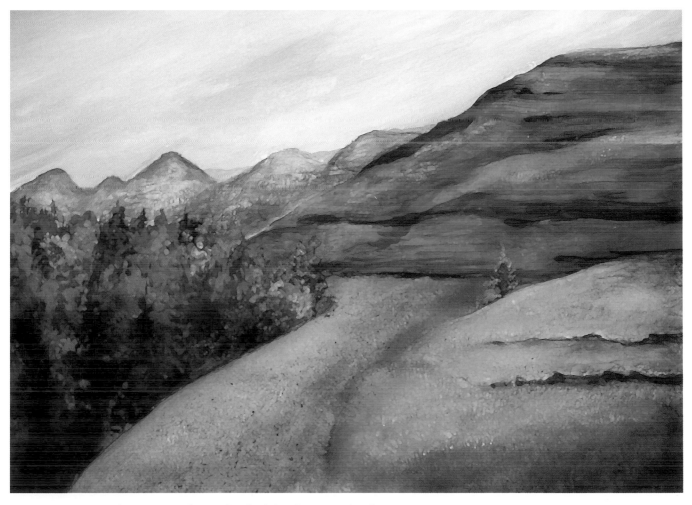

**Four or more** techniques result in a finished Southwestern landscape.

## A GOUACHE PAINTING PROJECT

Sketch a portrait in profile, like this one, or use a front or three-quarters view.

**1** On the support, draw the head, neck, and shoulders very lightly. This portrait will be painted on heavy watercolor paper.

**2** Wash in the background with generous amounts of thin paint. Watery gouache was used here for the blues behind the subject.

## YOU WILL NEED

- pencil or charcoal
- watercolor paper or illustration board, 8" x 10" (20.3 x 25.4 cm) or larger
- watercolor brushes: #2 round pointed, #8 round, and #10 round
- gouache paints
- water in containers
- rag or paper towels

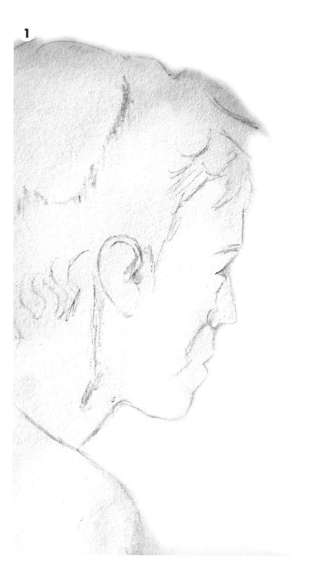

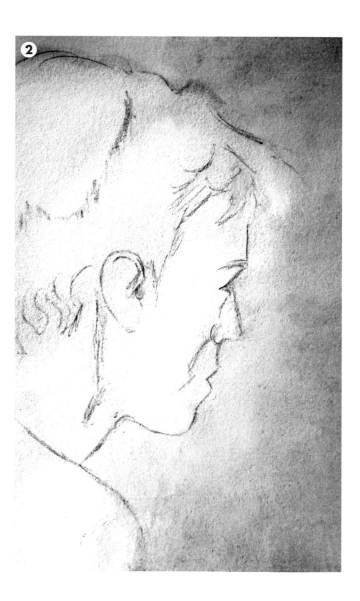

**3** Place tones on the face, hair, and clothing without concern for the finer details. They'll be next. The light and middle values should be added, with hair to come. This will be a monochromatic artwork.

**4** Intensify contrast and add the final elements with a small brush. Many values are represented, from very light to very dark.

# Clear Finish

A clear, oil-based finish can varnish and protect gouache and tempera paintings, but it must be applied gently. Keep in mind that it will stain very thin areas.

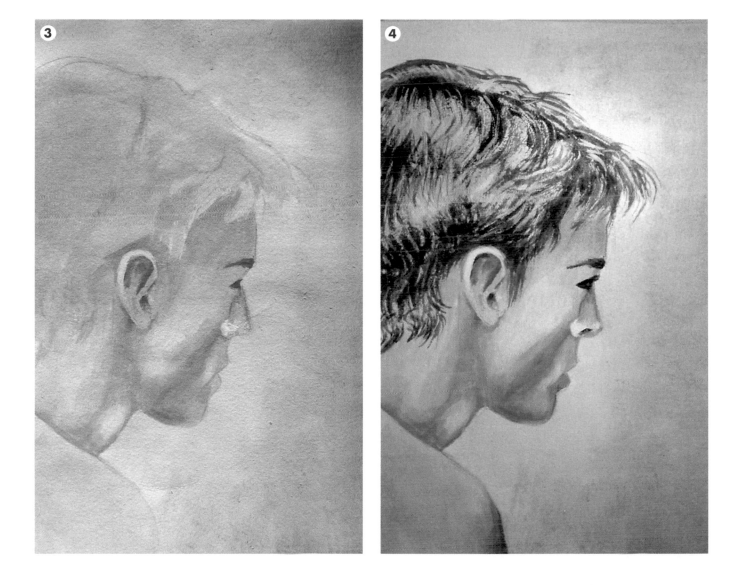

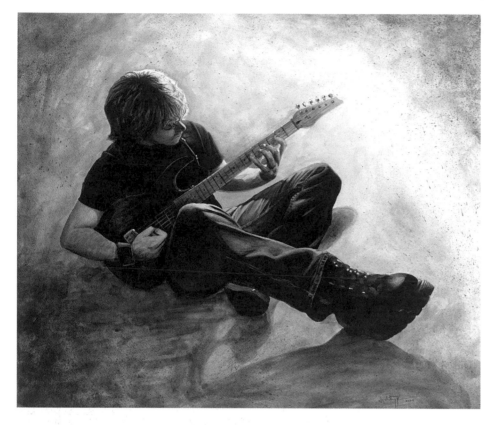

*Wrong Chord*
by Anthony Kosar
gouache on illustration board
Private Collection
14" x 11" (35.6 x 27.9 cm)

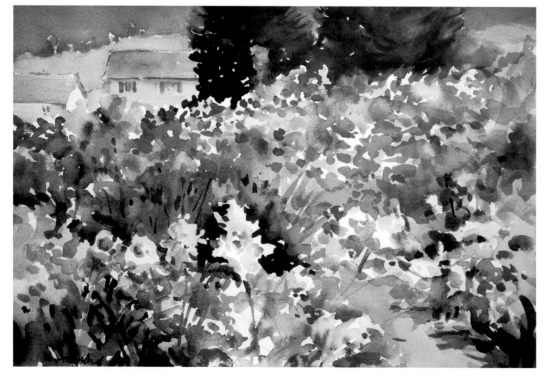

*Mo's Place*
by Tom Trausch
gouache, 9" x 12"
(22.9 x 30.5 cm)

*Never Known, Never Forgotten*
by Anthony Kosar
gouache on illustration board
Private Collection
14" x 11" (35.6 x 27.9 cm)

*Rock Wall* by Lora Schaunaman, gouache, 9" x 6" (22.9 x 15.2 cm)

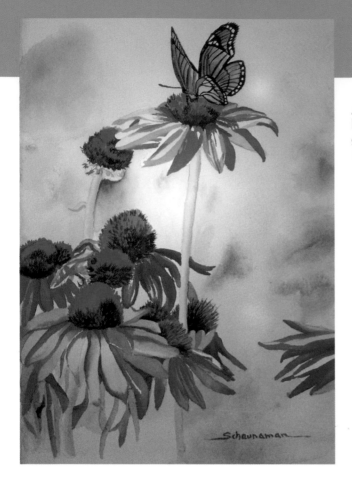

*Monarch's Vacation*
by Lora Schaunaman
gouache, 11" x 7½"
(27.9 x 19.1 cm)

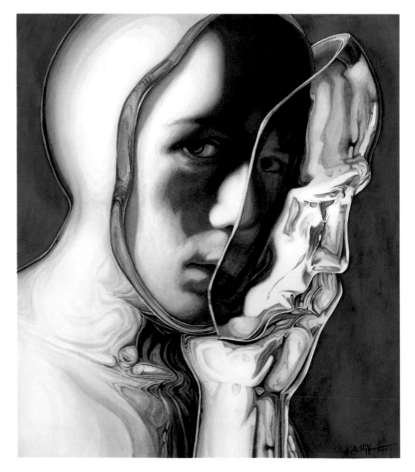

*Just a Reflection*
by Anthony Kosar
gouache on illustration board
Private Collection
11½" x 13¼" (29.2 x 33.7 cm)

A quick study
by Tom Trausch, gouache
9" x 12" (22.9 x 30.5 cm)

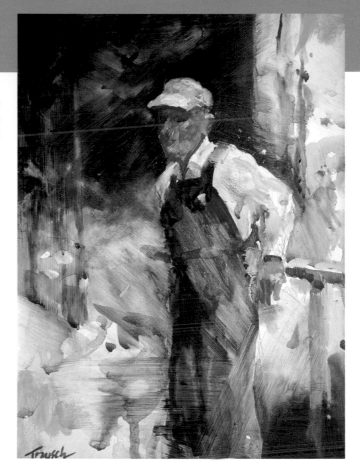

Window
by Geri Greenman
gouache, 9" x 12" (22.9 x 30.5 cm)

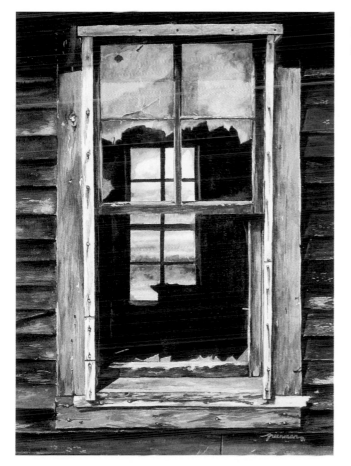

ACRYLIC PAINT

Acrylics have distinctive advantages and potential. Preferred by a large percentage of contemporary painters and crafters, they are expedient and durable and don't require harsh solvents. These fast-drying water-based paints, made from pigment mixed with acrylic (plastic) resin and emulsion, are permanent when cured.

## ABOUT ACRYLIC PAINT

Acrylics used to be available only in tubes, but creamier (heavy body) or fluid acrylics are now available in jars or plastic bottles. Diverse types of acrylic paints include fabric paints, high-gloss enamels, dimensional paints, fluorescent and glow-in-the dark colors, and much more.

Artist-quality products, with more concentrated pigment, are of a higher caliber than student-quality products, but the latter are more economical. Craft-quality acrylics are similar to tempera or gouache, but more permanent. In general, they are inexpensive and are good for craft projects and even small murals.

If applied thickly, or if mixed with white paint, all acrylic colors can be opaque. If thinned with water, they can be used like watercolors. One of the several advantages of acrylics is their convenience. They are safe to use, clean-up is easy, and there are no fumes! Another benefit is that they dry rapidly. When acrylic paints dry, they're insoluble, and can be overpainted without fear of disturbing the underlying color. They appear lighter when wet. Finished, dry acrylic paintings are not usually framed with glass unless the artwork is on paper and/or resembles a watercolor.

### Selecting Colors

If the financial outlay must be very limited, buy a student's starter set with black, white, cool yellow, cool blue, green, and both cool and warm red. Otherwise, the following colors make a good, basic palette of acrylics with which to begin: cadmium red medium, ultramarine blue, phthalo blue (also called phthalocyanine blue,

**Most portrait sets** include colors similar to these.

monestral blue, or thalo blue), cadmium yellow medium, yellow ochre, titanium white, Mars black or ivory black, raw umber, and phthalo green. While every artist's list of required and optional colors is different, we feel the following additional ones are good to have: burnt umber, raw sienna, cadmium orange, cobalt blue or cerulean blue, Hooker's green, Hansa yellow light, dioxazine purple, Payne's gray, titanium buff or raw titanium, and alizarin crimson.

An artist who wants to paint mostly people or scenery can purchase sets of portrait or landscape colors.

### Metallics and More

There is a stunning variety of shimmery, flashy acrylic paints from which to choose, including pearly iridescents, glitter paints, and interference pigments. The latter carry two shifting colors in one, each seen according to the angle of light.

**Metallic and iridescent** paints show off their attributes much better when mixed with the more transparent colors than they do with opaques.

## SUPPORTS FOR ACRYLIC PAINT

Painting supports come in a wide range of types, shapes, and sizes. Most commercial painting canvases are preprimed. In general, they're either rigid panels or canvas stretched over a wooden framework (called stretcher bars). The selection of shapes is enormous, including square, oval, round, and narrow.

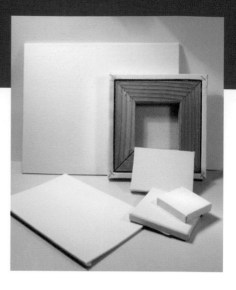

**This paper for acrylic painting,** 110-lb. (99 gsm) weight, is dry brushed to show the linen-like texture.

Flat canvas panels are best for beginners, since they are more economical.

Size and shape aside, consider the substrate's profile, too. Yes, that's really the term for the side view of a stretched canvas. Choose a traditional, back-stapled profile if the work will be framed. (Staple-free edges are desirable.) Gallery or museum wraps are deeper and more expensive.

There are also canvas-surfaced boards, as well as pads of canvas sheets or canvas-like paper.

In addition to traditional canvas, one can paint acrylics on numerous other surfaces: heavy watercolor paper, printmaking paper, illustration board, Bristol board, gesso board, hardboard, clayboard, wood panels, Plexiglas, metal, fired clay, leather, bone, glass, even walls! Some papers should be taped flat, and substrates like foamcore and matboard will warp.
Rusty, oily, waxy, or greasy surfaces should not be painted with acrylics.

# Working Time

The artist must work quickly, at times, to blend colors smoothly. If painting with acrylics on paper, dampening the paper first may increase the working time.

**Note the wooden stretcher** bars and the staples on this inexpensive canvas.

# BRUSHES, TOOLS, AND OTHER MATERIALS

While some experts advocate only synthetic-fiber brushes for acrylics, we suggest trying all types, even house-painting brushes and cheap foam brushes.

Bristle brushes for oils are also good with thick acrylics. Use #2, #6, and #8 flat synthetic or ox-hair brushes to start with. We also suggest beginning with synthetic sable filberts or rounds in #4 and #6 for watercolor effects. Make sure the brush bristles aren't extremely stiff.

From the array of sizes, shapes, and handle lengths available, select a few of each and try them. With time, favorites will soon emerge.

Acrylics begin to dry on brushes within minutes, so rinse out brushes that are not in use. At the immediate end of the painting session, before washing brushes, wipe them with a rag or paper towel to remove excess paint. Don't wash acrylic paint down the drain! Then press the bristles firmly into a bar of plain bath soap, work some lather

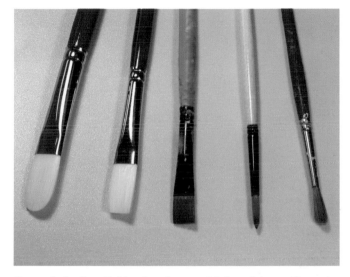

**From left:** Two Taklon brushes, a #6 flat, #4 round, and a #8 filbert.

**Spread the bristles** apart on the soap and scrub a bit.

far up into the body of the brush, and rinse thoroughly. Repeat if necessary. Shape the bristles and dry flat. Storing brushes upright is best only for dry brushes. If wet brushes were stored this way, water could run down the bristles and harm the brush.

Set up some good lighting, and protect the tabletop and floor. In addition, wear old clothes or an apron.

A water container and rags are essential, although using an easel is elective. There are many types of easels available, from large studio models and smaller table-top styles to outdoor versions and more.

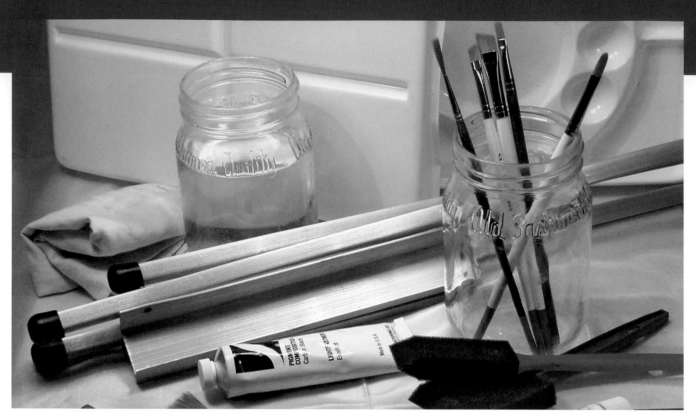

**Note the small**, fold-up easel and the lid for the palette, to help keep paints moist.

**Specially coated paper** is resistant to paint and won't bleed through.

A spray bottle of water is also optional. It's convenient for keeping paint on the palette moist by spritzing now and then. Painting knives are discretionary but useful at times. A palette knife, on the other hand, is a valuable tool for mixing and scooping paints or for scraping them off the palette.

Palettes take many forms, from the traditional curvy shape with a thumbhole, to round or rectangular. They're made of wood, ceramic, glass, enameled metal, composition board, plastic, and even coated paper! The latter, disposable palettes are tear-off pads—the top sheet is tossed after use. Because acrylics are fast-drying, some people prefer a palette designed to keep the paint wet longer. Stay-wet models consist of a base tray with a tight-fitting lid. They usually have a thin sponge in the bottom that retains moisture.

# Budget Booster

While it's practical to use a divided palette rather than a flat one, an old white dinner plate is serviceable and cheap. Add an old ice cube tray alongside, for its sections.

Squeeze small amounts of paint onto the palette in a logical arrangement. A matter of personal preference, the order might be from light to dark, warm to cool, or neutrals to primary and secondary colors. If acrylic paints must be left on the palette for a few hours or overnight, try covering them with plastic wrap or slip the palette into a large, zipped plastic bag. Press the air out before sealing.

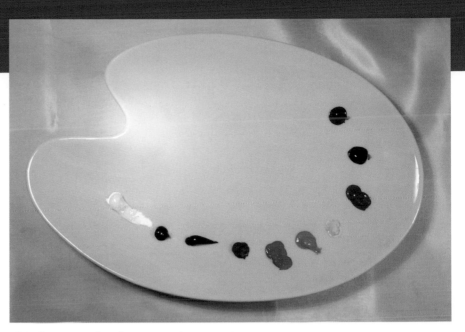

**This layout of colors** is Paula's penchant.

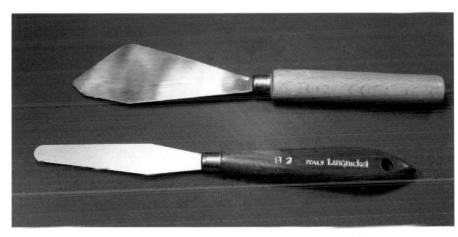

**Observe that these** two palette knives are flat, not trowel-style. See painting knives on page 70.

# Deeper Yellow

A common mistake of beginners is adding black to yellow paint to deepen it as in the example on the left. Instead, try a mixture of burnt and raw umber with yellow, shown on the right.

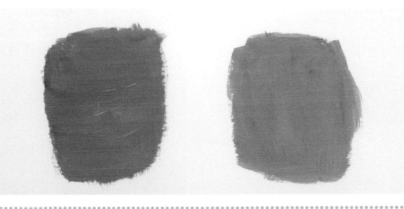

## Adding Other Acrylic Mediums

The medium isn't the message, but it sure helps!

Various mediums can be added to acrylics for body, flow, transparency, texture, finish, or to increase working time. All acrylic mediums dry clear except for modeling paste. Each of these products changes the character and extends the potential of the paint differently.

### Gloss or Matte Medium

Both of these fluids, also called polymer mediums, are adhesive, and they increase transparency when mixed with paint. Milky in appearance, they dry clear. Gloss medium dries shiny, while matte medium dries to a flat, nonshiny finish. Thin them with a small amount of water to seal the surface of a finished, fully cured painting. This varnishing coat is optional, but it does help protect the work from dust and grime. Another reason to varnish is to impart a uniform appearance if some areas are glossier than others.

Two transparent acrylic resins deserving special mention are Mod Podge and Triple Thick Gloss Glaze. The former

**Two gloss gels.** Super heavy gloss gel at left, and regular gloss gel medium at right.

is available in gloss, satin, and matte, and is a heavy, water-based sealer. Triple Thick, which really lives up to its name, imparts a high gloss with a diamond-clear finish. Both of these products go on smoothly to give paintings the illusion of depth.

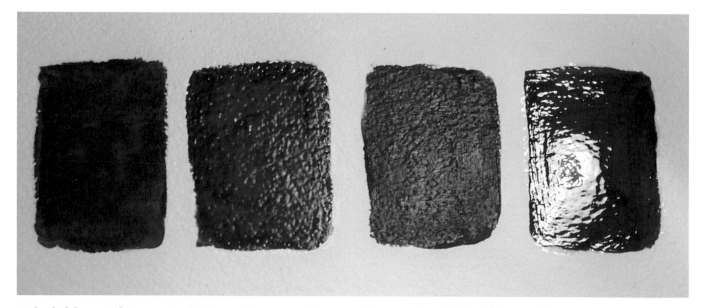

**Cobalt blue with** topcoats of, left to right, matt, gloss, semi-gloss, and triple thick gloss mediums.

## Gel Medium

This product, which has the consistency of jelly, is used for glazing, extending colors, and increasing translucence. It's milky until dry.

Soft and medium gels are less thick than heavy or extra-heavy varieties. Ultra-thick gel is the most viscous, capable of holding extreme texture. Gel medium is available in gloss, matte, and satin formulas.

Additionally, one can purchase many kinds of texture gels—specialty mediums with additives such as gritty pumice, sand, glass beads, fibers, or other particles. They can be used alone or mixed with acrylic paint.

Apply with a stiff brush or sponge, a palette knife, or a painting knife.

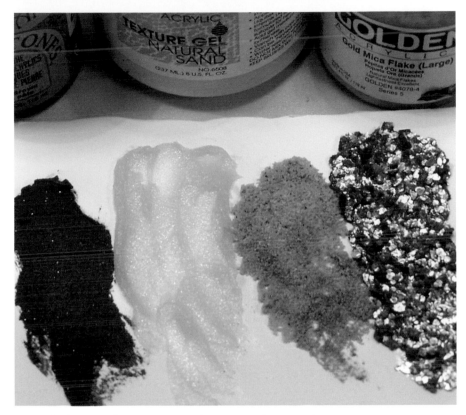

**From left to right:** Commercial texture gels in sandstone, coarse pumice, natural sand, and large gold mica flake

**Swatches from left to right** (all ultramarine blue): a thick application, a watery one, gloss gel mixed with paint, and modeling paste with paint. Gloss gel lightens the color but retains brightness.

### Drying Retardant

Retarder or retarding medium slows drying time and allows for easier blending. Use only a very small amount to inhibit water evaporation from the paint. Retarder is most effective with acrylic color mixed with gel rather than water.

### Floating Medium

This additive, a flow aid, creates free-floating colors that drift and run. Soft edges, filmy, seeping colors, poured streams of color—it's all possible. A gel or a liquid, floating medium also helps in blending.

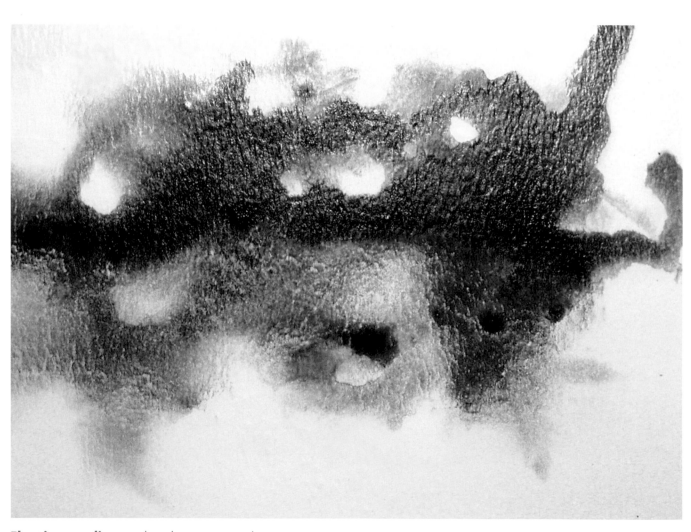

**Floating medium** makes sheer, runny color easy.

## Crackle Glaze

There are several types of furniture or craft crackle mediums. Some require a base coat of acrylic paint that can be painted over with a smooth coat of the crackle glaze once it dries. Brush it on in one direction. When the glaze is dry, apply a contrasting top color in the other direction. Cracks appear as the top color dries. Some crackle paints are one-step products.

**Red and black were** painted first, followed by a clear crackle medium, and finally, off-white latex paint.

## Crackle Paste

This is a thick, opaque material formulated to develop cracks and crevices as it dries. Thicker application produces larger cracks. Mix with color before using or paint it when dry. Use a rigid support with this paste and with modeling paste.

**The crackle effect** here (created with a craft glaze top coat) was emphasized by rubbing thin, dark paint into the crevices, then wiping the surface.

**At left:** smaller, finer cracks result from a thinner application.

## Modeling Paste

Not to be confused with crackle paste, molding or modeling paste is as thick as butter. Sometimes called paste extender, it's perfect for heavy, impasto areas (see page 75) and sculptural effects. Most often matte opaque white, it comes in a clear formula, too. In addition, there's a flexible type and a lightweight variety. Mix it with paint prior to application or color it when dry. To build up a thick area, apply it in thin layers (drying between coats), to avoid cracking.

It's simple to add homemade textures to modeling paste. Crush clean eggshells, gather some gravel, or scoop up some sand or sawdust!

**Detail, a finished** modeling paste painting with geometric lines and shapes.

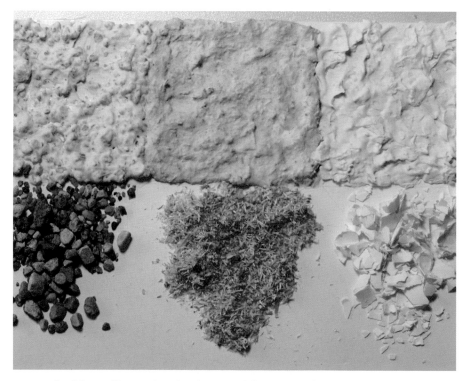

**Household stuff** mixed with white modeling paste for dimensional effects.

# Coloring Modeling Paste

If mixing tube color with modeling paste, begin with a very modest amount of the paste to avoid ending up with too much left over.

## Gesso

This is a fairly thick product used not as a medium but to prime surfaces or to obscure unwanted areas. White gesso can also be mixed with acrylic colors, although it's not a substitute for white paint. Gray and clear gessos are also available, as well as a heavy, sculptural type of gesso.

**On a black substrate**, combing through thick, wet gesso creates a rhythmic, textural pattern. Read more about scraping and scratching on page 78.

# Budget Booster

Gesso not only prepares raw canvas, but also covers up unsuccessful paintings so the substrate can be reused! Save by substituting ordinary latex housepaint from the local home improvement store. Even less expensive might be mismixed paint in an off-white tint. Ask a paint dealer if there is a gallon of beige in the back!

# ACRYLIC PAINTING TECHNIQUES

This versatile medium is adaptable to a great many painting processes. Try the ideas here and discover new means of self-expression.

## Underpainting with Grisaille

Going gray can be a good thing!

Create a value map of sorts by painting first with black, white, and gray. Or use neutral colors in place of black and gray.

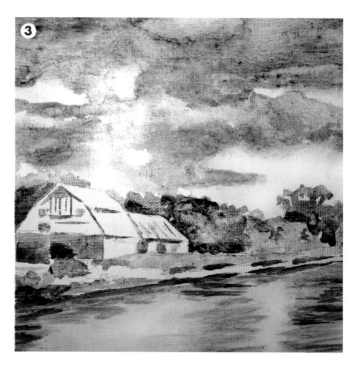

**1** Moisten a brush in clean water before dipping into acrylic paint. This helps keep paint from collecting at the base of the bristles.

**2** Place only black (or raw umber) and white paint on the palette. Note: to save paint when mixing up a batch of a light color, start with white and gradually add color to it. If the goal is a dark mixture, begin with the darkest color and, bit by bit, add white or lighter paint.

**3** Use paint brushes and thinned paint to draw lines and fill in the underpainting. Block in forms and shadows. Wherever it becomes too dark, scrub with a rag to uncover the white of the canvas. In this photo, thin applications provide the foundation with an initial drawing and value pattern.

**4** With more opaque layers of paint, blend in more values. While the monotone can stand alone as a finished artwork, many artists let it dry and then add translucent glazes of color over it. The grisaille now includes a full range of values from darkest black to white.

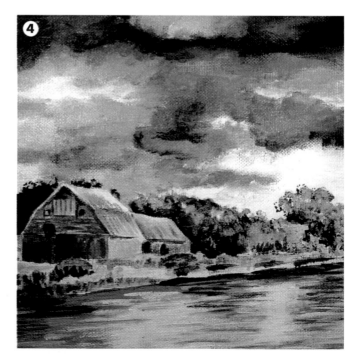

## Glazing

Carrots and ham aren't the only things that are glazed! Glazing grisaille paintings with thin color changes underlying hues, increases brilliance, and unifies a painting. Some polymer varnishes contain UV light stabilizers to protect the painting. Always wait two or three days after finishing an acrylic painting to varnish it (or until it is fully cured). Read more about glazing in the oil painting section (page 140.)

1   Consider the colors in the underpainting when choosing transparent color to apply over it. Use colors that support and intensify each other or that contrast with each other. For examples of the latter, a portrait with earthy green undertones might be overpainted with a reddish glaze, or a yellow ochre underpainting might benefit from violet and purple glazes that subdue the yellow.

2   To make a glaze, thin fluid acrylic paint with at least three times as much polymer medium or gel as there is paint. Use transparent colors such as the pthalos, the quinacridones, azo yellow, dioxazine purple, alizarin crimson, and ultramarine blue.

**The opaque** blue swatch here is glazed with a harmonious violet and a complementary orange.

**These swatches** illustrate the transparency of pthalo blue, ultramarine blue, quinacridone red, and quinacridone orange.

# Budget Booster

No need to toss surplus paint! Paula cleans empty plastic pill bottles (or 35-mm film containers) and stores leftover paint in them at the end of a session. Be sure to dab a bit of the color on the lid (for reference) before snapping the top on tight.

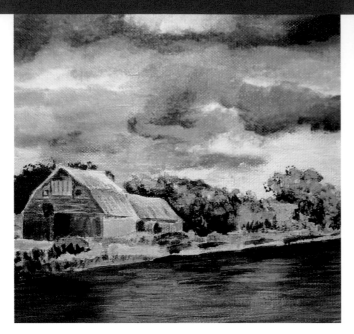

**A sheer glaze** of yellow was applied in places.

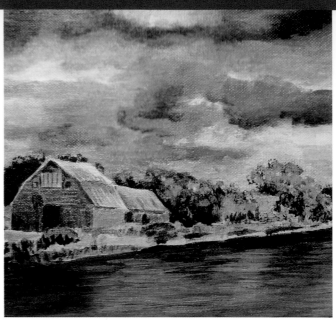

**Apply the glaze** atop previously painted, dry areas to enrich colors and create a glow. Red glaze, used sparingly, reveals evening light.

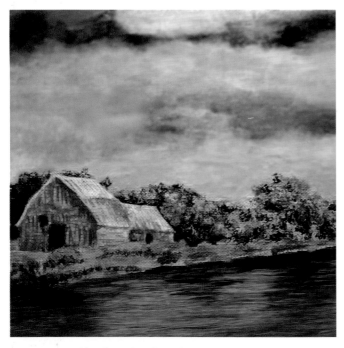

**Compare this finished** work to its beginning on page 66.

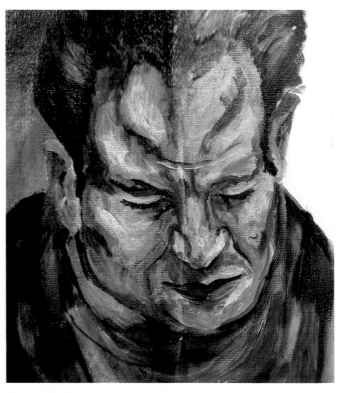

**Over a black** and white underpainting, three successive glazes on the left side added brilliance. The right side was enhanced with flesh tones.

## Painting in the Impasto Style

Get into the thick of it! Paint with dense, heavy acrylics to produce texture or relief designs.

Impasto paintings have highly visible brush strokes or painting knife marks. Use the paint straight from the tube or add thickening agents to it. Apply it with a stiff, heavily loaded brush, putty knife, squeegee, trowel, or other tool. In order to choose which tools to use, test several and find a few favorites. Caution: Don't put heaps of very thick, heavy paint on a stretched canvas!

1   Begin with large areas and "trowel" the paint. Use the flat underside and the edges of a knife, as well as the tip, to spread and scrape the paint on.

2   Next, work with a smaller tool (or just a knife tip) to lay in the medium-sized shapes. Strokes can be directional if desired, following the contours of the various forms in the picture. Knife marks curve around the form shown here.

3   Use a smaller tool to work in the details last. Read more about the impasto method in the oil painting section (page 139).

Instead of paint, one can carve and model a thick layer of moist modeling paste or gel medium. This technique works well with natural subjects such as trees, rocks, mountains, and clouds. Let dry before painting.

**Modeling paste was** mixed with color here, but an additive such as extra heavy gel works too!

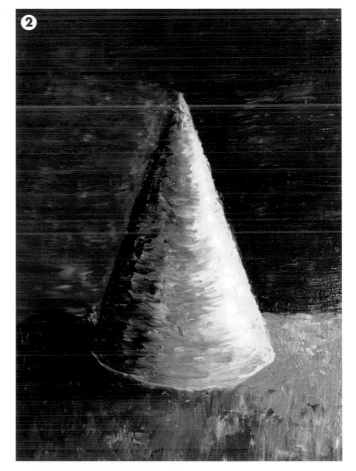

# Change Your View

Keep a mirror in the studio area, facing the easel if possible. Hard-to-spot flaws in an artwork will pop out in the mirror image! Or turn the piece upside down—areas that need work will become more noticeable with the change of outlook. Both tricks allow the artist to see a work with fresh eyes.

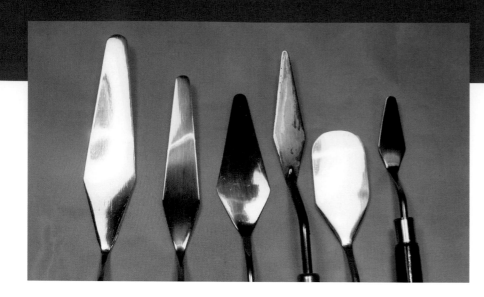

**Diamond-shaped**, elliptical, or teardrop painting knives, and more—there's a bewildering assortment of sizes and shapes on the market.

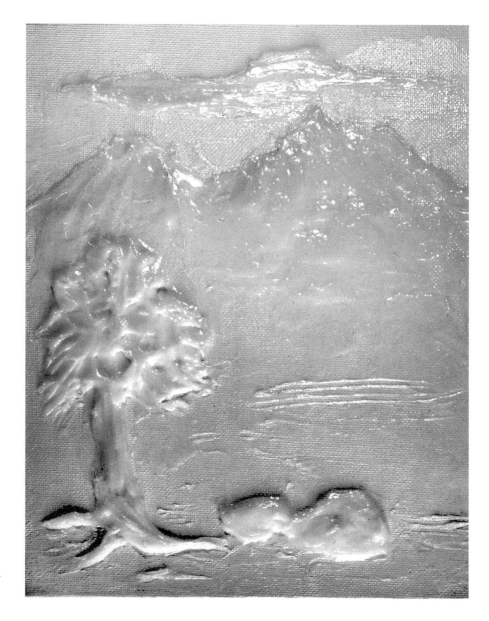

**Heavy gel forms** the scenery seen here in relief.

THE COMPLETE PHOTO GUIDE TO CREATIVE PAINTING

## Making Hard Edges

Be "edgy" with this idea! Mask parts of a canvas or a painting with tape to generate sharp lines or hard-edged shapes.

Hint: Use a slick painting surface rather than a canvas-textured one. Even with tape, it's difficult to get clean, straight lines on a nubby surface.

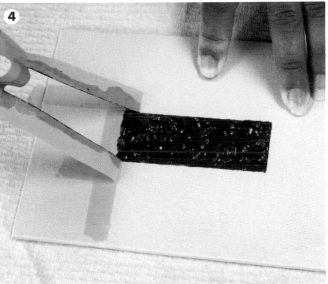

1  Use masking, drafting, or plastic tape on a smooth, primed substrate or on an already-painted (dry) area. Note: Avoid lifting previously applied paint by coating it with a thin coat of medium, as a barrier, and letting it dry first.

2  Burnish the tape edges with a brush handle to ensure good contact with the surface. Because acrylics are somewhat elastic and edges may peel, some artists first seal the tape edge with medium, too.

3  Apply fairly thin acrylic paint over the mask. Stay within the taped "lines."

4  Let it become at least semi-dry if not completely dry before pulling the tape off. This application of thick paint required tape removal before the paint was completely dry or it might have pulled up.

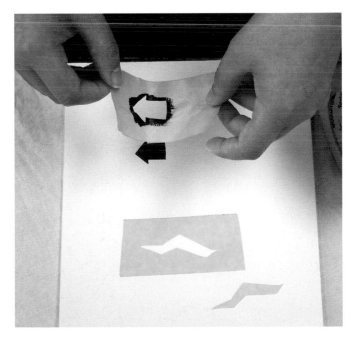

**The arrow is** a stencil cut from tape. If desired, paint over the positive tape shape, too (such as the green zigzag at the bottom of this example).

## Stenciling

Stencils, too, are masks or templates. Ready-mades (laser-cut) are easy to use, but original stencils can be created with a craft knife. Design, trace, and cut a unique stencil from heavy paper or a blank stencil sheet from a craft store. Cover sections of a stencil pattern with masking tape to create different designs from a single stencil. Experiment with a variety of paints and surfaces, mix colors, and overlay patterns.

Use acrylics, oils, spray paint, or stencil creams with stencils. Wood, walls, fabric, metal, and more...many surfaces accept stenciling. Sand and prime wood first. With textiles, ceramics, or glass, use paint especially formulated for those surfaces.

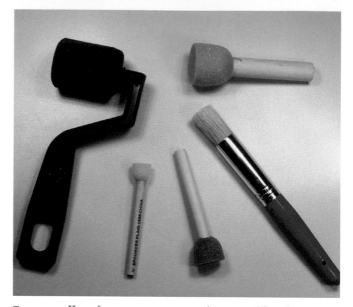

**Foam roller,** foam pouncers, and a stencil brush

**The stenciled pattern** on the left was spray-painted. To make the raised design on the right, modeling paste was layered onto a stencil.

1. Adhere the stencil to the clean, prepared surface. Hold stencils in place with low-tack masking tape or repositionable adhesive spray. Liquid stencil adhesive is also available.

2. Apply the paint with a stencil brush using a pouncing or stippling motion, dabbing it into the stencil openings. Use as little paint as possible to prevent seepage.

3. An alternative is to pour paint into a tray and apply with a roller.

4. More than one color makes a design more interesting. Apply the lightest color first, and blend to create multiple color tones.

5. When all the work is done, carefully remove the stencil. Clean it and the painting tools immediately.

6. When the paint is dry, seal the design with several thin coats of clear varnish (either brushed or sprayed on) if desired. This blank journal is now distinctive.

## Stamping and Printing

Perform this stamp act in either of two ways.

1   Create visual texture with found objects such as bubble wrap, burlap, a lace doily, or the bottom of a bottle. Simply roll or brush paint onto the item and press it to the surface of the artwork. Note the glass with taped edges and the rubber brayer with which to roll out paint onto the glass (or directly onto the objects).

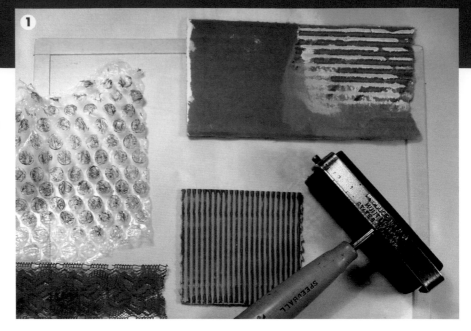

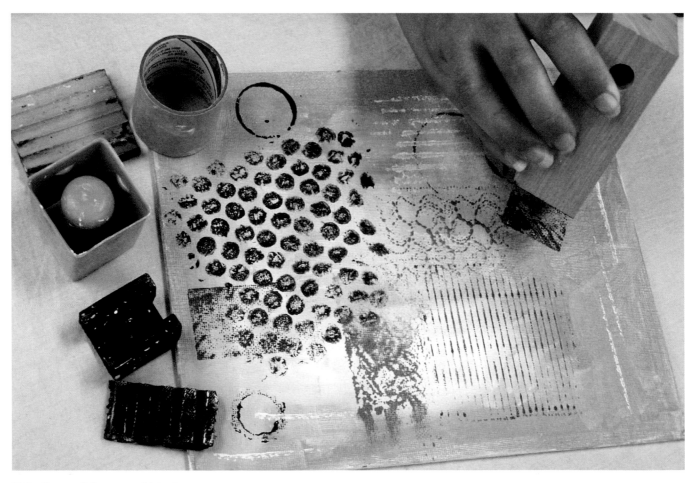

**Printing with** a wood block

THE COMPLETE PHOTO GUIDE TO CREATIVE PAINTING

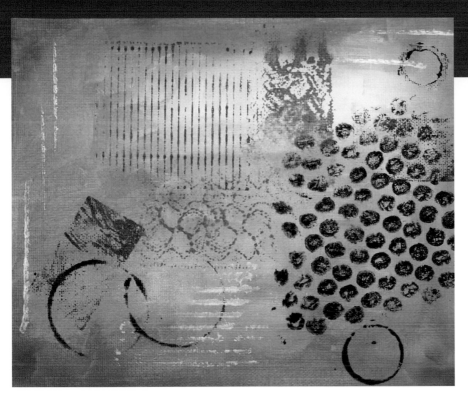

**The printed canvas** could be an artwork in itself or it could serve as the basis for further painting.

Or make an impression by first laying it on thick!

**1** Apply a thick coat of modeling paste to the substrate.

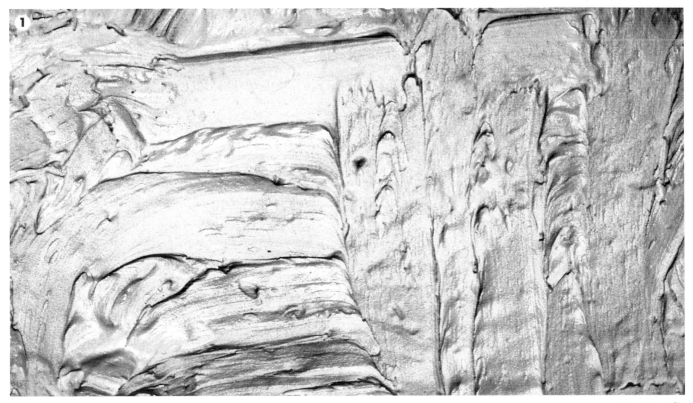

(continued)

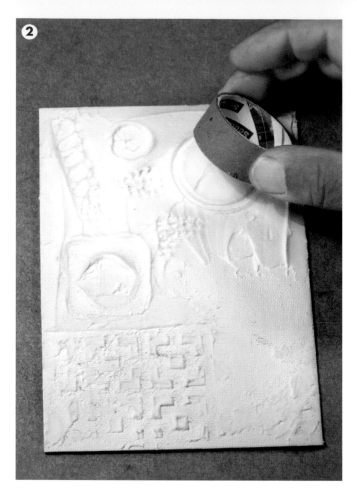

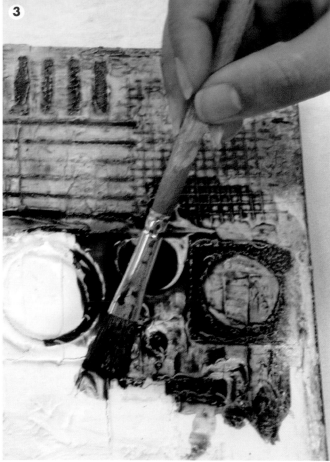

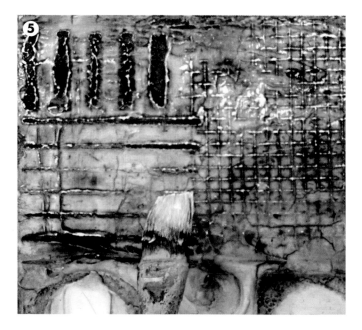

**2** Press gadgets and materials into a still-moist layer of modeling paste or heavy gel medium. Coarse fabrics, heavy lace, kitchen utensils, and more make great imprinting tools with which to stamp tangible texture. Remove objects before the paste dries, or see Embedding, opposite, for the alternative.

**3** When the modeling paste is dry, paint or stain it as desired. Washing dark paint over the surface (also called antiquing) enhances the dimensional effect. The dark wash should be thin enough to sink into the hollows and collect.

**4** Rub the highest surfaces with a rag to bring back highlights.

**5** After the antiquing wash is dry, drybrush white or a very light color so that just the highest ridges take the paint. White paint increases contrast by highlighting the uppermost edges.

## Embedding

Press clock parts, costume jewelry, beads, and more into moist modeling paste or gel to create embedments. Or implant objects directly into thick paint!

**1** Lay down a thick coat of the medium of choice. While it's still moist, set objects firmly into it. These objects are set into modeling paste.

**2** This example is much more appealing after being antiqued and painted.

**3** If transparency is desired, use heavy gel medium instead of chalky modeling paste. Build up layers gradually, with drying time in between. In this example, beads in a variety of sizes and colors are inserted into tinted gel medium.

## Scraping

Here's a way to use a credit card without spending a dime! You can also scrape with the edge of a painting knife, putty knife, spatula, or pastry knife. Underlying colors can be wet or dry. Pulling paint around with a rigid, flat-edged tool adds a sense of movement.

Feelin' groovy? A notched tool such as a tile adhesive applicator makes amazing lines. Cut serrated edges into old plastic credit cards for similar results. Hair combs and forks texturize a surface very well, too. Move paint around with these tools, or add texture to modeling paste, gel, or gesso.

**Note the cut outs** on the edges of the green credit card.

**This piece was** done entirely with various scraping tools. In the center, note the palette knife being dragged on edge.

## Scratching

Sgraffito (scratching through a top layer to reveal the layer beneath) is easy with a rubber- or silicone-tipped tool called a shaper. Or draw into wet paint or medium with the tip of anything that will work. Some artists even abrade parts of a dry painting with sandpaper! Scratching techniques are also used with oil pastels, watercolors, and other mediums.

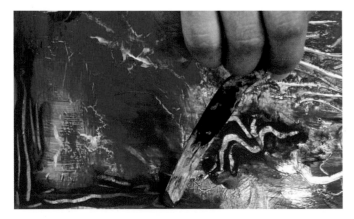

**Use the tip** of a painting knife to score lines into wet paint.

**Even a golf tee** or screwdriver will do. Note the double-ended shaper tool.

## Squeezing

Draw with extruded lines from squeeze bottles. It's easy to write words or numbers, or make borders. Large syringes (without needles, of course) and cake decorator's piping bags work great, too! Test the line applicators on scrap paper first.

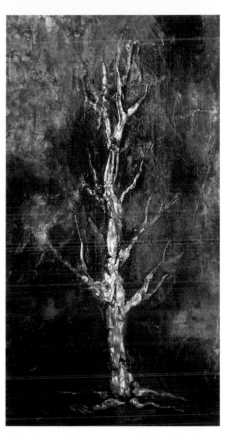

This bare tree was created with a squeeze bottle of metallic gold paint.

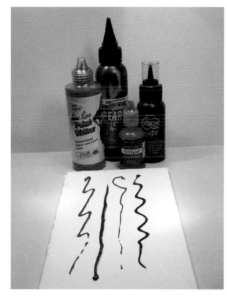

Paint writers and scribblers come in many sizes.

Squirt out quirky lines and shapes meant to be collaged to an artwork later (like this grid). Squeeze acrylic paint out onto a flexible, plastic page-protector. Peel off when dry.

## Spotting and Blotting

Meet Dot, Drip, and Dab!

1   Apply a color or colors to a surface and let dry thoroughly.

2   Choose a contrasting color for the next layer, and let that coat sit for no more than a minute.

3   Spatter water droplets onto the surface and let them remain for about thirty seconds. On a dry layer of dark green acrylic, yellow paint has been dotted with water.

4   Firmly pat the surface with a paper towel, then lift. The paper towel has lifted the spots where water was dripped.

See the watercolor section (page 186) for a spotting technique with rubbing alcohol (which also affects acrylics).

## AN ACRYLIC PAINTING PROJECT

Do some abstract thinking! A subject can be recognizable but reduced to its essentials. For this exercise, we'll create an abstract rather than a representational painting. Work with geometric shapes or freeform, organic ones. Base a design on the human figure, a landscape, a still-life, outer space—anything that can be broken down into a pleasing arrangement of shapes, forms, and lines.

### YOU WILL NEED

- canvas or other substrate
- acrylic paints, palette, rag, brushes, water container
- charcoal or other drawing tool (optional)
- polymer medium or gel (optional)
- retarding medium (optional)
- varnishing medium (optional)

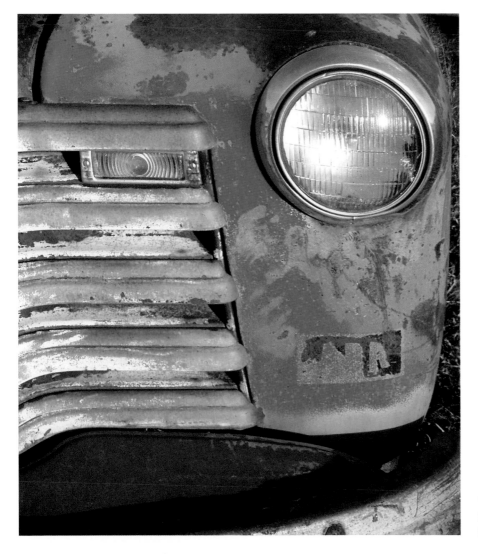

**The example** demonstrated in this section is freely derived from this photograph.

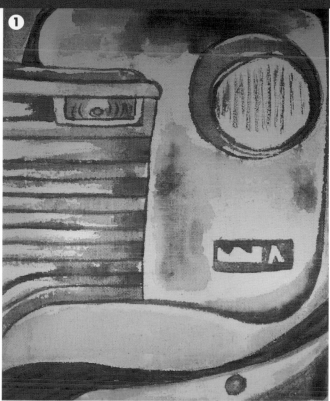

1   Make a preliminary sketch on the canvas. Many artists use charcoal for this, but pencil or waterproof ink will do. Even better, use a thin brush and diluted paint in a neutral color!

2   Squeeze small amounts of paint colors onto palette. The monochromatic sketch and underpainting here consists of thin, transparent burnt sienna.

3   Develop the middle and darkest tones further, adding some opacity. Thinner, darker colors seem to recede, so save thicker, lighter colors for later. The painting is still largely figurative or literal at this point.

4   Refine values, shapes, and lines, but remember that some softer edges keep objects from looking "pasted on."

5   Varnish the dry, finished painting with matte or glossy medium. Observe that the finished work has been changed considerably from the original reference photo. The composition seems more appealing after turning the canvas upside-down!

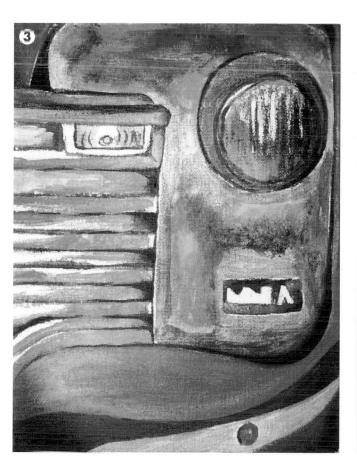

## PAINTING IN THE FOLK ART STYLE

Decorative painting is a broad term for a number of techniques used throughout painting history. The terms tole and rosemaling encompass many techniques. These classic styles often include floral motifs, scrolls, and ornamental borders. Surfaces include walls, furniture, musical instruments, and many other objects.

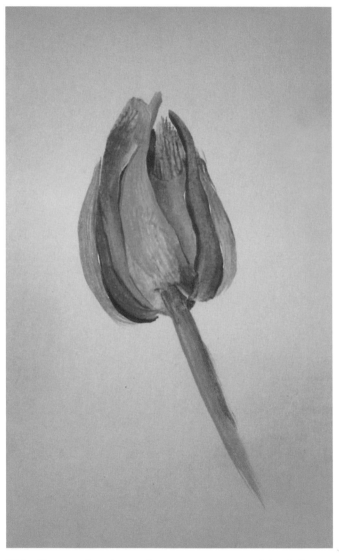

**This flower is** a loose, free interpretation of the folk art style.

Today, folk art painting using traditional motifs is done most often with acrylics, although purists use oil paints. Mix at least three values of each color used in a painting.

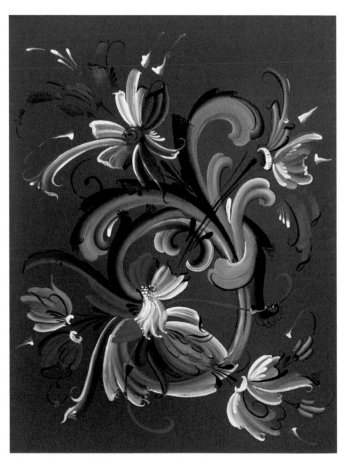

**This rosemaling**, on a 16" x 20" (40.6 x 50.8 cm) Masonite panel, was done by Signe Bruers in the transparent Telemark style.

**Craft paints come** in a huge choice of colors.

Priming and/or underpainting a surface are recommended, especially since acrylics might peel off glass, polished metal, or smooth plastic. The only alternative for a slick surface is to roughen it first with an abrasive.

If the object is porous craft wood or papier mâché, seal it first, sand it, clean it, and then proceed. If using a basecoat of color, sand lightly when dry, and wipe down the piece with a tackcloth. Do the same with a second coat.

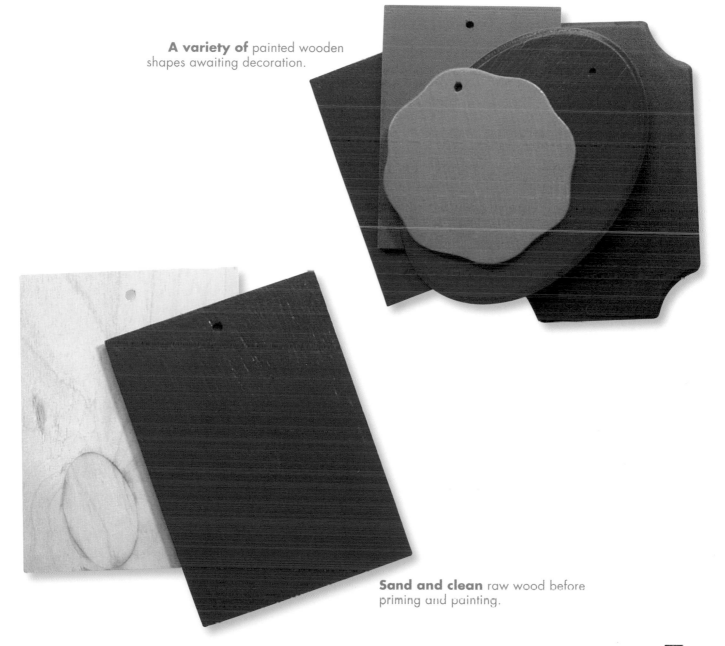

**A variety of** painted wooden shapes awaiting decoration.

**Sand and clean** raw wood before priming and painting.

## Brushes, Tools, and Other Materials

Teardrop (resembling an abbreviated, pointed, round brush), filbert, and fine liner brushes (also called pointers or stripers) are perhaps the most useful brushes for folk art style, although short, pointed rounds and small flats can also be used. Use good sables if possible. Quill brushes are optional.

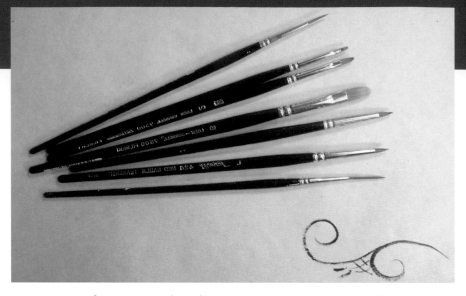

**From top to bottom:** #1 long liner, two #3 teardroppers, #8 filbert, #2 filbert, #0 filbert, and #2 liner brush

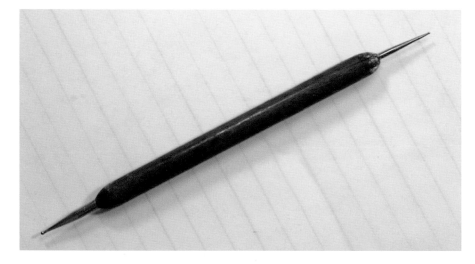

**A stylus is** used to transfer designs to objects by tracing with it.

**Besides items such** as these, Masonite, Bristol board, or painted papers can be used.

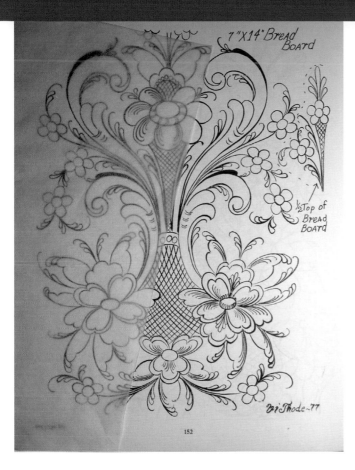

**Patterns are widely** available in craft painting books and magazines. Here, tracing paper is overlaid on the left.

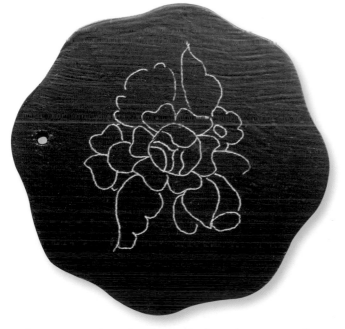

**A design** transferred with Saral white shows up well.

**Use graphite paper** or colored transfer paper that contrasts with the background color.

**Repeat until** the stroke becomes smooth and routine.

**While these are** side-by-side, a series of them done head-to-toe would make a nice, simple border.

**These could** be called "stop/start" strokes.

## Techniques

The beginner to decorative, folk art painting should first practice the simple, basic strokes found here. Rehearse them on paper or Bristol board with a #2 and/or a #4 pointed round brush. Practice curved, wavy, and straight lines, too.

### The Right Comma

Loading the brush refers to filling it with paint. Dip the tip into a puddle of paint, and lightly tap it back and forth to fill the bristles. Be sure to roll the bristles on a clean spot on the palette to rid the brush of excess paint.

Hold the brush at a 45° angle to the painting surface.

Apply pressure to the tip of the brush (the toe) to begin with a wide mark, and guide the stroke downward and to the right a bit. At the same time, lessen the pressure to thin the mark. Then curl from right to left to form the tail.

### The Left Comma

Holding the loaded brush, press the brush toe down to spread the bristles a bit, and lift during the pull from left to right and downward.

### Combining Two Strokes

Leaves are made by uniting right and left strokes. Leaf stems and veins are added later.

Make a thin line at an angle at the top of the stroke, stop, and apply pressure to widen the brush toe as the stroke is begun again. Then lift and finish with a thin tail.

**Combining two or** three strokes is not just for leaves but for petals, too!

**These three-stroke** petals are flat and unfinished.

**The completed** flower head now has highlights and a center.

### The Teardrop

This stroke is also called the straight comma. Lay a loaded brush (teardrop, pointed round, or short liner) nearly flat to the page, using enough pressure on the tip to widen the mark. Then, with a lifting/rolling/pulling action, taper the tail of the stroke as it's steered straight downward. Or start at the bottom of the thin tail, holding the brush straight up, and then tip the brush forward and set its heel down to make the fat top.

### The S Curve

Begin with the tip of the brush on the paper, to form the top of the S. At the change in direction, increase pressure, then let up at the final direction change. The brush comes to a sharp edge at the bottom of the stroke.

### Double Loading

This technique employs two colors on the brush together. Begin by loading the brush with the first color. Touch one side of the brush to the second color, and lift upward. Then swipe the brush on the palette in a straight motion, to slightly blend the two colors where they meet. Sweep the brush, don't roll it. Sweeping is the term for dragging the brush on a clean place on the palette.

Note: If oil paints are used instead of acrylics, mix linseed oil into the light colors.

**Press down**, pull, and release!

**Begin with a** very light touch and end by lifting.

**On the upper left border,** the short, angled lines were done separately between each of the S curves. The dots were added last.

**Two colors are** merged in each single stroke here, but the proficient painter can triple load!

## Beginning a Folk Art Painting

**YOU WILL NEED**

- prepared surface or object
- pattern to fit
- painter's bridge or mahlstick (optional)
- ruler or measuring tape (optional)
- tracing paper and pencil
- transfer paper
- stylus
- masking tape
- fine sandpaper and/or steel wool
- paints
- primer
- protective smock
- table cover
- palette
- brushes
- water container (for acrylics) or linseed oil and solvent (for oil paints)
- rags
- satin varnish

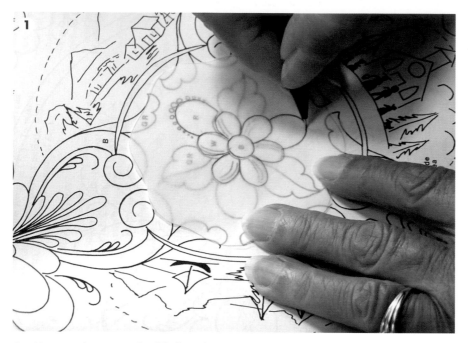

**1** Measure the area to be filled. Make an original pattern or use a store-bought one. Trace the pattern with pencil onto tracing paper of the correct size and shape.

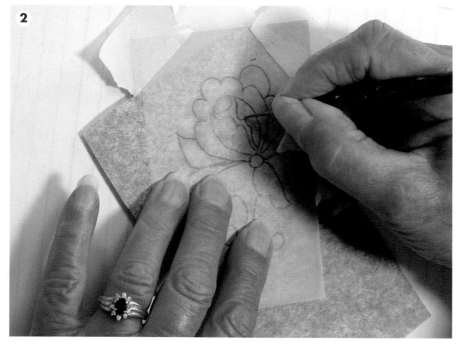

**2** Center the tracing-paper design on the object, tape it into place on two or three sides, and slip the transfer paper underneath, dark side down. Now go over the pattern again, using a stylus. Don't press hard enough to indent the surface.

**3** Lay in the base, "underneath" shapes first. Begin with the farthest away elements of the composition and work forward.

**4** With those back elements in place, put in the middle values first, in the center of each shape.

**5** Next, double-load the brush with middle and dark values and stroke in the shading.

**6** Clean the brush and do the same with middle and high values, to add highlights.

**7** When the bottommost layer is finished, work on the next level up, which overlaps the previous layer. Continue in this manner.

**8** When the finished painting is dry, erase any graphite that might show. Seal the piece with varnish.

# A GALLERY OF
ACRYLIC PAINTINGS

*Birds and Butterflies*
by Carol Weber Green
acrylic on wood with mirror
24" x 36" (61 x 91.4 cm)

Acrylic on leaves
by Calvin Schultz
5" x 4½" (12.7 x 11.4 cm)

*Rose Reflections*
by Carol Weber Green
acrylic on muslin with mirror
28" x 28" (71.1 x 71.1 cm)

Acrylic paint on goose eggs
by Carol Weber Green

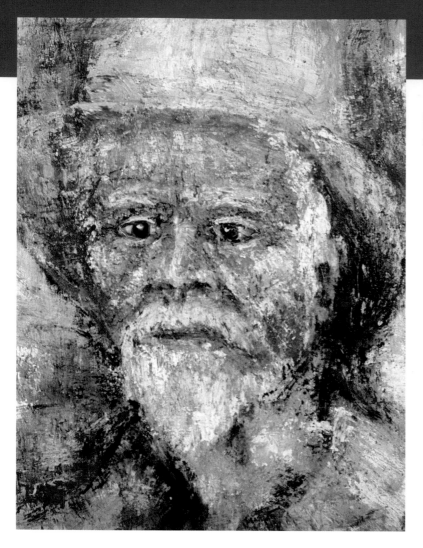

*A Hard Life*
by Paula Guhin
acrylics and gravel
18" x 22" (45.7 x 55.9 cm)

*Alluvial*
by Geri Greenman
mixed media acrylic
on gessoed Masonite with
modeling paste, corrugated
cardboard, and more
28" x 36" (71.1 x 91.4 cm)

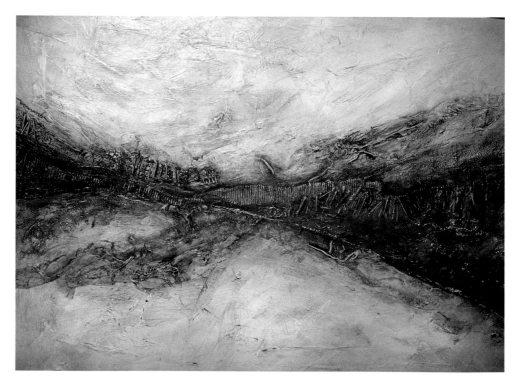

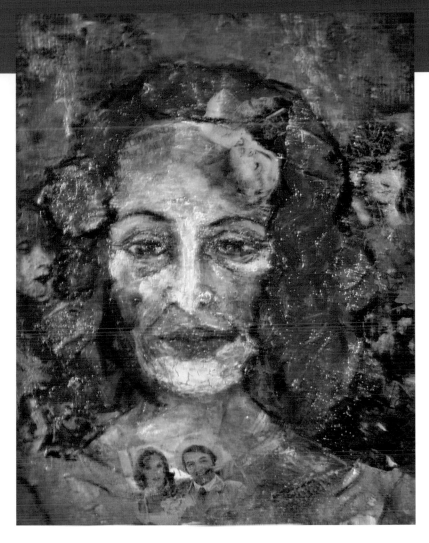

*The Old Actress*
by Paula Guhin
acrylics and collage materials
18" x 22" (45.7 x 55.9 cm)

Detail of *The Old Actress*

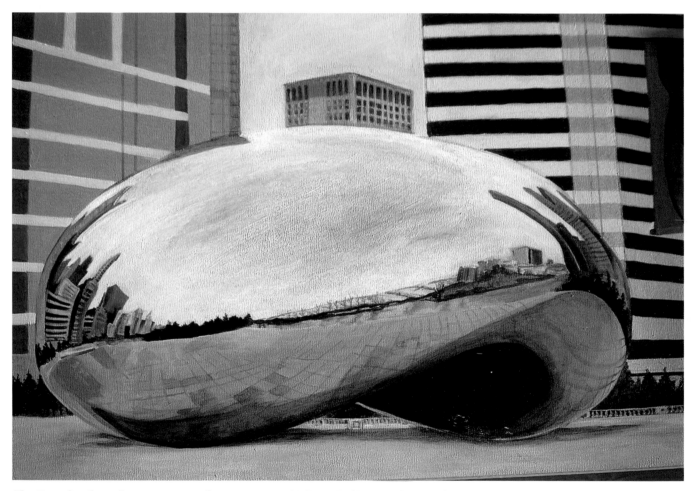

*The Bean* by Geri Greenman, acrylic on canvas, 11" x 14" (27.9 x 35.6 cm)

A non-objective painting on canvas by Paula Guhin, 18" x 18" (45.7 x 45.7 cm)

Medicine wheel in acrylic on bone with leather and feathers
by Brenda No Hawk Kohlman, 22" x 22" (56 x 56 m) skull, tip to tip

A heavily textured collage painting, by Paula Guhin, 8" x 10" (20.3 x 25.4 cm)

THE COMPLETE PHOTO GUIDE TO CREATIVE PAINTING

*First Snow*, acrylic paint on bison scapula, by Brenda No Hawk Kohlman, approx 11" x 25" (28 x 63.5 cm)

*Tiger Eyes*, painted on a bison jawbone, by Brenda No Hawk Kohlman

Tri-cornered Norwegian hat box
by Signe Bruers
12" (30.5 cm)

Wooden plate
painted in a traditional style
by Signe Bruers
10½" (26.9 cm)

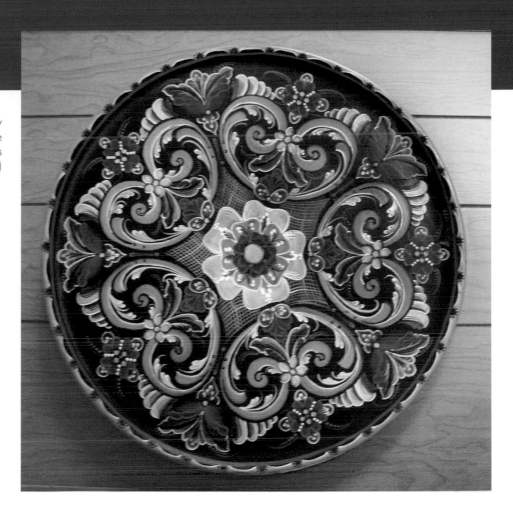

Wooden tray
painted in a traditional style
by Signe Bruers
16" (40.6 cm)

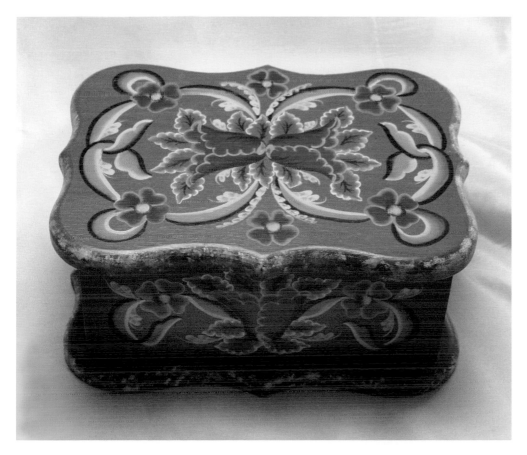

Decorative wooden box
painted by Signe Bruers
5" x 5" x 8"
(12.7 x 12.7 x 20.3 cm)

OIL PASTEL

Oil pastels are a perfect blend of soft pastel and oil paint in a handy stick form. They were originally designed by Henri Sennelier for Pablo Picasso, who had asked if Henri could create this new medium so he'd be able to draw and paint at the same time. With oil pastels, Picasso was able to use almost any surface of his choosing.

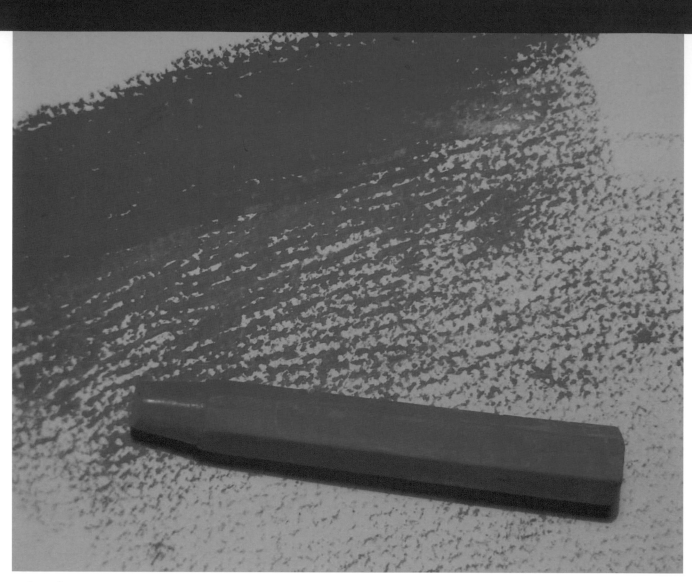

**Using this inexpensive** oil pastel broadside produced the textured areas (center), while the tip was used for solid coverage.

## ABOUT OIL PASTEL

Dense and buttery, oil pastels are vibrant, luminous, and intense. They're a bit more translucent than soft pastels, and they require a much different approach. One cannot build up too many layers of oil pastels, because the surface may become too slippery to accept more.

Oil pastels come in student-grade sets as small as twelve pieces; some of these brands are Cray-Pas, Pentel, and others. These are waxy but good for beginners.

Holbein and Sennelier brands, however, are high-end oil pastels of excellent quality, available in boxes of twenty-five and up. Most are short, rounded sticks, while Holbein's are square sticks. Some of the best brands make large, 38 mL (1.2 oz) sticks as well. Several companies package colors together specifically for portrait, landscape, and still-life subjects. Oil pastels also come in shimmering iridescent and metallic colors, too!

Water-soluble oil pastels feel slightly moist to the touch. These are not your parents' pastels. In their "dry" state, they function in much the same way as regular oil pastels, but, when brushed over with clean water, they melt into washes. They're great for wet blending and watercolor effects. Colors can be very strong or diluted considerably. They are also effective on a damp surface.

## Using Oil Pastel

Draw with the tip or use broadside. Apply thinly or as an impasto. Oil pastels can be messy, so keep the wrappers on them as long as possible! Also, they may stain work surfaces and clothing.

**These are soft,** creamy, and pearlized.

Baby wipes, pop-up moistened towelettes, or Lava soap do a great job of cleaning hands.

Oil pastels themselves become dirty from fingers and from mixing with other colors directly on the painting. Use dry paper towels or a rag to wipe down the sticks as needed.

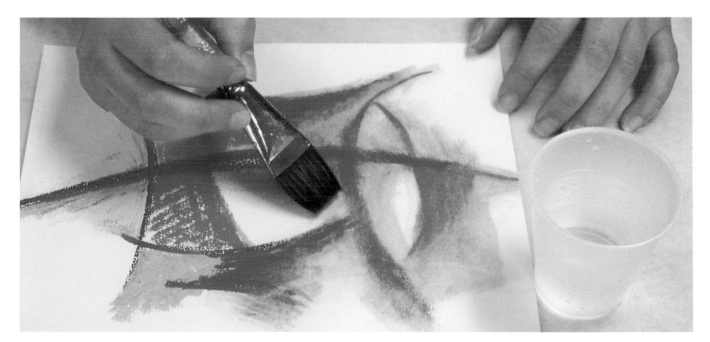

**The artist already** brushed water over one side of these water-soluble oil pastels.

## SUPPORTS FOR OIL PASTEL

Use gessobord, matboard, water-color paper, illustration board, artists' panels, and even a vellum or suedelike surface.

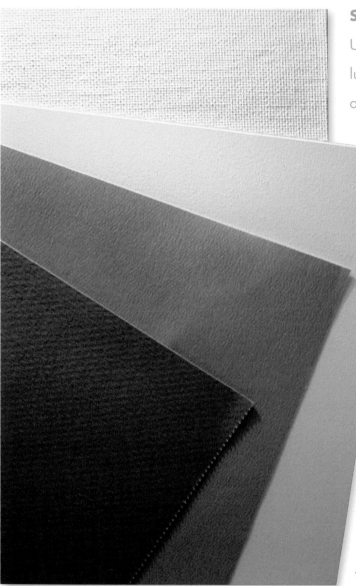

**Top to bottom:** canvas panel, gessobord, and two luxurious papers ideal for oil pastel.

Pads of paper for oil pastels are also available. Textured papers grab better, but the nubby surface is a challenge to fill in solidly. Oil sketching paper functions well for a painterly work, while sandpaper does better with dry work. Experiment with various surfaces to see which perform best. Stretched canvas is not advised.

## TOOLS AND OTHER MATERIALS

The oil pastel painter will want to have a tortillon handy for blending small areas. Some artists blend oil pastels entirely with their fingers, whereas others wear surgical gloves to keep their hands clean.

Other necessary materials include soft rags or paper towels, a solvent such as Liquin, and/or gel medium. Disposable gloves are convenient, especially when using oil pastels and/or mineral spirits.

A safety-edge razor blade can be used for moving a layer of pastels in different directions or for unveiling undercolors.

A drawing board is optional.

## Budget Booster

The back side of acid-free matboard works perfectly for an oil pastel painting. If a local framer cannot provide free scraps, buy a large, acid-free matboard and cut it to the preferred sizes. Use either the colored side or the white back side.

## OIL PASTEL TECHNIQUES

Build your repertoire of oil pastel methods. We're not suggesting using all the techniques here in a single artwork, but several tactics in one piece work well together.

### Planning Ahead

Here's a smart bit of start-up business.

Before starting an oil pastel painting, fasten a masking-tape border of ½" to 1" (1.3 to 2.5 cm) on all four sides of the painting surface. Neutral, cream-colored tape is preferable, since colored tape like blue or green may alter one's choice of pastel colors. This untouched border of the painting surface will provide a clean area for matting later on.

### Setting the Stage

Don't be afraid of the dark!

While some people make a light sketch in soft pencil or a neutral color of pastel first, many artists begin by covering the painting surface completely. Some use light colors first, and others prefer to start with darker values, depending upon subject matter.

1   Fill in large areas quickly by using a stick broadside, without its paper wrapper (the square Holbeins are excellent for this because of their shape). Keep applications thin at first. Skimming, as shown here, covers areas and combines colors in a more unified manner. It can also be used to tone down a too-bright color.

(continued)

**Oil pastels are** . . . oily, and could stain a mat later on. Taping helps prevent this.

**2** Smoothing in and blending these base colors convincingly conveys depth and can be an effective way to suggest the density of a bower of flowers, the darkness within a forest, or even the dark area where stems of flowers fit into the neck of a vase. Here, background colors of blues and violets have been put down.

**3** Draw directly into the background color with lighter or darker colors, sketching the elements of the composition on top of the "understory." Applying these lines is easy because the previous layers are thin.

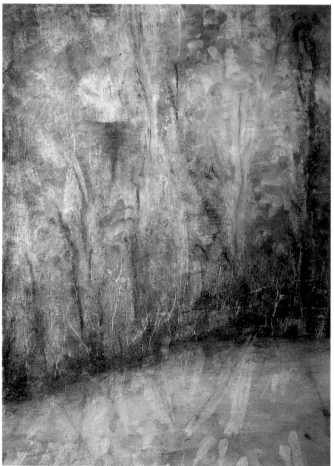

**Dark lines show** up well on the background of *Moody Blues,* by Geri Greenman.

## Blending Oil Pastels

Rub-a-dub with style!

Combine colors in some areas with fingers or a lint-free cloth. Avoid using cotton balls, since their fibers will stick to the surface.

Don't overdo it—too much blending makes colors muddy.

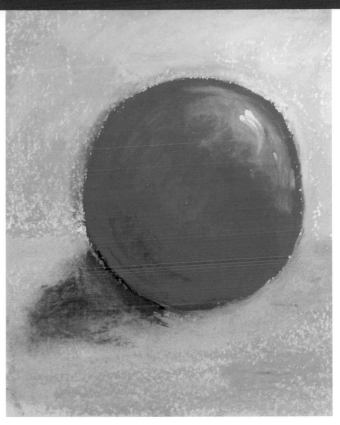

**Much of this example** has been rubbed smooth. Note that the orange sphere has been shaded with blue, which is its complement.

**Sometimes nothing's** better than a finger for blending.

**Rub with a soft fabric,** not a coarse one.

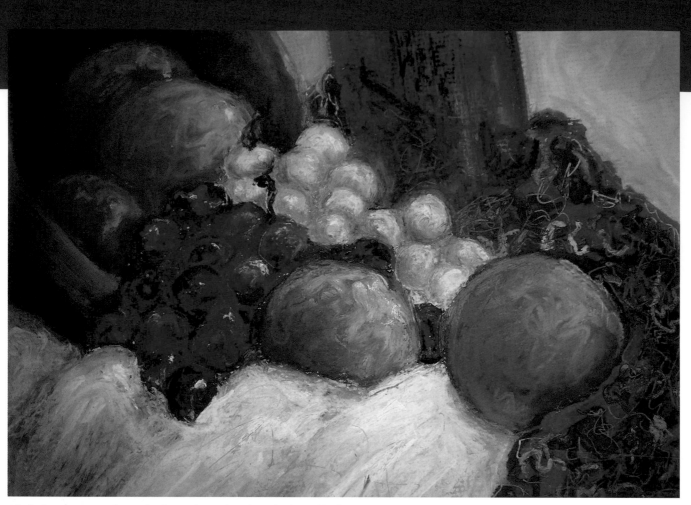

**Pink is repeated** nearly throughout this detail of a still life.

**A fingernail scratched** through the red topcoat of oil pastel.

## Introducing Repetition

Repeating various colors throughout the composition not only builds the structure of the painting, but it also adds harmony. Recurrence of color leads the viewer's eye around the painting and lends a sense of harmony and unity to the whole. As Geri says, "We've got rhythm!"

## Removing Oil Pastel

Play the scrape 'n' scratch game to expose underlying layers.

Abrading layers of oil pastel can serve several purposes. Scrape the surface to lighten or remove color. Or scratch into a multilayered area

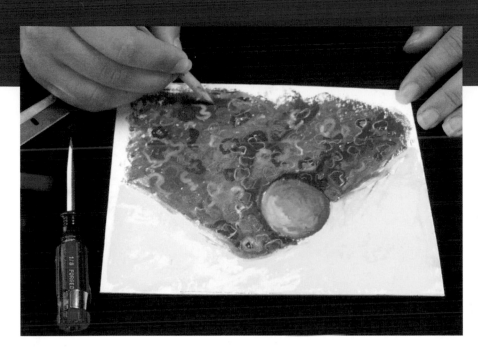

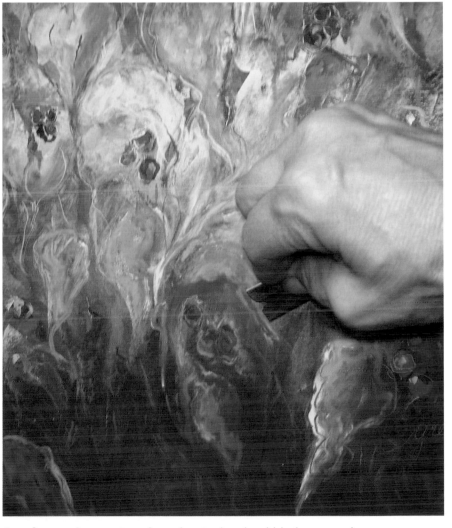

**The tip of a screwdriver** or the corner of a razor blade would work as well as this pointed stick.

with a sharp tool to reveal what lies beneath. First lay down a heavy coat of solid color, and then another that covers the first. Work dark over light or vice versa. This is a convenient way to "draw" veins in leaves or to suggest texture or patterns (e.g., carving a repetitive design into the drapery in a still life painting). Such mark-making creates interest. Avoid scratching so deeply that the surface of the substrate is cut.

**A color stain** remains where the single-edged blade scraped.

## Wet Brushing

Even without water-soluble pastels, the artist can reduce graininess and achieve a smooth, painterly effect.

Soften regular oil pastels with turpentine, mineral spirits, or Liquin. Blend previously applied colors with a brush dipped into the solvent. Note: Turpentine and mineral spirits are toxic hazards. Keep all solvents out of reach of children, and work in a well-ventilated area.

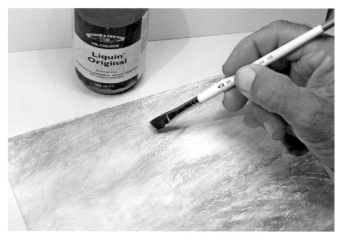

**The oil pastel** on the left side has already been liquefied into a wash effect.

**Another option** is to lay down a thin, clear coating of solvent and then draw with and smear oil pastel directly into it.

## Stippling

Take a stab at stippling with oil pastels!

Repeatedly touching the tip of an oil pastel to the painting surface creates a kind of sparkle. Make jabbing, stabbing motions for such subject matter as clumps of leaves or fields of wildflowers. The eye blends the dots together and the painting seems to vibrate.

Stippling can be very time-consuming, so applying it to very large areas is a daunting task.

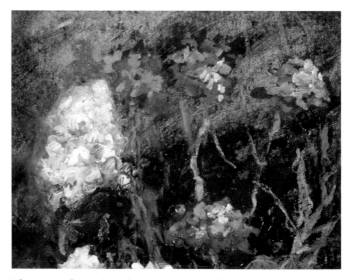

**The petals** in this close up are stippled.

## Finishing an Oil Pastel Painting

Oil pastels do not require a sealant when they're done, although some artists varnish them with acrylic gel medium. Brush strokes will likely be apparent, however.

Sennelier makes a spray-on fixative especially for oil pastels, but many oil pastelists don't apply a finishing coat.

When storing or transporting unframed oil pastel paintings, wrap each separately in nonstick paper—waxed or freezer paper—and store flat.

Since the wax in oil pastels never fully dries, risers should be used when matting and framing oil pastels, so that neither the matboard nor the glass ever touches the painting.

# Signatures

Some artists sign their work the same way and in the same place every time; some like to change the look of their signature at times. Norman Rockwell used either a stenciled print or a signature to make his mark, depending on the subject matter.

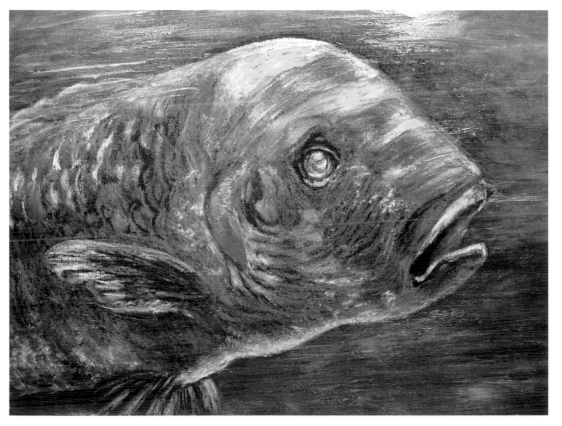

**The glossy coating** on this example is medium-weight acrylic gel.

## AN OIL PASTEL PROJECT

Unleash your creativity with a spectacular still life. With this easy venture, *Red Geraniums with Gourd*, we hope to cultivate some ideas. Like sunflowers? Daisies? Have fun and translate the endeavor into new masterpieces!

## YOU WILL NEED

- oil pastels and a substrate
- drawing board (optional)
- masking tape
- rubber gloves (optional)
- Liquin (optional)
- rags or paper towels
- pointed wooden stick or other scratch tool

**1**

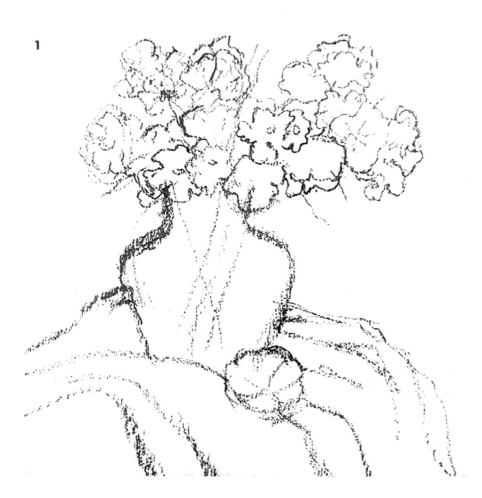

**1** Tape the edges of the chosen substrate with cream-colored masking tape. Lightly sketch out the most basic placements of the subject with oil pastel. No detail is required—just a quick idea of how the space will be engaged.

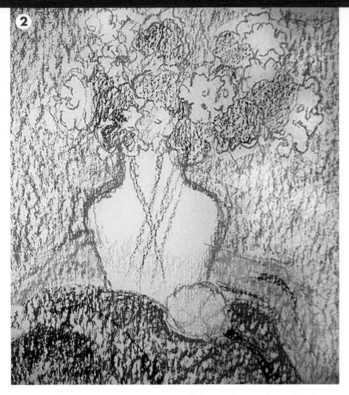

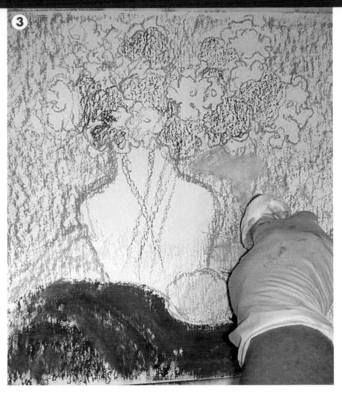

**2** Skim the appropriate areas with lavender, red, and yellow. Hold the pastels broadside to create a subtle base to add onto later. A bit of green has been added, too.

**3** Smooth the foundation colors together (a white pastel helps do this). Now that there's a base all over the composition, soften the background with a small amount of solvent, such as Liquin, on a soft rag. Also apply some white oil pastel to the vase shape to simulate transparency.

**4** Applying more pastel gives a sense of volume, weight, and mass. Introduce white on top of the violet in the background. Smudge more red into flowers, using a rag or fingers. Also add blue or violet to them and the drapery, and rub in with fingers or a soft rag. That color is also repeated in the red drapery to help hold the piece together. Carrying some of the blue into the red drapery shadow adds coolness.

(continued)

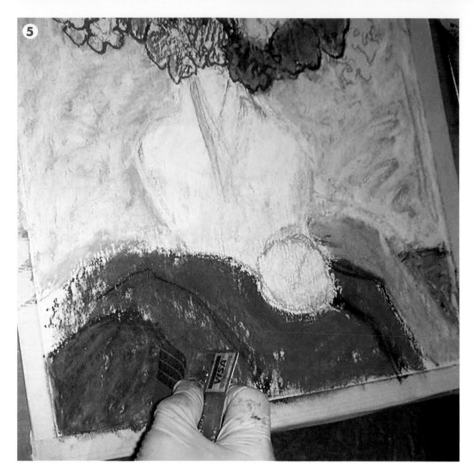

**5** An old credit card can be used to move and scrape excess color.

**6** No need to finish any one part of a painting at a time. Be bold! Move around the composition, adding a little of one color in another area. These touches will help unify the painting.

**7** Apply pinkish-reds to the edges of petals, yellows to the flower centers and the gourd, and several greens to the leaves. Scribble a pattern into the drapery. Scratch veining into the leaves. Place green lines suggesting stems inside the vase.

**8** Etch fine lines with a pointed tool such as a caramel-apple stick.

**9** Blend the stems with white to make them appear to be inside the glass vase. Hard pressure with a dab of white oil pastel on the shoulder and neck of the vase makes them seem to reflect light.

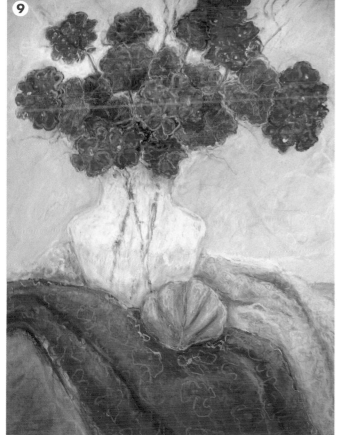

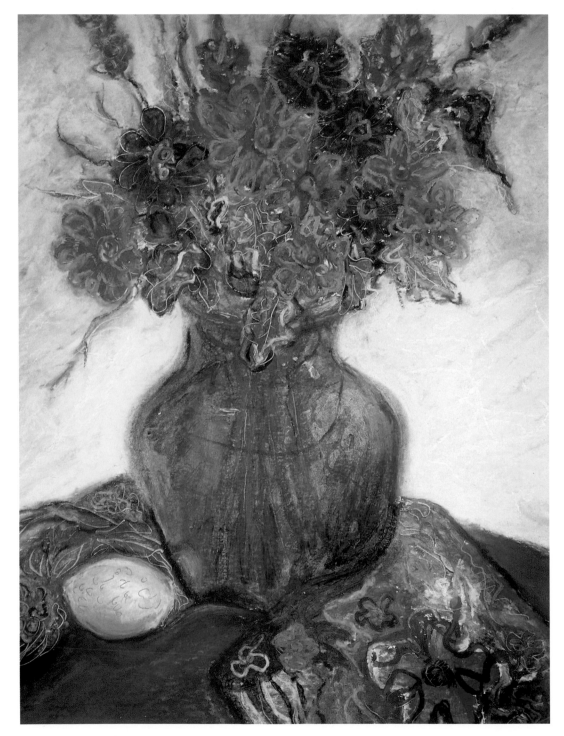

*Blue Vase with Lemon*
by Geri Greenman
12" x 16"
(30.5 x 40.6 cm)

*Blue Bottle with Fruit*
by Geri Greenman
12" x 16"  (30.5 x 40.6 cm)

*Plums and Grapes*
by George Shipperley
25" x 25" (63.5 x 63.5 cm)

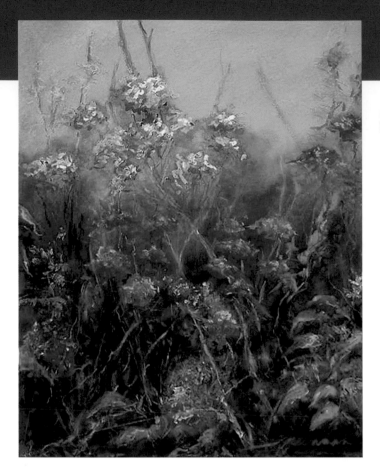

*Hidden Bower*
by Geri Greenman
12" x 16" (30.5 x 40.6 cm)

Detail of *Hidden Bower*
Note the stippled petals.

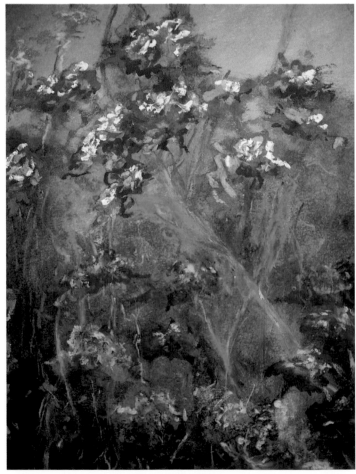

Detail of *Hidden Bower*

*Still Life with Pears*
by Geri Greenman
14" x 18" (35.6 x 45.7 cm)

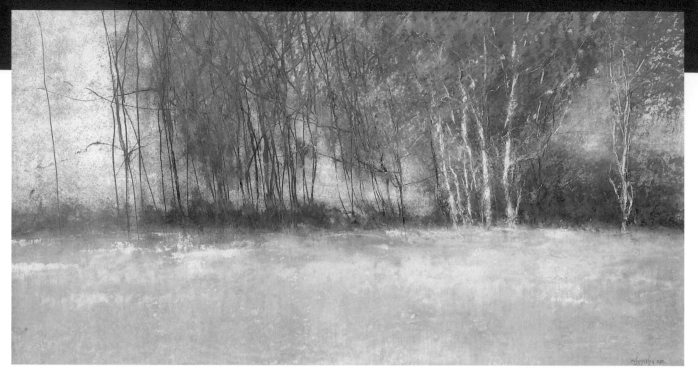

*Fall Edges* by George Shipperley, 21" x 35" (53.3 x 88.9 cm)

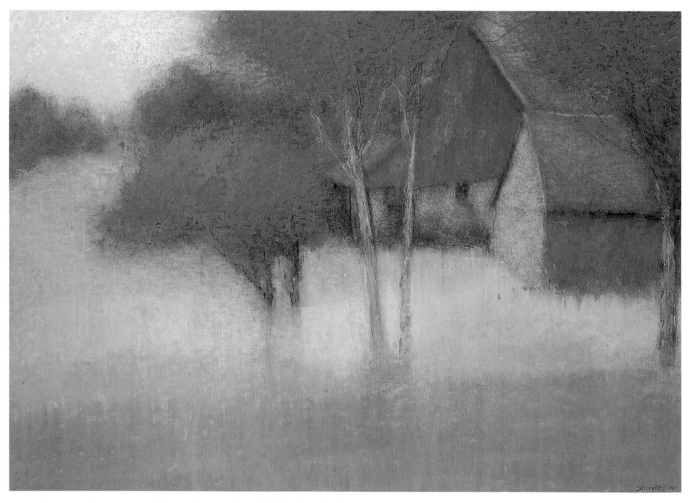

*Morning Dew* by George Shipperley, 24" x 31" (61 x 78.7 cm)

*Chicago Fountain Lion*
by Paula Guhin
8" x 10" (20.3 x 25.4 cm)

*Enchanted Path* by Randie Hope LeVan, 23" x 35" (58.4 x 88.9 cm)

OILS

**M**any artists and art educators consider oil painting to be basic and essential, something that every student should study and learn to appreciate. The beauty of oils is that they remain workable for a long time which allows the artist to work on a painting for many sessions. Oil paint can be manipulated in many ways. Adjacent colors can meld into very subtle color blends. This medium produces vivid color with a natural sheen and a surface translucency similar to human skin, making oil paint an ideal medium for portraits.

## Brushing Up

Brushes for oil painting traditionally were made of hog hair or boar bristles. Oil paint is so creamy and viscous that other types of natural bristles weren't strong enough to stand up to the body of oil paint. Hog bristles hold a lot of paint and are fairly inexpensive. However, today, many synthetic brushes work reasonably well.

Conventionally, oil and acrylic brushes have long wooden handles so that the artist can step back from the canvas and observe the work as would the viewer. Attached to the handle is a metal cylinder, the ferrule, which holds the bristles or fibers.

Keep several extra brushes handy. Constantly wiping and cleaning a single brush slows the painting process considerably. Many hobby and art suppliers offer inexpensive brush sets in a variety of shapes and sizes. Though they're not of the finest quality, they provide the opportunity to experiment with many different brushes. Beginners should invest in better brushes later on.

To start, one will need a couple of flats, one smaller size and one larger. The square ends of flats are good for broad strokes and backgrounds.

Have on hand a #10 or #12 round and at least two smaller, sable rounds (e.g., #2 and #4). These versatile rounds are suited to thin strokes and detail.

Brights are useful for short, controlled strokes and impasto techniques, while filberts are good for thick to

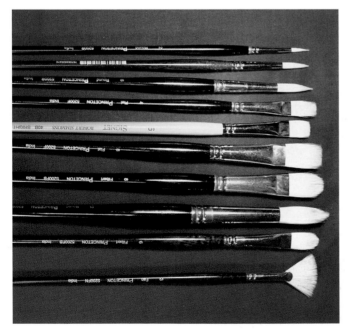

**Bristle brushes from top:** #2, #4, and #6 rounds, #4 flat, #6 bright with shorter bristles, #8 flat, #8 filbert, #12 round, #6 filbert, and #3 fan.

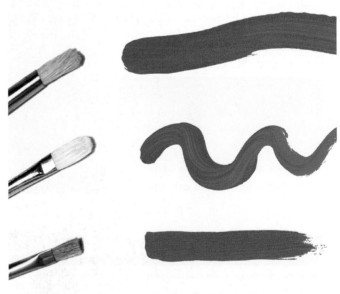

**Natural bristle brushes** from top to bottom: #8 round, #4 filbert, and #4 flat

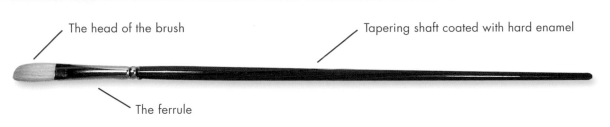

The head of the brush

Tapering shaft coated with hard enamel

The ferrule

**The anatomy** of a brush

thin strokes without hard edges. Try #4, #6, and #8 filberts if possible. Portrait ovals are similar to both, but are rounded on either side of a flat top. Finally, a medium-sized fan brush works well for wispy blending and feathering.

## Cleaning Up

First, clean excess oil paint from a brush with rags or paper towels. Press the brush into solvent and wipe thoroughly with another cloth. Then, wash the brush with very warm water and a bar soap, such as Lava, to remove oil residue. Rinse and gently squeeze excess water from the bristles, and reshape them.

If errant hairs are sticking out, dampen finger and thumb with a gentle face soap and reshape the bristles, allowing the soap to dry as it holds the bristles together (like hair gel!). The next time the brush is used, a gentle sweep of the bristles rids them of the dried soap residue.

There are also many brands of brush cleaning products on the market. Always lay brushes flat to dry.

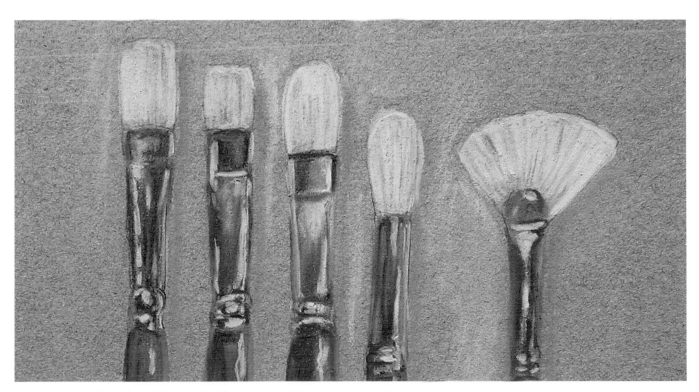

**Size #8 brushes** from left to right: flat, bright, filbert, round, and a fan blender

## Selecting Solvents

Oils should never be thinned with more than one-third solvent to color. Overthinning creates an unstable oil paint film.

Choose an odorless solvent (unless using water-mixable oils).

White mineral spirits are less expensive, and they're fine for cleaning brushes. Turpentine or paint thinners are additional diluents used to thin oil paints. They are toxic.

Nontoxic alternatives to traditional solvents are specially formulated, safer products. They're great for those with health or environmental concerns.

Oils can be applied without thinning, of course, but many artists begin a painting with thinned oils and employ thicker paint in the final steps. A vivid term for such is "fat over lean."

In selecting the appropriate solvent, read all directions for the type of oil paint being used. Secure the cover on a jar of solvent when not painting, and keep out of the reach of children. Don't pour liquid waste down the drain. Always dispose of dirty rags with caution. Do not expose oil painting materials to heat sources or flames.

## More Mediums

There are many primers, additives, and other materials associated with oil paint (several of which serve a similar purpose). Linseed oil is an optional medium that is often mixed half and half with turpentine. Combined with turpentine, it provides a good, general-purpose medium for oil painting.

Linseed oil adds transparency when mixed with oils and imparts a high gloss. It also slows drying time. Stand oil is a faster-drying version of linseed oil. It, too, adds gloss and reduces paint consistency. Poppy oil is often used with lighter colors and white, because it's less likely to yellow over time.

**Special cups are** made for holding solvents such as turpentine, which can break down other containers.

Alkyd gel and liquid oil painting mediums can be added to conventional oil paints to speed drying time. They can also be used as glazing mediums.

Other oil products include drying oils, cold wax, texture gels, and premixed combination mediums.

## Varnishing

The unvarnished truth? Varnish is elective but it's recommended by many oil painters to protect paintings.

# Reusing Turpentine

Allow used turpentine or Turpenoid to settle in a lidded glass jar so the sludge will sink to the bottom. Then gently pour the clean turpentine into another container for reuse; stop pouring when the settled goo begins to approach the mouth of the container. To reuse the dirty jar for the same purpose, wipe it out with a rag and the long handle of a brush.

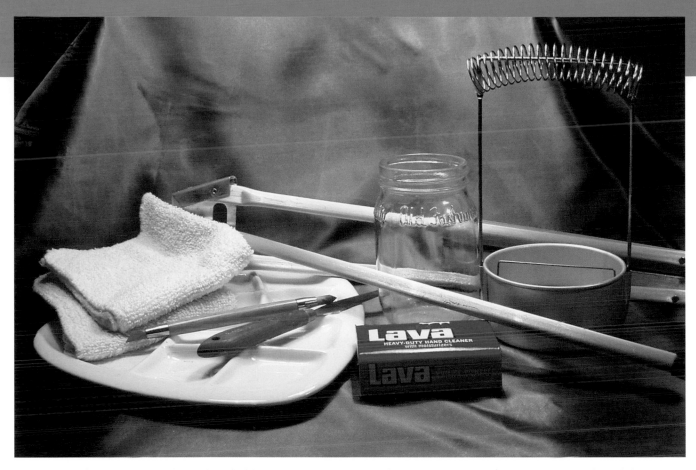

**Note the aluminum** brush washer/holder at right above, used for suspending bristles in water or solvent. There are also many other types of brush rinsers.

If varnishing a traditional oil painting, wait at least six months so that the paint is thoroughly dry. Never varnish on a humid or rainy day, as moisture and mold can collect under the varnish layer.

Damar varnish dries to a glossy or satin finish in a few hours and is removable later on. Gloss or matte picture varnish is spirit-based and will not yellow or bloom (develop a whitish, velvety surface). Gloss and matte varnishes can be mixed to give a satin finish. They can be removed with turpentine or white spirits.

## Gathering Other Supplies

Oil painting requirements include a palette, a palette knife, glass jars, lint-free cloth rags (or paper towels), and protective coverings for work area and clothing. An easel isn't absolutely necessary, but is very practical. Painting knives and rubber-tipped color shapers make it easy to create interesting surface effects.

A brush holder/cleaner is discretionary. Many such products keep paint solids separate from the brushes. Store extra dry brushes, handles down, in a sturdy container.

**Paint saver keys** help get every bit of paint out, so the tubes are good to the last glop!

## OIL PAINTING TECHNIQUES

This section describes and demonstrates some of the many dynamic possibilities with oil paints.

### Beginning with a Turpsy Wash

This technique is great for sketching out the subject on a blank canvas or other substrate.

Mix an earthy color such as umber or sienna with a little Turpenoid or odorless mineral spirits. Drawing with this thinned color and a brush ensures that the shapes and sizes in the composition will be correct, since an error is easily erased. Simply wipe it off with a rag and a little solvent!

Never sketch with a pencil that can pierce the canvas or mix with the paint, thereby dirtying up the oil colors.

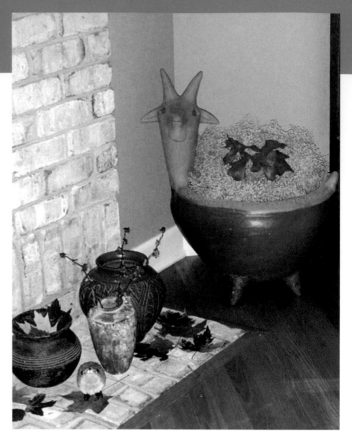

**Actual basis for** the turpsy sketch below

**A painted** "drawing" of a gourd

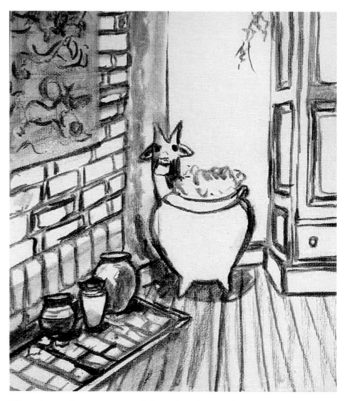

**The interior composition** has been laid out with thin burnt umber paint.

**The initial outlining** in thin paint

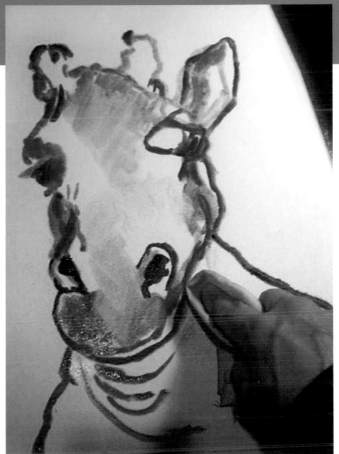

**Wipe out errors** with a cloth.

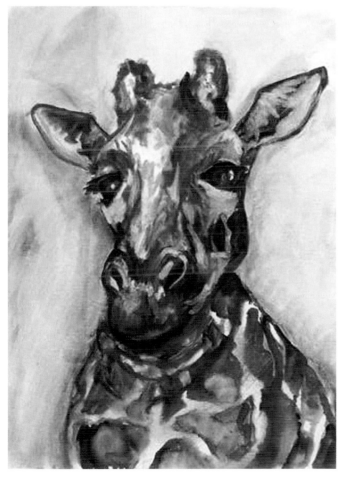

**After the previous** paint is dry, slightly heavier paint is added.

**The diluted paint** here seems somewhat opaque because yellow ochre has white in it.

## Working Alla Prima

Alla Prima is an Italian term meaning, roughly, "at once." It refers to the completion of a painting in one sitting, as might occur when one is painting a live model.

This takes some skill, but it also gives the artist little time to get bogged down with minute details. Key factors are the lighting and the simplified suggestion of the forms.

Working quickly by adding strokes or dabs of wet paint into wet paint could result in muddy colors. Don't overwork this active, energizing technique.

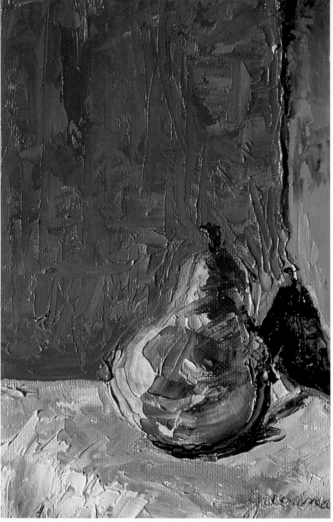

**This small impasto** piece was finished in fifteen minutes.

**Geri completed** *Alla Prima Diva* in a three-hour session with a live model.

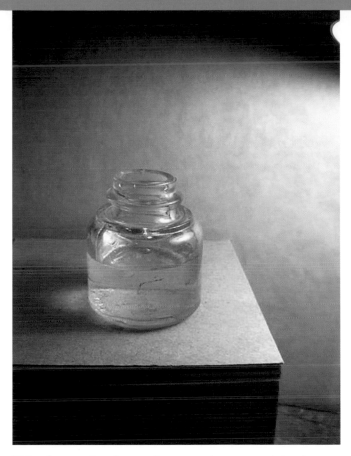

**This dramatic photo** of an actual antique ink bottle demonstrates how a transparent subject casts refracted light and shadows when there is a direct light on the subject.

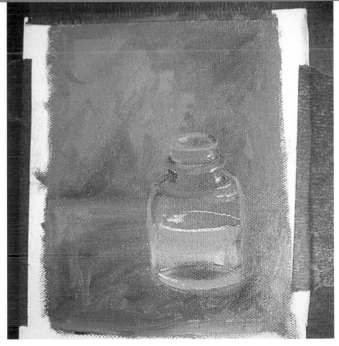

**In progress**

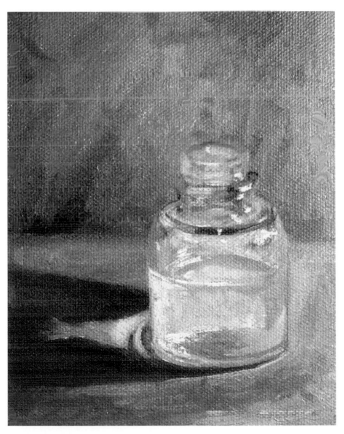

# Do Over!

Oils are forgiving—if an area isn't working, paint over it. Or scrape it off the canvas!

**Geri painted this** piece wet on wet, all at once.

## Painting Imprimatura

Get over the pressure of ruining a pristine white canvas by toning the entire surface. Italian for "first attempt," imprimatura employs a thin umber, sienna, or other color to tint the entire surface of the support. This initial staining of the painting surface ultimately allows light to reflect through the paint layers. Covering a clean canvas with thin ultramarine blue paint lends a cool note to all that follows. (Some artists prefer to apply the tone over a sketch.)

1. Some artists create an imprimatura by drawing the subject in India ink on the white canvas first, but here a charcoal sketch was done on a pre-tinted canvas.

2. To establish the undertones, apply a wash. Here a gold oxide glaze has been added.

3. Wipe away the thinned paint wherever the subject is lighter, bringing out the highlights.

4. Next add veils of tinted color to build dimensionality into the subject. Paint in darker color where the subject is in shadow.

5. Strengthen highlights with heavier, light-colored paint.

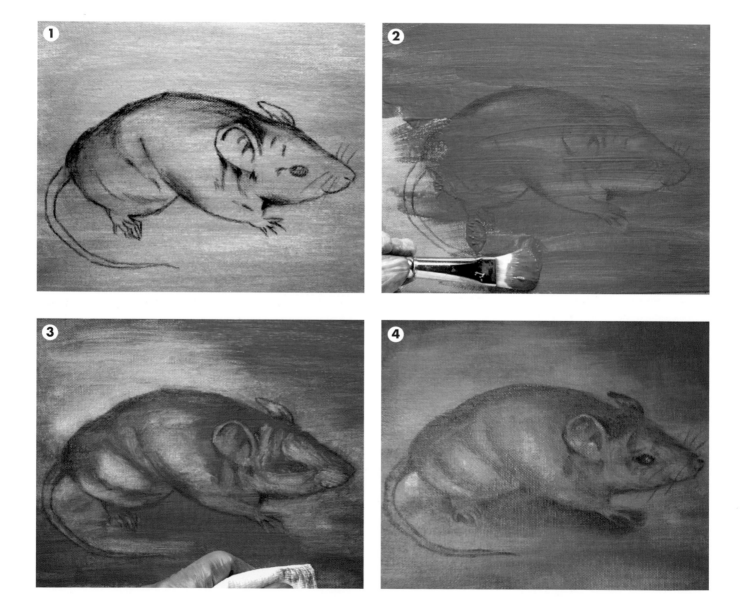

While imprimatura is an indirect method that can stand on its own, it can also serve as the base for subsequent, thicker layers of paint.

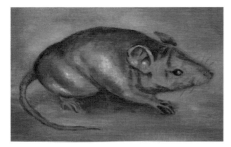

**Medium tones** are added.

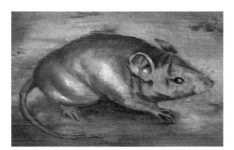

**Blue paint** is blended into the background.

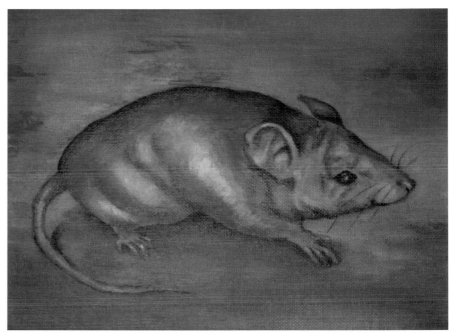

**The finished painting.**

**Light, medium, and** darker skin tones each require different amounts or combinations of colors. Medium to darker skin colors can include more yellow ochre, burnt sienna and umber, and/or blue. For shadowy areas, add a bit of green, blue, or violet.

### The Skin-ny on Flesh Tones

Let's flesh out the topic of mixing realistic skin colors.

There are many tones in "flesh," so start with several colors of paint: titanium white, cadmium red light, cadmium yellow medium, yellow ochre, burnt sienna, burnt umber, sap green, and ultramarine blue.

Mixing red, white, and yellow creates a peach color. A very small amount of green makes it more believable as skin. Add more yellow to get a warmer tone or more red for rosiness. For darker skin tones, use burnt umber, cadmium yellow or ochre, ultramarine or cerulean blue, and terre vert. If a redder tone is needed, try Indian red.

Another way to achieve a nostalgic, golden glow for an imprimatura is to add a yellowish acrylic paint to white gesso or tint the prepared canvas with a warm wash of yellow ochre acrylic paint. It will dry quickly for subsequent steps in oils.

A variation of painting upon a tinted or lightly stained ground is employing a dark ground. After the darkened background is dry, draw a light-colored sketch.

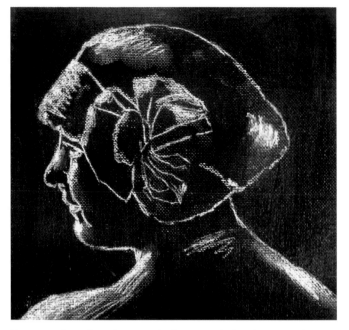

**To see the sketch** on a dark ground clearly, use white paint or chalk.

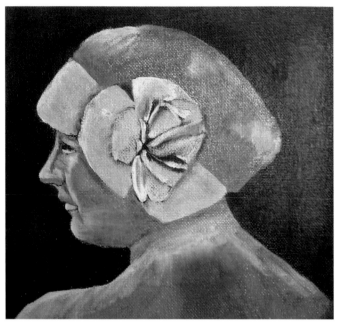

**Paint the medium** and light tones, allowing the dark ground to serve as the shadows.

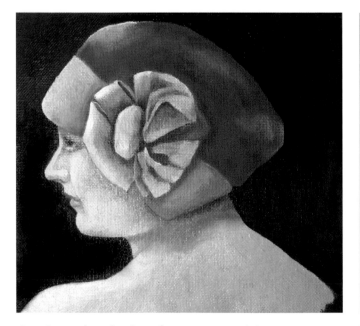

**Continue developing the** painting with heavier paint.

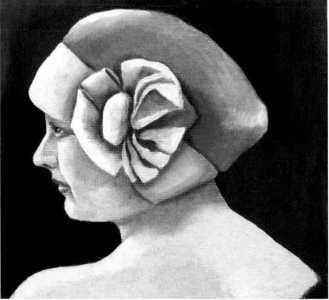

**The strongest white** highlights are reserved for last.

## Painting Thickly

Add textural interest with heavy paint.

Impasto, a very immediate method, is achieved with painting knives or stiff brushes. It's a lively technique using rich, buttery paint and separate strokes. Acrylic modeling paste is expedient as an underlayer if desired (let dry thoroughly before painting over it with oils).

Manipulate the creamy paint in a variety of ways: small dabs, bold horizontal smears, impressed daubs that leave ridges, and more.

Do keep the following in mind through thick and thin: "Fat over lean" allows for drying and shrinkage. Shadows, especially, might be made with thinner paint, and highlights with thicker, light-catching paint. Another rule of thumb: The thicker the paint, the stiffer the brush.

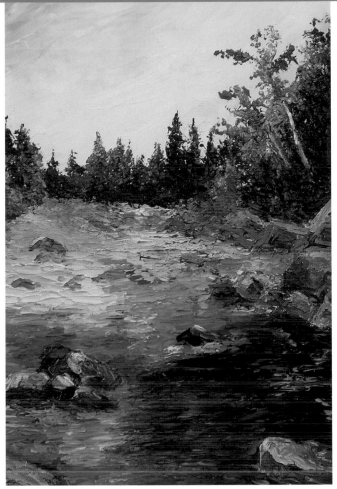

*Vermont Stream*, an 11" x 14" (27.9 x 35.6 cm) knife painting by Geri Greenman

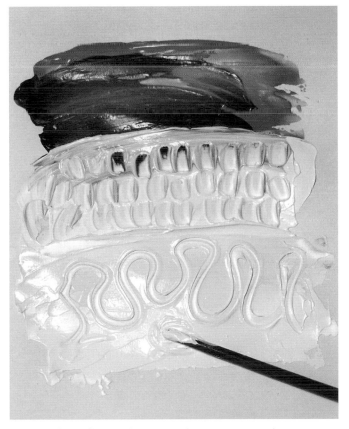

**Even a brush** handle can make exciting marks!

# Oil Over Acrylic

One can always use oils over an acrylic sketch or painting, but never put acrylic over an oil painting. An easy reminder is that A (for acrylic) comes before O (for oil) in the alphabet!

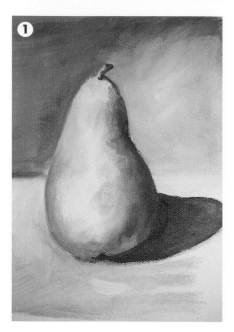

## Glazing with Oils

Yes, we're raising the glazing subject again: Thin veils of color made transparent with a medium added to the paint.

The grisaille technique sets the stage for subsequent layers that will bring the subject to naturalistic color and three-dimensional realism.

1   The monochromatic painting is allowed to dry before proceeding. In our example, the pear was first done in fast-drying acrylic paint, to save time.

2   In the first of three color overlays, a small amount of Indian yellow or yellow oxide oil paint is mixed with an equal amount of Liquin and glazed over the underpainting with a soft brush.

3   When the yellow layer is thoroughly dry, mix ultramarine blue or cobalt blue oil paint with Liquin and glaze again. If a glaze is too opaque, lift and wipe it (while wet) with brush or rag to allow highlights to show through.

4   The final layer to be applied is red: try either alizarin crimson or rose madder. Avoid cadmium reds for glazing, since they are more opaque.

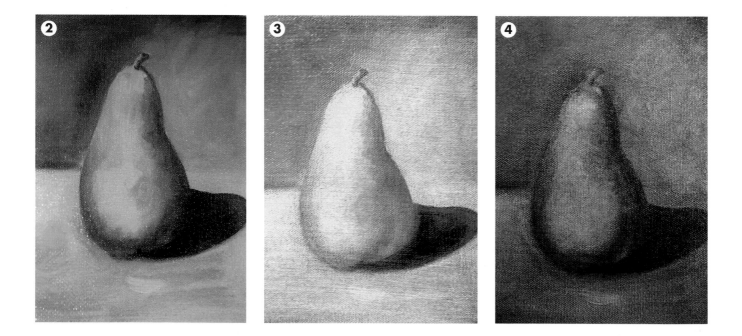

## Scumbling with Oils

Scumbling helps to achieve a lively interaction of color. If a canvas has a rough weave, make the most of it with this textural technique.

Dragging brushes or oil bars over previously painted areas leaves broken color and adds visual texture. With oils, this is usually achieved once the undercolors are dry. Hold the brush or paintstick almost parallel to the surface of the painting.

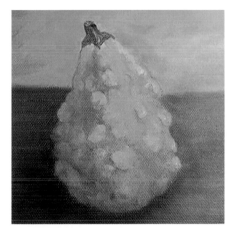

**Soft blending and** dabbing precede the drybrush technique.

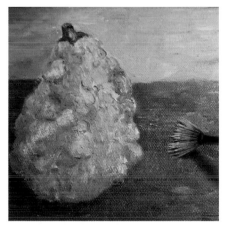

**When the raised** areas were dry, a loaded fan brush was dragged over them.

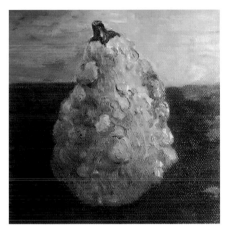

**The finished** example

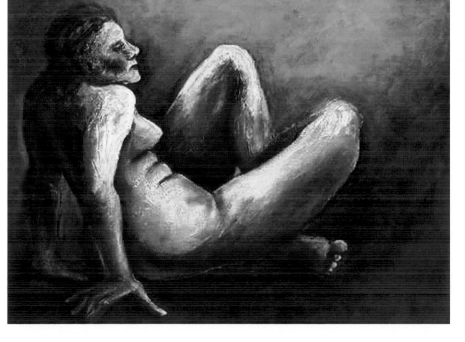

**This figure was** scumbled with oil bars to produce a little texture instead of a lot.

# Near Black

Mix a near black with colors that are in the painting. For this project, burnt umber and ultramarine blue together are almost black in appearance.

## AN OIL PAINTING PROJECT

Build painting skills with an architectural subject. As we've seen, even the corner of a room can become an interesting painting!

## YOU WILL NEED

- oil paints
- oil painting brushes: #2 filbert, #4 flat, and a #3 round
- canvas or other substrate, 8" x 10" (20.3 x 25.4 cm)
- rags or paper towels
- solvent and/or mediums
- palette and knife
- easel (optional)

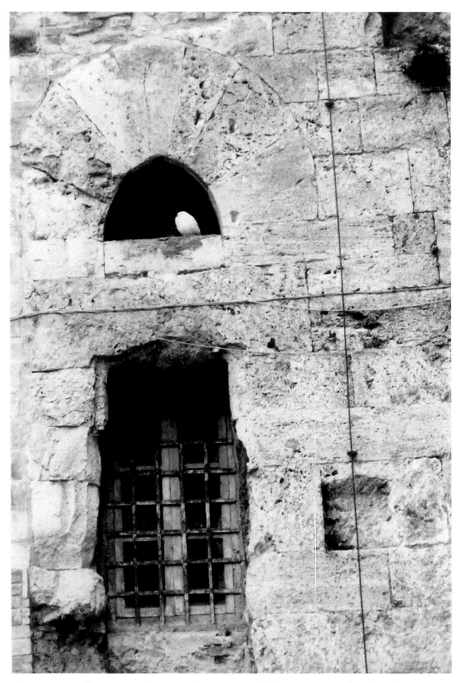

**The scene shown** in this snapshot inspired the artist to make sketches.

**A sketchbook drawing** and notes made in an Italian village will be the basis for a painting.

1. Sketch the composition onto the canvas using a brush and diluted umber oil paint. Eliminate detail, considering only the placement and proportions of major elements. Note: If the underdrawing is done in charcoal instead, it must be brushed down lightly to remove excess charcoal powder.

2. Set up a full palette of paint. There are many colors in every subject, so the artist should have them all on the palette.

3. Lay in some base colors, working all over the canvas. Avoid finishing any one area at a time.

4. Dab on more paint (wet on wet). Place blue-green, sienna, ochre, and white in appropriate places to hold the composition together. The green window trim is a great companion to the bluish color in the stones.

5. Bring the painting to completion by making additional corrections and refinements. Add linear touches with a small round brush. Crevices between the stones are made with a dark mixture of brown and blue. Add a little white to the green window frame (to suggest weathering) and to the darkened glass of the windows, denoting refracted light.

6. Step a distance away from the painting and look for anything that needs revising. More contrast here? A touch of bright color there? Better yet, revisit the painting a few days later. Rifinito!

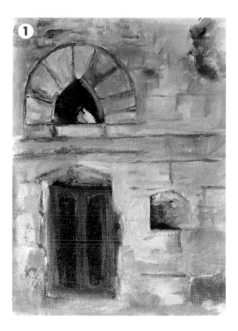

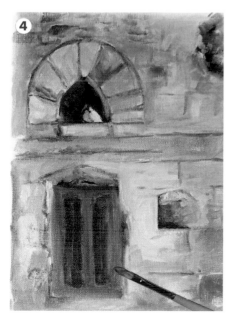

# A GALLERY OF OIL PAINTINGS

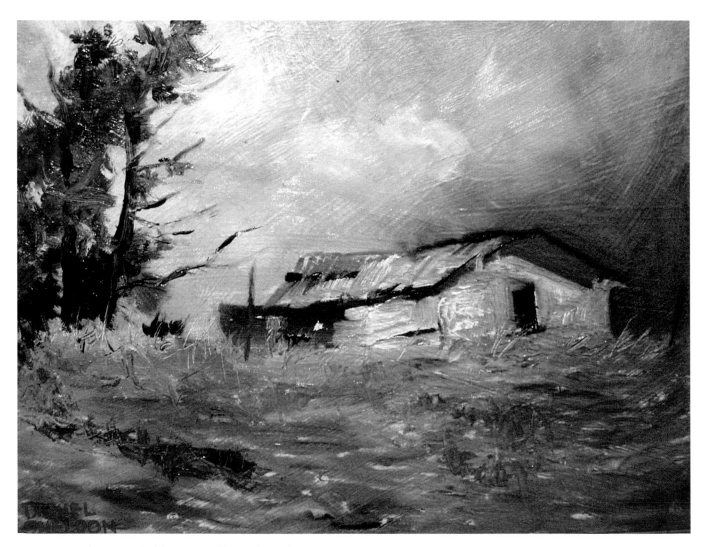

*Section Line* by Dan Sheldon, a small, quick study, 15"x 24" (38 x 61 cm)

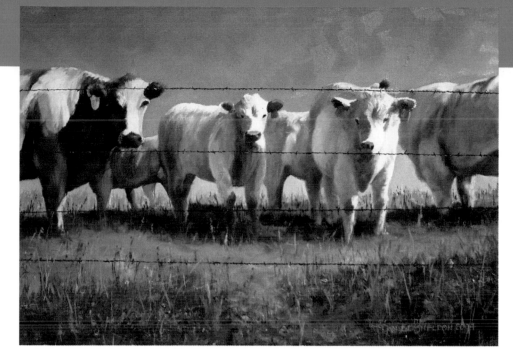

*Tag Sale*
by Dan Sheldon
18" x 24" (45.7 x 61 cm)

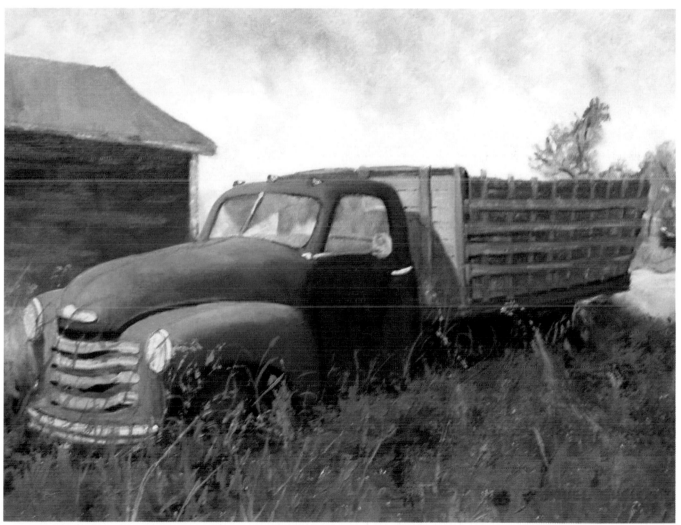

*Uses No Oil* by Dan Sheldon, 13" x 17" (33 x 43.2 cm)

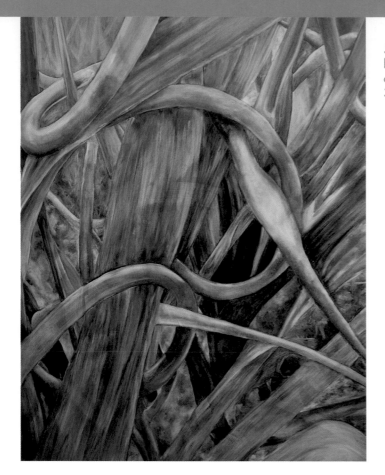

*Spring Symphony*
by Geri Greenman
oils transparently done
3' x 4' (0.9 x 1.2 m)

*Petaluma Garden*
by Jacque France
16" x 20"
(40.6 x 50.8 cm)

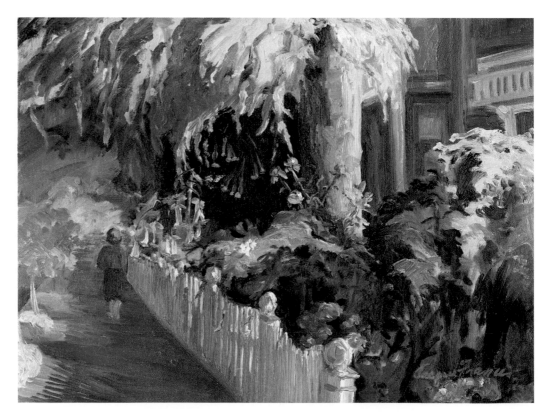

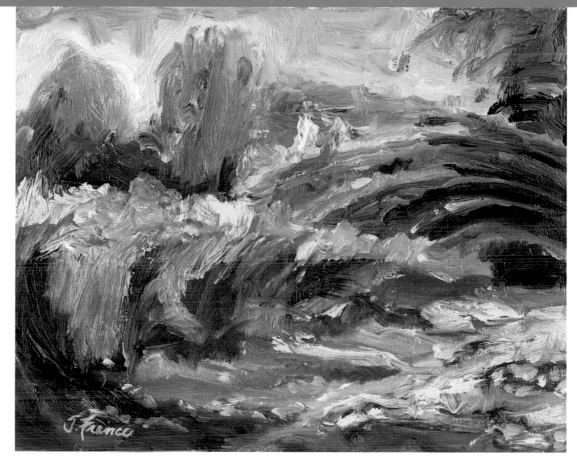

*Monet's
Garden Alle*
by Jacque France
8" x 10"
(20.3 x 25.4 cm)

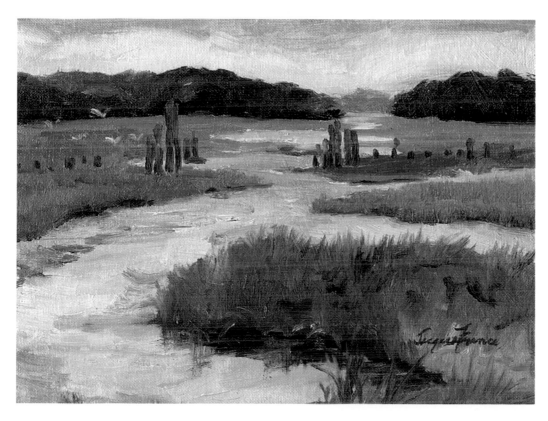

*Madeline's Tidal Marsh*
by Jacque France
en plein air
9" x 12"
(22.9 x 30.5 cm)

*Eastward*
by Tom Trausch
24" x 18"
(61 x 45.7 cm)

*Atelier*
by Tom Trausch
24" x 20" (61 x 50.8 cm)

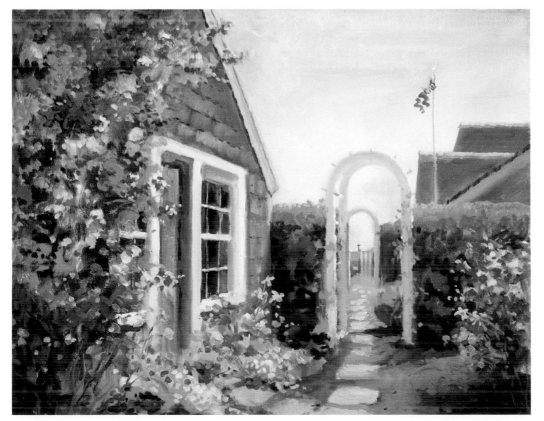

*To the Sea*
by Tom Trausch
24" x 30"
(61 x 76.2 cm)

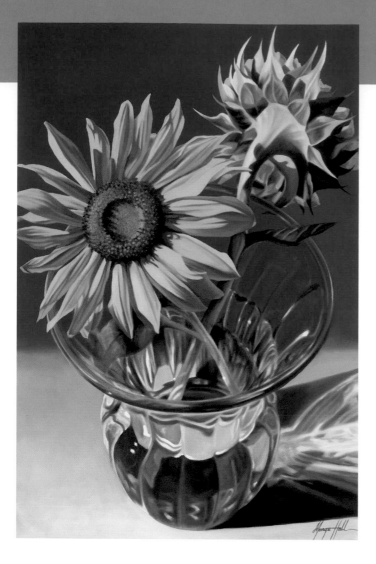

*Sunflower in Vase*
by Marge Hall
24" x 36" (61 x 91.4 cm)

*Pink Hollyhocks*
by Marge Hall
Artist's Collection
30" x 40"
(76.2 x 101.6 cm)

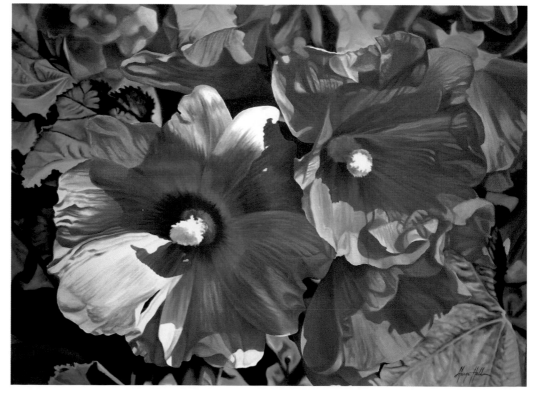

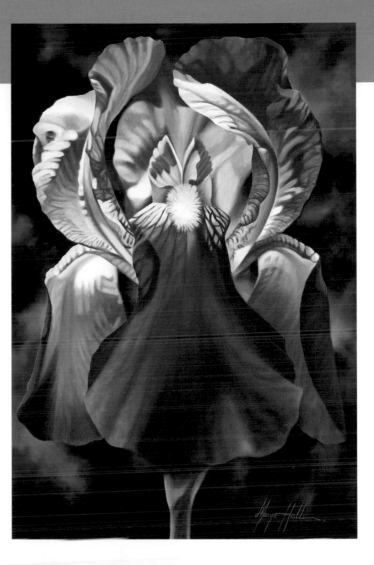

*Purple Iris*
by Marge Hall
24" x 36" (61 x 91.4 cm)

*Pink Rose in Crystal Bowl*
by Marge Hall
Private Collection
18" x 24" (45.7 x 61 cm)

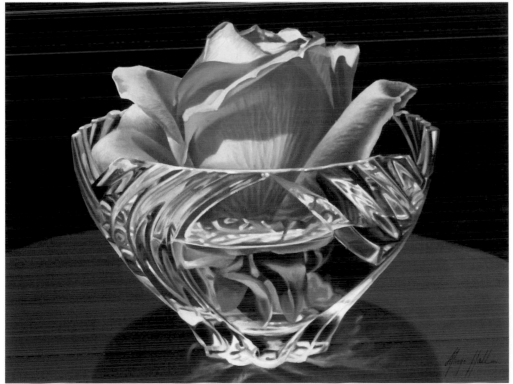

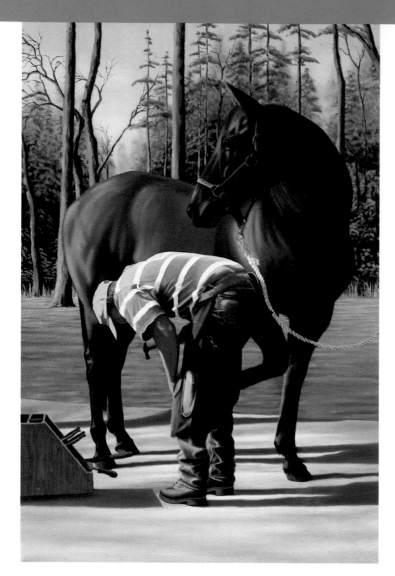

*The Farrier*
by Len Bielefeldt
36" x 24" (91.4 x 61 cm)

*A Pear-ody: Forbidden Fruit,*
*Harmonious Boscs*
by Geri Greenman
14" x 33" (35.6 x 83.8 cm)

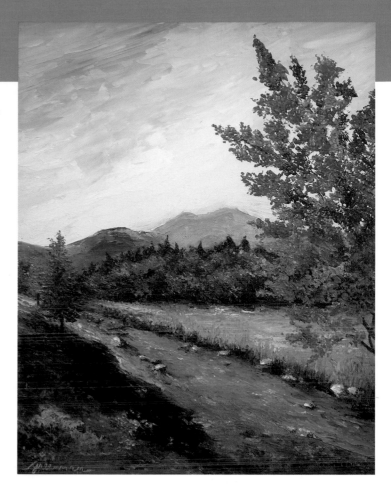

*Autumn in Vermont*
by Geri Greenman
9" x 12" (22.9 x 30.5 cm)

*Baby Bjorn*
by Len Bielefeldt
14" x 11" (35.6 x 27.9 cm)

TRANSPARENT WATERCOLOR

W atercolor is, above all else, a transparent medium—almost all the strokes in a watercolor painting are revealed. Traditionally used in a light to dark order, watercolors allow the whiteness of the watercolor paper to glow through.

## ABOUT WATERCOLOR

Watercolors may date as far back as prehistoric times. Ancient Egyptians and scribes of the Middle Ages used watercolors to illuminate their manuscripts. Later, the Renaissance raised watercolor to the level of a bona fide art medium, as seen in Albrecht Dürer's botanicals and other paintings.

Watercolor paints are made of water-soluble pigment, with gum arabic as the usual binder. They come in tubes, semi-moist pans and half pans, cakes, and concentrated liquid form. Tubes are preferable, but many artists enjoy the convenience of tray and pan watercolors.

**For plein air** (outdoors) painting, carry a small travel set like this, with a sketchbook, a paper napkin, and water in a sport bottle.

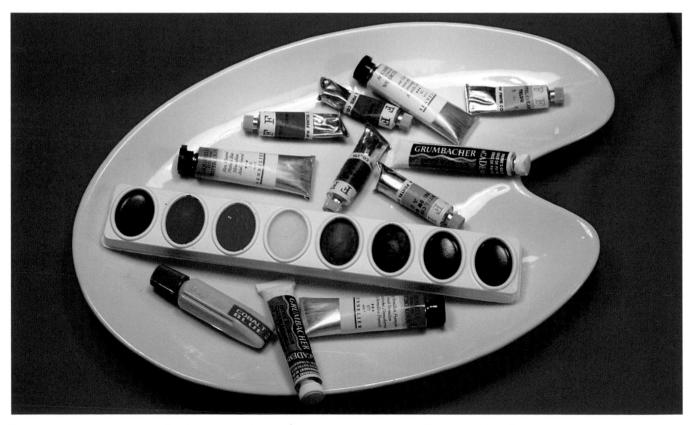

**From economy** paints to fine artists' quality, watercolors come in many forms and grades.

**Metallic, glittery, even** fluorescent watercolors are available.

Watercolors are practical, since solvents or mediums are unnecessary and cleanup is a cinch. Their luminosity is perhaps both their best and their most challenging characteristic.

Cadmium colors are less transparent than others. Aside from hue and transparency, the choice of different watercolors also depends on two other qualities: granulation and staining.

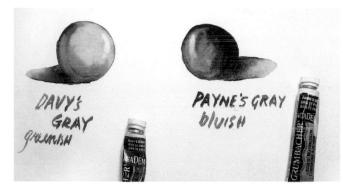

**Many artists** avoid using black. Instead, mix Payne's gray or Davy's gray with colors to create shades.

**Because black is** rather dense, Davy's gray (which has a slight greenish tinge) was mixed into the blue shadows under these peppers.

**Payne's gray** (which has a somewhat blue cast) was added to red to create a violet shadow here.

## Understanding Granulation

Granulation refers to the pigment particles settling into the hollows of the paper, producing visual texture. Some earth colors tend to granulate, as do cobalts and ultramarine blue. Using distilled water can reduce granulation in hard-water areas. Granulation becomes more apparent with rougher paper.

## Understanding Staining

The very fine particles in some modern watercolors cause them to permeate and stain the paper. Often, these colors cannot be lifted completely, even with a damp sponge. Staining colors do not easily allow for reworking, especially if the paper is very soft. Experiment with a variety of colors to determine your preferences.

## Painting with Pencils, Markers, and More

Pump spray bottles of diluted watercolors are plentiful. Other related products include water-based markers and water-soluble pencils and crayons.

**A grainy** appearance is created with rough paper and pigments that sink into the depressions.

**Shimmering metallic** and micro-glittered watercolor sprays

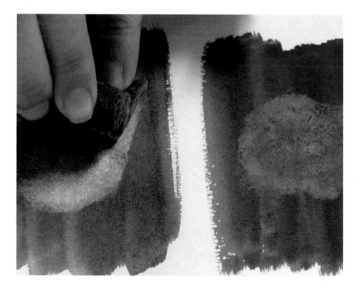

**The burnt umber** paint on the left is less staining, while the lifted area of pthalo blue on the right leaves more pigment behind.

**The background** has been sprayed with sparkling mists.

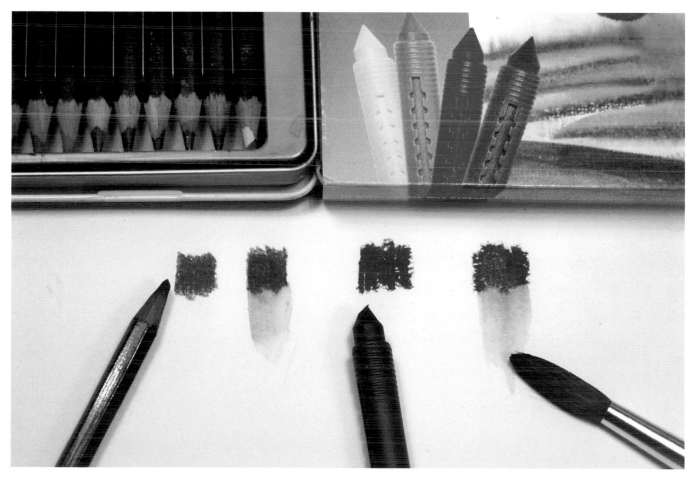

**The marks of** water-soluble pencils and crayons liquefy when water is applied to them.

**Use watercolor pens** by drawing thin lines of color on damp paper. They can also be used on dry paper and dampened afterward.

**First drawn with** watercolor pencils, this piece was then brushed with water and paint. More sketching with watercolor pencil completed it.

**This sketch was** done with water and brush-tipped watercolor pens. Such pens have a watercolor reservoir inside and synthetic bristles at the point.

## Painting Clear-ly

In the Opaque Water Mediums section (page 34), we discussed tempera and gouache. Watercolor sets, especially starter kits, sometimes include a tube or pan of Chinese white in the tray. Be aware that adding Chinese white to other colors creates an opaque cloudy effect. Think twice before using opaque colors, especially if the intention is to use the white of the paper to establish transparency.

**More water was** added to the violet (top) with each increment. In the hazier bottom strip, increasing amounts of opaque white paint were added.

## Mending Mistakes

There are several ways to fix faults on a transparent watercolor. Covering an area with Chinese white is quite controversial for many watercolor artists, since it changes the appearance of a transparent painting perceptibly. Another, perhaps better, option is to dampen the error with clean water on a clean brush. Gently lift paint off with a paper towel, a clean brush, a soft cloth, or a small sponge. Such efforts at correcting a watercolor painting may fail. If that is the case, allow the area to dry and paint over the mistake with a darker value of watercolor paint.

# Creative Reuse

If a painting is not satisfactory, don't toss it—cut it up and create a collage or other lovely artwork from the pieces!

**This paper weaving** of Geri's was made of strips cut from disappointing watercolor paintings.

# SUPPORTS FOR WATERCOLOR

There's a vast selection of surfaces and textures to suit even the most discerning watercolor painter. Choose from watercolor boards, Claybord, illustration board, and many types of watercolor paper.

**Illustration board** (tan colored), "aqua" board, and spiral pad with 90-lb. wet media paper

**Arches Rough** shows its texture here.

Selecting the right watercolor paper is crucial in determining painting results. It comes in a variety of fibers, finishes, and weights.

The weight system is determined by the weight of a ream (usually 500 sheets) of a particular style of paper. Student-grade watercolor paper might be 80- or 90-lb. and less expensive than, say, 140-lb. or 300-lb. paper; 300- to 400-lb. paper need not be stretched to prevent buckling.

In the metric system, paper weight is described in grams per square meter (gsm). If you search the Internet for paper weight conversion, you will find conversion charts.

Paper texture is another consideration. Each type of finish has a distinctive name. Rough paper has, yes, a surface with quite a lot of tooth. Cold press paper has a slight texture and is extremely popular. Some papers are labeled "not/cold press," another term for cold pressed paper. So a "not" sheet is not hot pressed. Paper labeled hot press is very dense and smooth (a memory device is to think of a hot clothes iron pressing out the bumps).

Try different papers to learn their characteristics and find a favorite texture and thickness. A change in paper weight may affect painting success as much as does a change of surface.

**Two loose** Strathmore sheets and (at top) clear Mylar

**The correct side** of the paper is the side from which the watermark can be read. However, either side can be painted upon.

**Stretched woven** cotton canvas specially coated to perform as watercolor paper. Note the gallery-wrap sides.

**This block of** twenty sheets is 140-lb (253 gsm) cold pressed.

Watercolor tablets, in block form, have many sheets glued together at the edges. This allows the artist to paint on the topmost sheet without buckling the papers below. When the painting is finished and dry, the artist can gently separate the edges of the artwork from the block with a craft knife. This is a very convenient support to work with.

Another type of watercolor paper, Yupo, is a smooth synthetic that is nonabsorbent, so colors sit on top of its surface and stay bright. The impermeability allows the artist to wipe off unwanted sections of a painting.

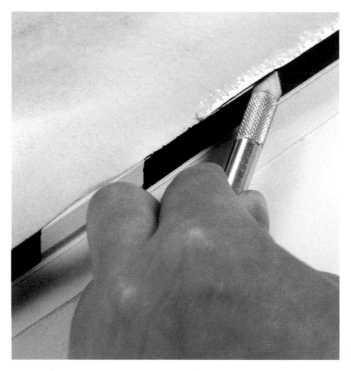

**Cutting the** top sheet from the rest

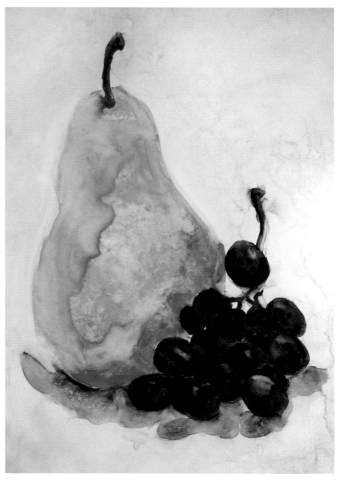

**A quick** study on Yupo

**Begun on** transparent Dura-Lar acetate, this example is taped to a brown board, which shows through in places.

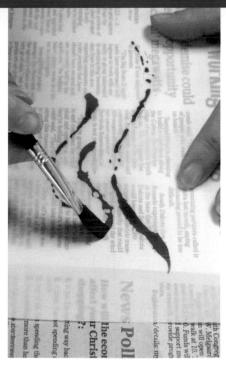

**Paint may bead** up, as shown here on frosted architectural film, another plastic product.

Try Dura-Lar poly film for wet mediums, too. It's specially treated on both sides and available in several finishes, from clear to tinted and more.

Even a sheet of Mylar can be painted upon!

**On the right** is the first portrait, painted on Bristol board. Mylar was placed over it and a second portrait was painted. Here the Mylar was flipped over for a mirror image.

**Note the large,** smooth board in the background that is used for stretching paper.

## BRUSHES, TOOLS, AND OTHER MATERIALS

Sable brushes are wonderful for watercolor painting, because they hold a considerable amount of liquid. Squirrel or "camel" hair brushes are a less-expensive alternative.

Most watercolor brushes are shorter-handled than oils brushes. They come in flats, filberts, brights, rounds, fan, or mop shapes. Another option is synthetic brushes created to mimic natural bristles. A large, soft Hake brush is also recommended.

**This 2" (5 cm)** wide Japanese Hake brush can easily complete a graded wash (detailed in the techniques section on page 181).

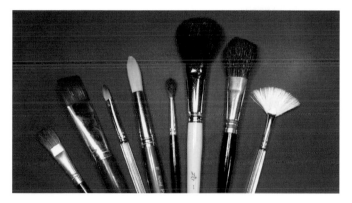

**Note the large** mop brush (with yellow handle) and the #0 soft fan brush (at right).

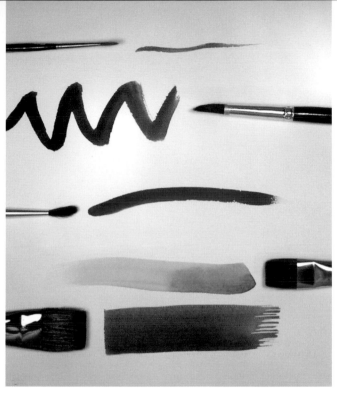

**From the top:** a #1 round, a #9 pointy round, a #5 round, a ¾" flat wash, and a 1" flat wash.

Clean watercolor brushes with a gentle bar of soap and cool water. Reshape pointed rounds at the tip and smooth all others to their original shapes to dry.

**From top to bottom:** ¾" oval brush, squirrel mop brush, sable round, and (nearly upright) #1 synthetic long liner.

**Practice strokes** with a number of brushes on both wet and dry paper.

Palettes made of plastic (or glazed ceramic) with wells for mixing are particularly practical, especially the covered trays. Palettes are available in strippable paper form, too, and some people use white enameled butcher's trays instead.

**Dabs of paint** colors in the small wells around the edge can be blended and mixed in the larger inward spaces.

**This palette** includes a lid.

# Mist It

A little spritz of water from a gentle spray atomizer keeps watercolor paints workable and moist.

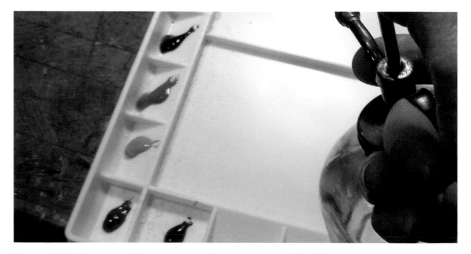

**Even dried** watercolor paint can be reconstituted with water.

The best sponge for watercolorists is not the average sponge, Bob! Use an "elephant-ear" if possible.

Other important tools and materials include a stapler or tape for stretching paper. By tradition, brown butcher's paper tape was moistened to use. It has a water-soluble adhesive coating on one side.

Use two water jars, if possible: One with clean water for adding to paint, and the other to rinse brushes. A pump spray bottle is useful, too. Paper towels or rags are handy for cleaning brushes and controlling the amount of pigments and water being used.

Last, a blow dryer is optional. It can speed up the drying process.

**Two sea sponges.** The one in the foreground is an "elephant ear."

**Hold the dryer** 10" to 12" (25.4 to 30.5 cm) away. Use a low setting, not hot, and move it back and forth.

## Choosing from Other Watercolor Mediums

The watercolorist's arsenal includes many additives (the term is used here interchangeably with the word medium) that alter or enhance the paint. Watercolor mediums allow one to blend, change drying rates, or to add texture, gloss, or pearlescence.

While most watercolors contain a proportion of gum arabic, adding more increases the gloss and transparency of watercolors. It also slows the drying time. Blending medium also slows the drying time of colors. It's ideal in very warm climates.

Oxgall liquid is a wetting agent that allows paint to flow more freely. It's effective for marbling techniques, but it should be used sparingly.

Granulation medium encourages the watercolored surface to take on a mottled texture when dry. It comes in liquid form. Similarly, texture medium produces a textured finish. It is either painted onto the paper first or mixed with paint.

Lifting preparation is applied to the paper first and allowed to dry before painting begins. This enables the removal of colors more easily later, so corrections are simpler.

Iridescent medium is added to transparent colors for a pearlized or glittery effect. Mix with paint or apply over a dried wash.

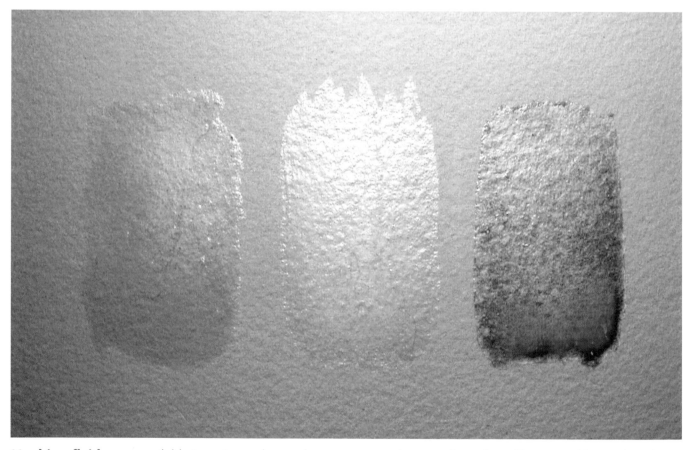

**Masking fluids are** available in various colors so they are easy to detect on the surface. They are rubbery when dry.

THE COMPLETE PHOTO GUIDE TO CREATIVE PAINTING

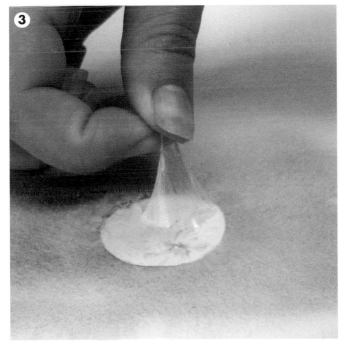

## Preserve and Protect with Masking Fluid

Not strictly an additive, liquid frisket, Miskit, or Maskoid is a resist material used in small areas to reserve highlights. It can be purchased in colorless or lightly tinted formulations. It's not mixed with paint, but rather applied to white or lightly tinted areas to safeguard them.

Shake masking fluid well before using, and apply it to dry surfaces only. Avoid leaving it on the paper for long periods. Note that it can be used with thin acrylic washes, too.

**1** Select an old, small brush, and rub the bristles on bar soap to promote easier cleanup later. Then apply the rubbery fluid on white or light-colored areas. Or, instead of a brush, use a masking fluid pen. If thin, white lines are needed, stamp frisket on with the edge of an old credit card or piece of matboard! Wash the brush with soap and water immediately after use.

**2** Within minutes, a wash can be painted over the masking fluid. Use gentle strokes; do not scrub when floating color over the frisket.

**3** Do not remove the mask until the wash is dry. Remove the masking material later by rubbing or peeling it off.

Resistance is not futile! No frisket? Rubber cement can serve as a resist material with either acrylics or watercolors, but it's viscous and nonarchival. It might even damage soft papers when it's removed. Read more about rubber cement on page 195.

# WATERCOLOR PAINTING TECHNIQUES

There is no single correct way of watercolor painting. Various exploratory approaches will lead to personal style.

**Wet into wet** and wax resist methods were used here.

Remember, though, that while individual techniques are very useful, a painting should be an integrated whole. Many different methods in a single artwork could be a distraction.

## Stretching and Growing

Stretching loose sheets of watercolor paper is one way to buck the buckling. Some weights, such as 72- to 140-lb (104 to 253 gsm) papers should be stretched, but 200- to 400-lb (122 to 240 gsm) need not be. In fact, heavy, handmade papers have a desirable, deckle edge (i.e., a tapered, irregular border) that would be damaged by tape or staples.

A smooth board is a requirement for stretching. Buy a Homasote board or plywood at the building supply store.

## Experiment

Explore various watercolor techniques without fear by using scraps. Cut the paper into bookmark-sized pieces and laminate them later!

1  Soak the paper in clean water for a few minutes. Small sheets can be soaked in a shallow tray. Drain. Hold the paper from one corner so that excess water can run off.

2  Cut four strips of paper tape to the paper's dimensions. Dampen them one at a time (do not overwet) and apply each to a side, overlapping the watercolor paper only about ½" (1.3 cm). Many artists prefer to dampen the adhesive coating on butcher's tape with a sponge. It should be a separate sponge, not the same one used on watercolor paper! Burnish the tape for a good bond.

**Dip tape strips** briefly to avoid overwetting.

Some artists prefer to staple damp paper to stretch it. Place staples about ½" (1.3 cm) from the paper's edge and about 1½" (3.8 cm) apart.

Small pieces of watercolor paper—say 5" x 7" (12.7 x 17.8 cm)—can be stretched with thumbtacks. Have a larger sheet to stretch? Soak it in the tub!

**Do not rest** the stapler on the paper—it will mar the surface.

**Paper will** seal better to a moist surface, so dampen the board as shown.

**Draining a very** large sheet of wet paper

**Drag the wet** paper onto the board from the opposite side, to form a better bond between the two.

**Gently sponge** off surplus water, and "burp" the paper before taping or stapling, so that no air bubbles remain.

## Practice, Practice, Practice!

Painting exercises can aid in increasing knowledge and developing watercolor skills.

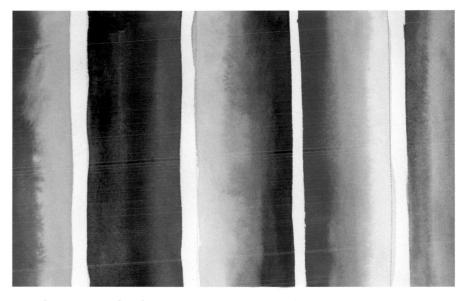

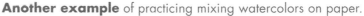

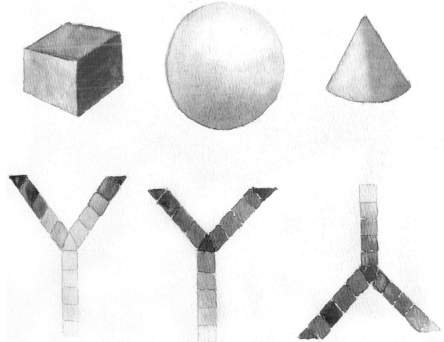

**One way to** learn a technique is to repeat it using different colors. Here gradient washes (page 181) are practiced in circles of different colors.

**Another example** of practicing mixing watercolors on paper.

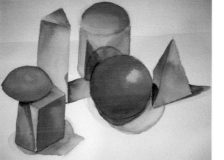

**Here, the beginner** used a pale wash, warm-colored forms and cool shadows, and wet into wet paint.

**Top left,** a hard-edged object (allowing each area to dry before going on). Top center and right, wet into damp. Bottom row, Y legs are painted in values of one color. Y arms are done in mixed colors, one warm, one cool.

Sketchbooks are another tool for advancing one's abilities. Watercolors and their essentials are relatively portable—so an artist could paint a scene, or an object while in a museum, easily and quickly.

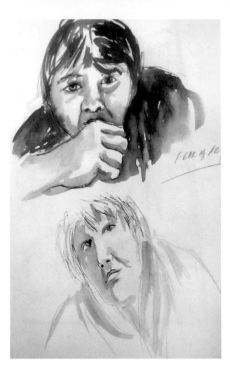

**Burnt umber was** used to finish these two fast portraits in a sketchbook.

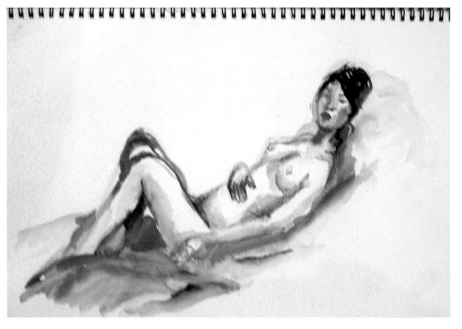

**The fast-drying** property of watercolor paints means that a painted sketch in a journal can be saved as a memento.

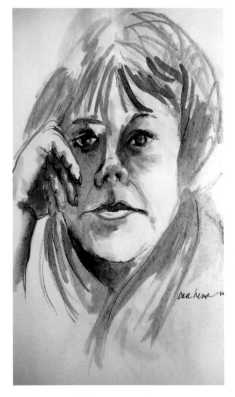

**The pencil lines** still show here. A burnt sienna wash was added.

**Pan watercolors were** used with no predrawing for this quick figure study in a spiral book.

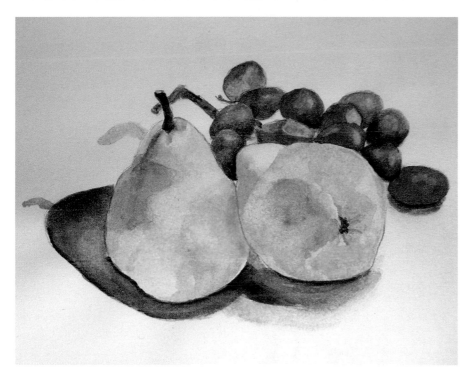

**A practice** still life in an artist's notebook

**This unfinished** painting was done over a pencil sketch in a journal.

**Bring drawing** and painting materials along on the next trip to a natural history museum.

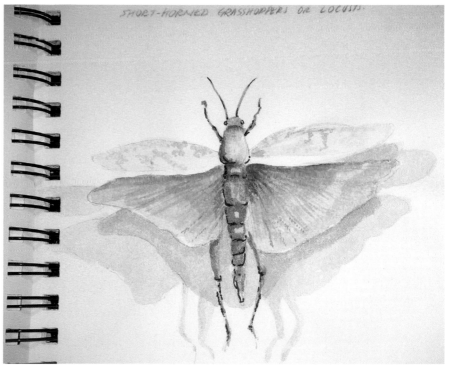

SHORT-HORNED GRASSHOPPERS OR LOCUSTS

**When painting** specimens or art in a museum, take along a lightweight folding chair.

## Painting Into Wet and Onto Dry

The wild and wonderful wet into wet technique is also called wet on wet. Color diffuses (spreads) at the edges in remarkable ways. If hard edges are desired instead of soft, paint on dry areas.

**Wet** into wet

**Wet paint** onto dry paper

**The hard edge** at the top of the red was done on dry paper, but the lower section was wet.

## Wet and Wild

The wet into wet technique produces very soft, fluid effects. Add more paint while the paper is wet enough to be shiny and reflective. There will be bleeding of colors where they touch, so choose colors that are pleasing when combined. Tilt the board to encourage the movement of color. If rich, jewel tones are desired, load the brush with intense color.

**An up-close** look at wet into wet

**A nonobjective wet** on wet watercolor on Whatman paper, mouldmade (100% cotton paper cast in a mold).

**The drawing was** made first in water-based marker, then wetted down and painted.

**If an area** is partly dry, and greater wetness is added to it, the resulting effect is called a "bloom."

Whether it's water or paint, accidental or deliberate, wetness introduced to a slightly dryer area will likely create a blossoming of color. Let's call it "dropping in on hue." Pigment is pushed aside and concentrates at the edges of the shape.

If clean water is deliberately dripped or made to flow into dry or slightly damp areas, the effects can be very interesting.

**Touching water to** the moist sky color at the horizon creates "trees."

## Wet on Dry: Contained and Controlled

This method is aptly named, since the brush is wet with paint, but the paper's surface is dry. Use it for sharp, crisp accents. This is a far more controlled technique than wet into wet. It's hard-edged rather than soft, so it's great for painting details with a smaller brush.

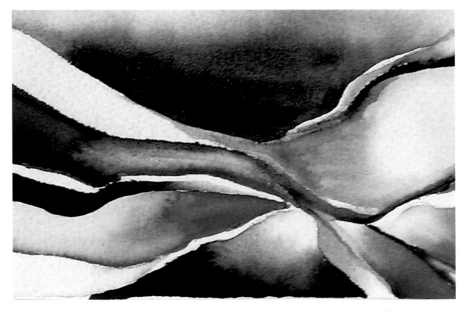

**Painted on dry** paper, this nonobjective example was done in ultramarine blue and Payne's gray.

## Making the Grade

Often called a gradient or variegated wash, the graded wash is a valuable tool for the artist. It smoothly changes in value from dark to light, and is especially effective for painting skies. (In general, realistic open skies have lighter coloration toward the horizon.) The soft blends of a graded wash are easily achieved either by dampening the paper first or by working on dry paper.

**1** Mix a liberal amount of pigment with water to use first. In a clean portion of the palette, mix another puddle about half as strong, with more water.

**2** Many watercolorists angle the painting board a bit higher at the top when creating a smooth wash on dampened paper. After each stroke, the slight incline effectively allows the pigment to bleed into the next stroke.

Note: See page 183 to learn how to lift out clouds if desired.

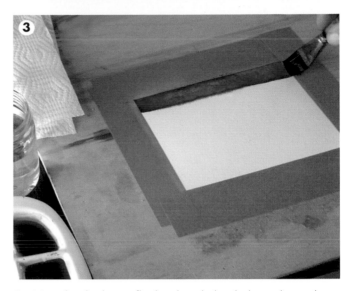

**3** Next, load a large, flat brush with the darker color and swipe a horizontal stroke at the top of the paper. Elevation of the top of the board allows gravity to assist with the downward flow of the paint.

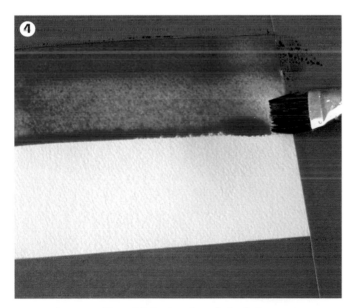

**4** Working quickly, refill the brush with the lighter, more-diluted color. Touch the bottom of the first stroke and swipe across. Dab the brush on a paper towel and refill it with an even more watery color mixture. Each stroke becomes consecutively lighter with the addition of more water.

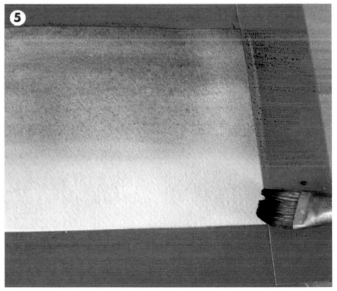

**5** Make the next stroke, slightly overlapping the bottom of the previous one. Repeat with increasing amounts of water in the brush until the sky area is completed. Squeeze the water from the brush and use it to pick up the bead of watery paint at the bottom of the sky. The last stroke can be done with clean water.

A multicolored variegated wash blends several different colors. Great for sunsets, this technique is also done with a big brush loaded with a water and paint mixture. Make puddles of each color in advance. Charge the brush with enough pigment to do the job brilliantly! Use the same graded wash process as on page 181 to create a seamless joining of values.

## Glorious Glazing

Any thin, transparent wash of color laid over a dry, previously painted area can be called a glazed wash. It's used to adjust the color, value, or intensity of the underlying painting. Select transparent glazing colors without any white in them. The hues created by glazing sheer layers over one another can be beautiful and effective.

Allow each wash some time to dry before overlaying the next color.

**Smooth graded** washes and flat (one-color), even-toned washes require a lot of practice.

# Keep it Simple

Spontaneity can be a virtue with watercolors. Do not overwork them or they will lose their brilliance.

**Thin applications of** warm yellows and oranges were each applied to dry reds and violets here.

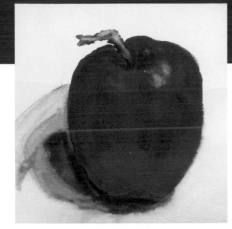

**Highlights give this** shiny apple the illusion of weight and mass, a sense of three-dimensionality on the paper's flat surface.

**A soft paper** towel or facial tissue, crumpled into a wad, lifts faintly edged clouds from a moist wash. An elephant ear sponge works, too.

**Dampen a fine** brush and "draw" stars, lifting them from a still-damp sky.

**This clear acrylic** brush handle has a sharp, angled end perfect for scraping.

## Moving and Lifting Watercolor Paint

The lifting technique is an excellent means of adding highlights. While a painted area is still slightly damp, select a brush of appropriate size, damp but not dripping wet, and touch the area(s) to be lightened. Repeat with a clean, barely damp brush until the area looks like it is caught in a glare from light.

Even dry areas might be lifted with a clean, damp brush or sponge, used as a gentle scrubber. Blot as necessary with a dry paper towel. If the area to be lifted is large, it's possible to mist it with clean water and blot repeatedly.

Mopping up is another form of lifting. If a puddle of excess water or paint must be cleaned up, a large, fluffy brush will absorb much if it. Use a thirsty brush (slightly damp, not dripping wet) to swab and soak it up.

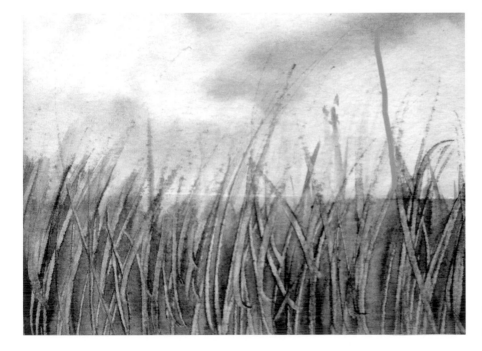

**The blades of** grass in this example are both painted and scratched.

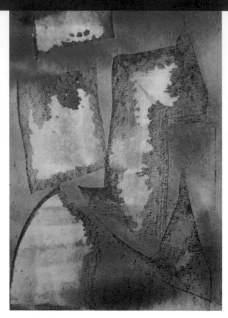

**Here, paint was** scraped with the flat edge of a piece of plexiglass.

**Another example of** mostly dark lines created by scratching into wet, painted paper

**A nice** mix of light and dark scratches

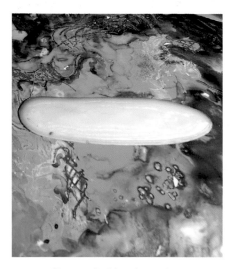

**Even discards** like this white plastic piece can be used to scratch into paint!

## Scraping Paint for Sharp-er Images

Need white lines in an artwork but don't want to paint them in? Scratch that idea! Just scrape with a tool or fingernail while an area is still partly damp. The timing is crucial, however, and dark lines may result.

Scratch with a chiseled brush handle, razor blade, or sharp tool to carve into the damp paint, moving it. This technique is suitable for a large tree trunk, hair highlights, grasses, and more.

Want darker lines, not light ones? Scratch into wet paint, which accumulates in the shallow furrows where the paper's fibers have been bruised. This technique is sometimes called paper engraving or debossing. Whether the lines are dark or light, though, depends on such factors as wetness, the tool used, and even the paper itself.

Broadside scraping, such as that done with the bevel that is built right in to some brush handles, works as a squeegee to move and push the paint around. Timing is key: the paper must not be too wet or too dry.

Sandpaper, like a razor blade, is very rough on paper, and many painters would never use such a destructive method of picking out highlights. Used with restraint, however, sandpaper can create a worn, scoured, or grasslike effect.

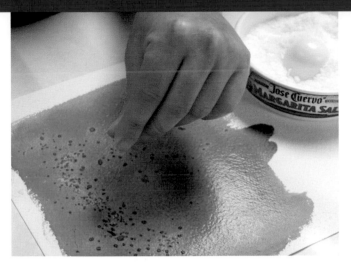

**Dropping margarita** salt into a wet wash

## Adding Visual Texture

Additives such as salt, alcohol, and coffee grounds work well when applied to wet, painted paper. And there are even more fun ways to increase textural interest in a painting!

### Pass the Salt, Please

Sprinkling coarse salt into wet watercolors is a great way to create the illusion of natural-looking sand on a beach or snowflakes in a dark sky. The area must be shiny wet. Don't sweep off the dried salt until the paint is dry.

Try table salt, rock salt, and more. (Salt affects wet acrylic washes, too.)

**The salt has** absorbed the pigment, leaving lighter spots in the now-dry paint.

**Ordinary table** salt was used in the finer-grained areas.

**Kosher salt works** well, too. It was used in the bottom portion of this painting.

**This close-up,** a detail of the previous photograph, is worth its salt.

## No Rubbing: Isopropyl Magic

Here's one way to spot a watercolor painting, literally!

Spattering rubbing alcohol into wet, richly charged colors produces unique, uncontrolled shapes. Use it to add the texture of pebbles, pitted rocks, or rusted-out metal, perhaps.

This technique works best on wet or quite damp paint. Dip a clean brush into a small amount of rubbing alcohol, and then rap it sharply against the handle of another brush. Or use a toothbrush, drawing a thumbnail over it. Go ahead, have a fling, but avoid splattering into the eyes!

Alcohol influences thin, wet washes of acrylics, too.

**Practice this** technique on a damp, painted scrap first.

**Notice the** darkened centers—this effect is called "fish eyes."

**Here the** rubbing-alcohol result is quite pronounced.

## Coffee, Anyone?

Another texture option is grounds for improvement.

Sprinkle dry, unbrewed coffee grounds into a wet area and allow to dry thoroughly. Try it to suggest mottling on sand, mud spatters on a barn, mildew on leaves. . . the possibilities are endless. It's an unconventional approach that can reap exceptional results.

**The dark coffee** specks make this pear a more accurate rendition.

**Splatters on both** wet and dry areas

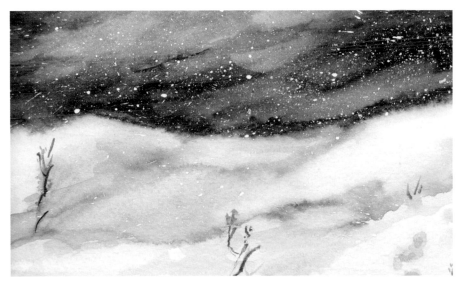

**Snowflakes are** indicated with fine, scattered paint specks.

**Reminder:** If the brush used for dragging is too wet, the broken effect will not be achieved.

## More Effects: Spattering and Dragging

Spattering is great for enlivening flat areas of watercolor. The paint cannot be too watery because large, accidental drops will result. If this happens, gently blot with a paper towel or soft rag and try again with less water and a little more pigment.

Protect areas that must remain unsplattered. Practice on plain paper with several different brushes—even a toothbrush—to achieve desired results.

While spattering requires a moist brush, the drybrush technique of dragging calls for the opposite. Wipe the brush with a paper towel or rag so that just a trace of color remains. Then drag the brush nearly parallel to the paper, grazing the tips of the bristles onto the surface. This skimming method is suited to painting tree bark or ripples in water, for example.

**Here's a Hint:**
**Imprint!**

Making an impression is easy with lace, mesh, or pieces of string, all of which absorb the color and leave a likeness behind. Lay them flat on the watercolor paper and soak them in strong, wet color. Allow to dry thoroughly.

**Achieve a better** imprint by not overlapping the string!

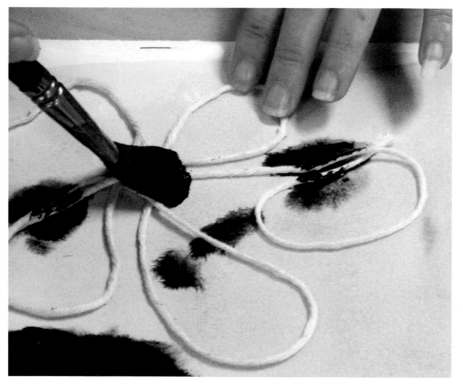

**Saturate the fibers** with very wet paint.

**The crocheted piece** (at top) made a better impression than the heavy string below it.

**Gauze is** pulled off when dry.

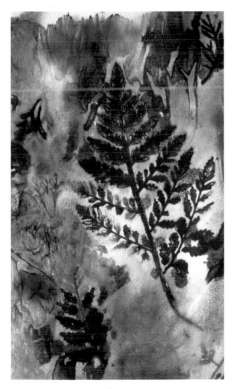

**A lightweight** piece of glass held these plants in place while the paper dried.

**Netting lends** itself to an underwater mood.

Rather than absorbing the paint, some materials move and push it. Place fragments of glass or heavy plastic onto wet paint and see the outlines of geometric shapes when it dries.

Stamping is yet another way to imprint. Apply paint to the edge of a credit card or matboard to press in lines. Dip a pencil eraser or a sponge into paint and touch it to paper for texture.

**Shards of plexiglass** created a sharp, angular design.

**Even a synthetic** cellulose sponge can be used. Cut it into interesting shapes if desired.

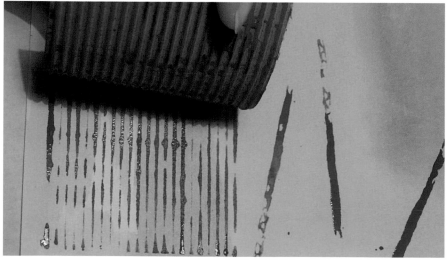

**The ribs of** corrugated cardboard print well, too.

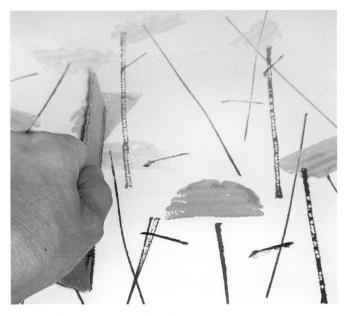

**Press the wet,** painted edge of a matboard piece onto a painting.

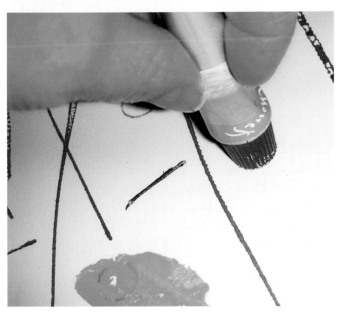

**Either paint or** frisket can be stamped with various-sized caps or lids.

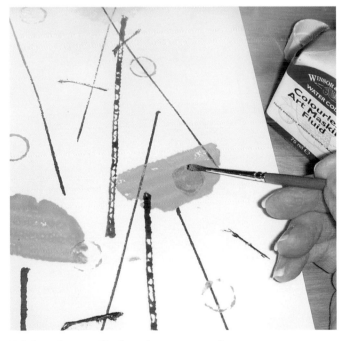

**Frisket is applied** to the same work-in-progress.

**The** finished artwork

**Leaves were painted** on the veined side and pressed onto the paper.

**For a lovely,** natural motif, leave it to leaves.

**Use a** variety of sizes.

Wrap up the visual texture challenge with waxed paper or plastic wrap.

A sheet of waxed paper applied over very damp, rich paint will wrinkle in wonderful ways, especially with a book on top. Ensuing patterns can be terrific.

Plastic wrap, too, is best placed over wet, vivid paint.

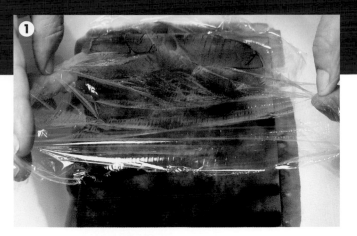

1   Make sure the plastic wrap is a bit larger than the area to be textured.

2   Scrunch and move the clear plastic around until satisfied with the pattern.

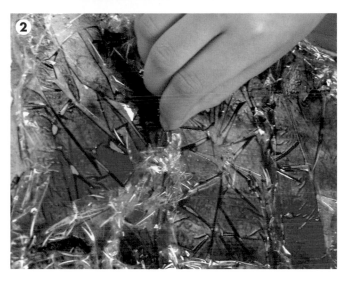

3   No need for a heavy book. Allow the piece to dry with the plastic in place.

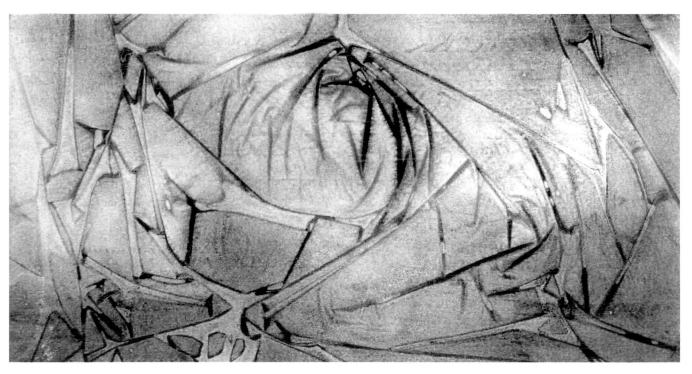

**This plastic wrap** pattern is reminiscent of cracked ice.

**This waxed paper** (at left) was folded and unfolded prior to use. The result is at right.

## Joining the Resist-ance

Use wax or grease crayons, paraffin, or rubber cement to create a pièce de résistance. This is often a hard-edge technique and, like liquid frisket, should be used sparingly.

Paint directly over designs made with candle wax, grease pencils, or non-water-soluble crayons.

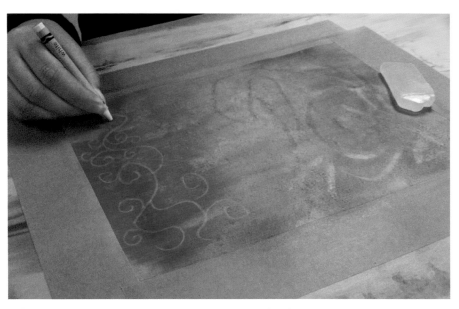

**White crayon in** use over a dry background color.

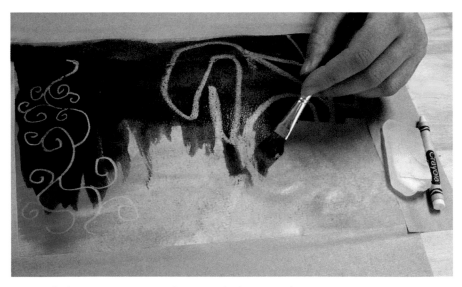

**A wash in** a contrasting color reveals the waxy lines.

**White crayon was** applied heavily and painted over. It repelled the paint and caused spots (beading) to appear.

Repelling paint with petroleum products is quite permanent. One cannot easily paint over the reserved area later.

Rubber cement is less expensive than frisket, and can be dribbled, stamped, or drawn on dry paper. Apply thin coats of it to white or light areas. Wash paint over it with a light hand. When the paint is dry, remove rubber cement with a finger or a resist eraser.

**Rolling off the** rubber cement with an art gum eraser

**Some rubber** cements are not archival.

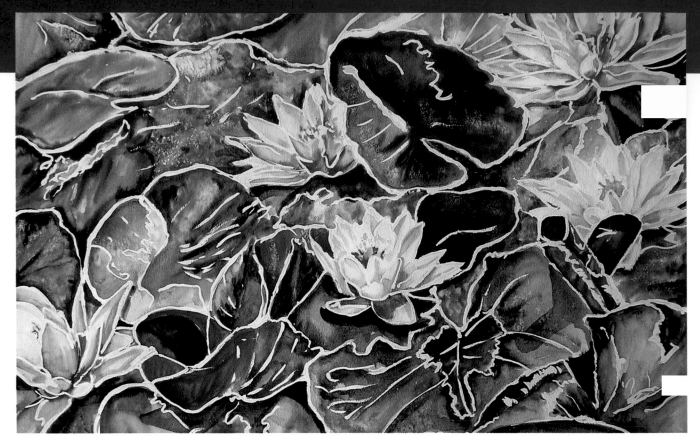

**Geri used wax** to reserve the whites in this batik-like watercolor painting.

## Salvage Old Paint

Have old, rock-hard tubes of watercolor paint? Don't toss them out. Remove part of the tube casing and give the paint a second life.

**1** Carefully cut open plastic or thin metal tubes with a craft knife. Leave a bit of the casing to hold onto.

**2** Draw lines or shapes directly onto wet (or damp) paper with the dried-up paint.

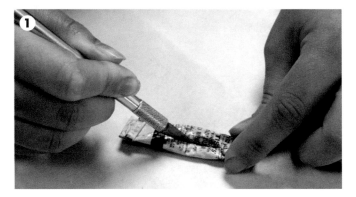

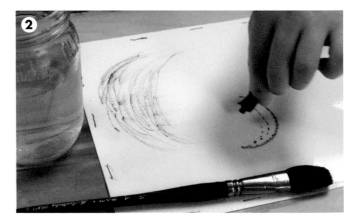

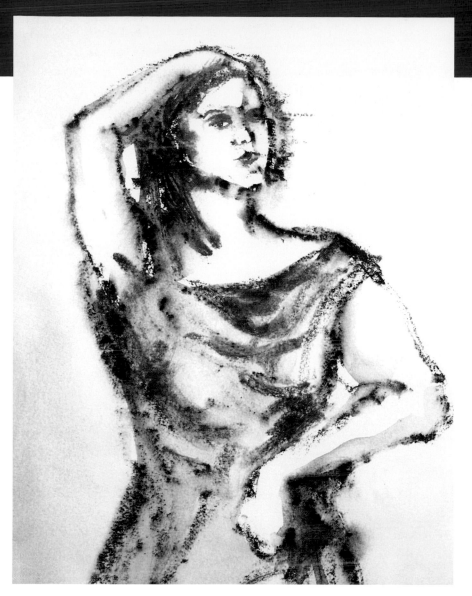

**This figure was** sketched with solids recovered from an otherwise useless tube of watercolor.

# Cap is Stuck

On another note, if the tube is still moist inside but cannot be opened because the cap is stuck, strike up a match! Turn the cap around the flame and— voilà —the tube opens.

## A WATERCOLOR PROJECT

An interior scene can be intriguing, perhaps even more so with a window in the picture. The natural light source creates compelling shadows, highlights, and reflections. The title of this painting will be *Char's View.*

## YOU WILL NEED

- soft pencil and kneaded eraser
- watercolor paints and brushes
- water containers
- watercolor paper or other surface
- rags or paper towels
- elephant ear sponge
- smooth board and tape or stapler (if paper must be stretched)

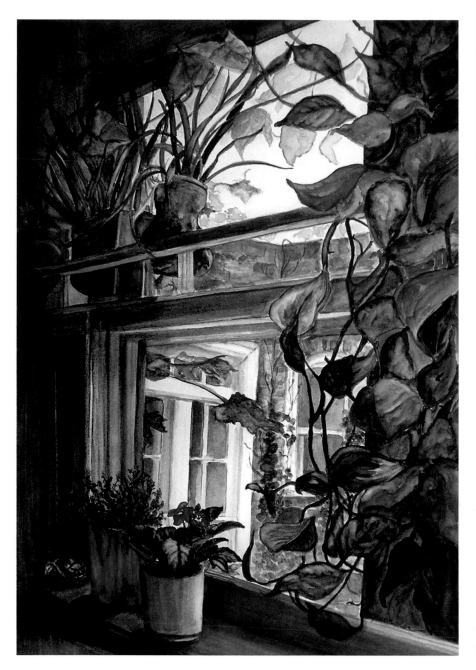

**The finished** painting displays many values from light to dark.

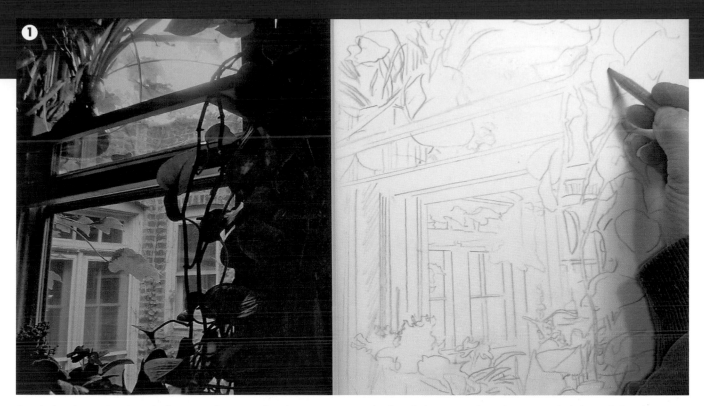

**1** A sketch can be done before stretching or after the paper is stretched and dry. Draw the subject very lightly, with fine lines. Avoid erasures on good watercolor paper if at all possible, as they could mar the surface. Use a regular #2 pencil (not a hard "H" pencil), because pencil grooves would capture the pigment.

**2** Preplanning—thinking about where to reserve the lightest parts of the painting—is a good idea before starting to paint.

**3** Begin with thin, watery paint. Mix a quantity of a very light blue and wash in the sky in the far background.

**4** Paint in more background areas without going too dark. Soft, slightly blurred edges create a sense of distance. The sky areas in the lower windows are next.

(continued)

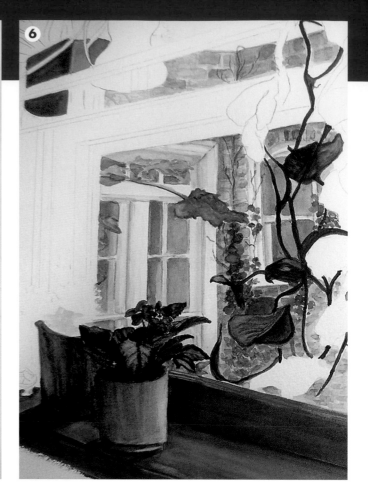

5   Working in the middle spaces, suggest the walls. Don't finish any one area completely, though—paint wherever the paper is workable. Here the two vases and some greenery are begun, but their darkest values will be added later.

6   Add more details to the middle ground, including some vines and more leaves. Greenish brown darkens some shaded areas.

7   Pencil lines can be gently erased when the painting is partly done, or they can be left as part of the artwork. Continue developing the middle- and foreground. More shading has been added to the wall at the right.

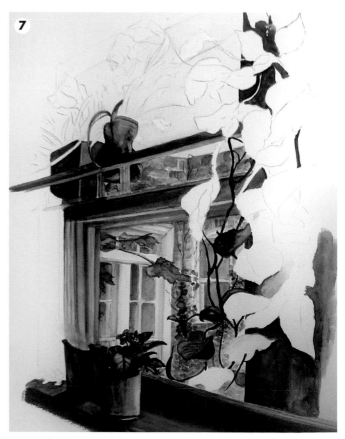

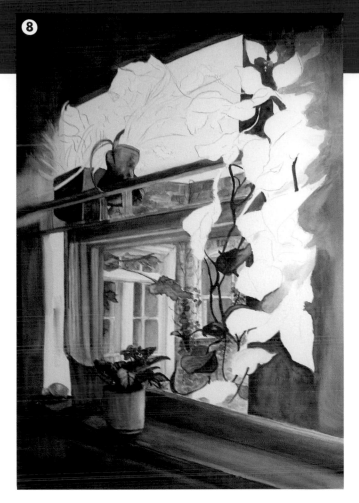

**8** Mix Payne's gray, viridian, and ultramarine blue for foliage in cool shadows. Make a light, watery mixture of yellow and green for leaves that are in the light. Lift out the veining in leaves. Only the wall at left and some potted plants remain to be done.

Moisture can damage watercolor paintings, so frame them under glass. The painting should never be displayed in direct sunlight. Museum glass cuts damaging UV rays, although it is expensive.

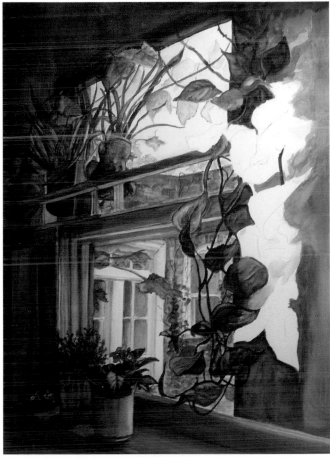

**The vines in** the foreground were saved for last.

*Watercolor Knowledge*
by Lenny Fumarolo
21¼" x 29" (54 x 73.7 cm)

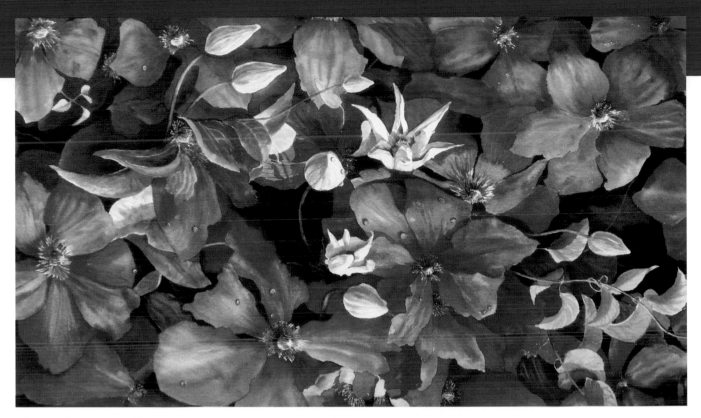

*Clematis* by Kay Wahlgren, 15" x 22" (38.1 x 55.9 cm)

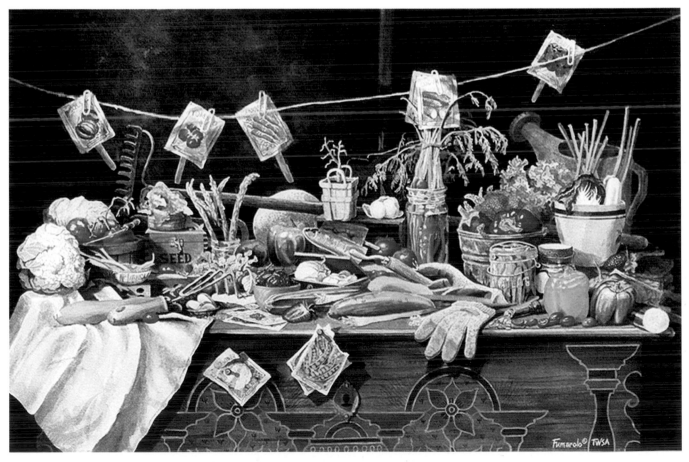

*Seed Box* by Lenny Fumarolo, 20¼" x 29¼" (51.4 x 74.3 cm)

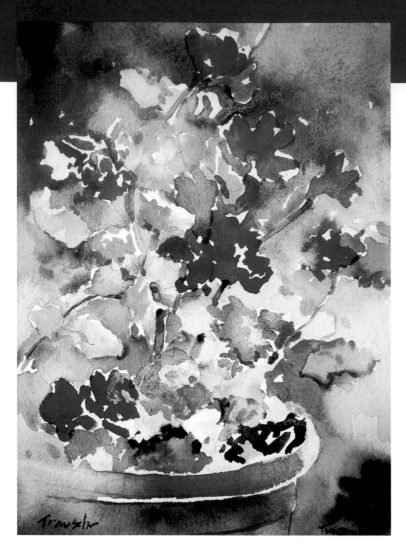

*Geraniums*
by Thomas Trausch
15" x 11" (38.1 x 27.9 cm)

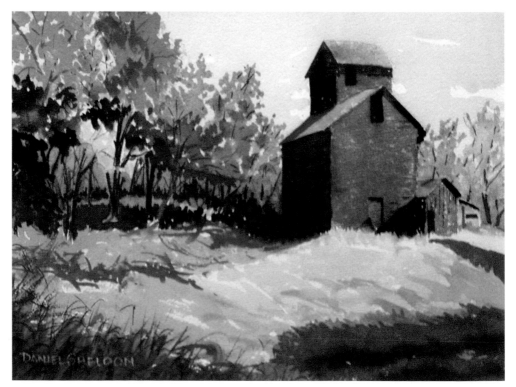

*Elevator Lost*
by Dan Sheldon
11" x 14" (27.9 x 35.6 cm)

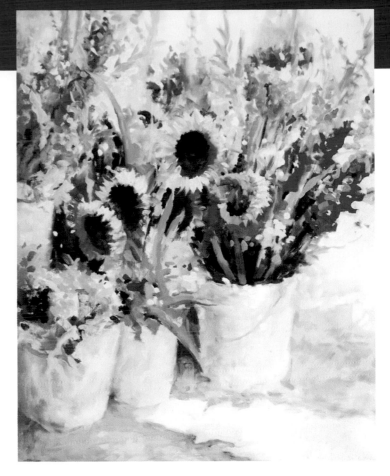

*Sunflower Conversation*
by Thomas Trausch
24" x 19" (61 x 48.3 cm)

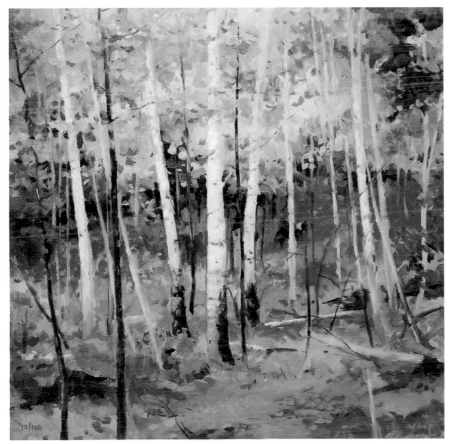

*Doorway*
by Tom Trausch
Private Collection
32" x 32" (81.3 x 81.3 cm)

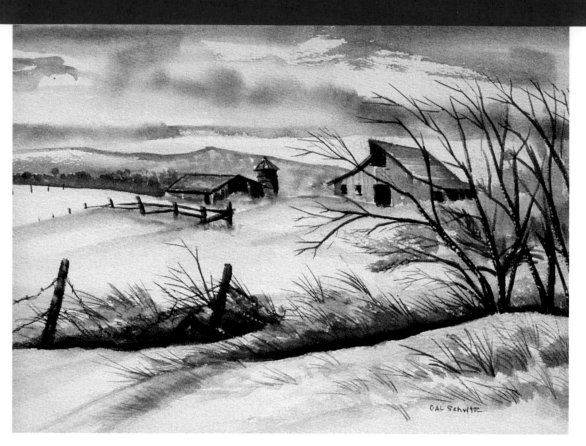

*Wintry Scene*
by Cal Schultz
9" x 12"
(22.9 x 30.5 cm)

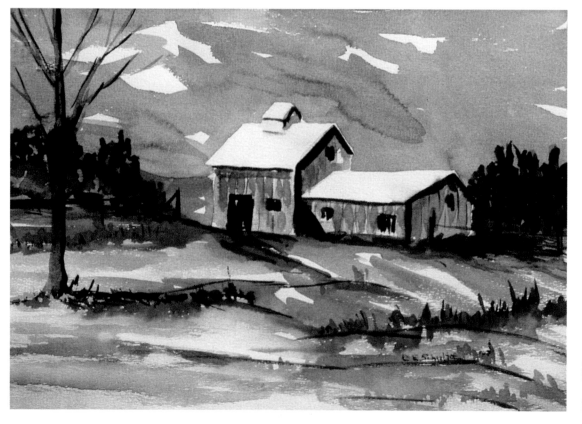

*Dakota Barn*
by Cal Schultz
11" x 14"
(27.9 x 35.6 cm)

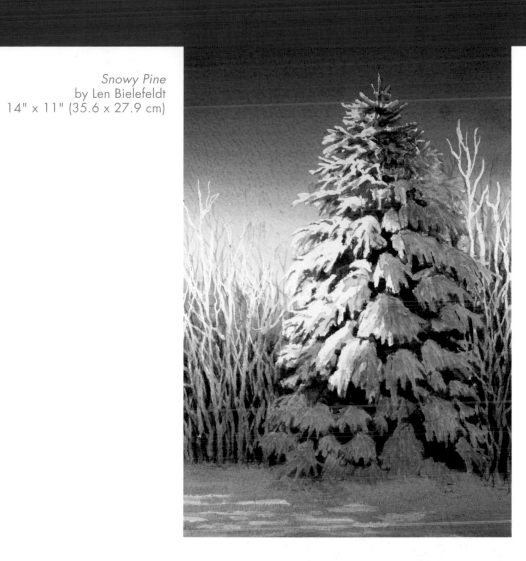

*Snowy Pine*
by Len Bielefeldt
14" x 11" (35.6 x 27.9 cm)

*Fresh Snow*
by Len Bielefeldt
10" x 14"
(25.4 x 35.6 cm)

*Wrigley Rain-Out* by Gordon France, 20" x 28" (50.8 x 71.1 cm)

*Cabbages* by Kay Wahlgren, 15" x 22" (38.1 x 55.9 cm)

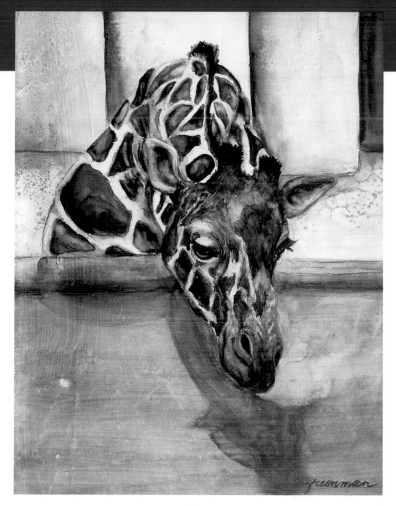

*Giraffe*
by Geri Greenman
transparent watercolor on Masonite
9" x 12" (22.9 x 30.5 cm)

*San Juan Capistrano*
by Geri Greenman
transparent watercolor
on Masonite
11" x 14"
(27.9 x 35.6 cm)

*In Under the Tag* by Gordon France, 20" x 28" (50.8 x 71.1 cm)

*Welcome Wagon* by Gordon France, 20" x 28" (50.8 x 71.1 cm)

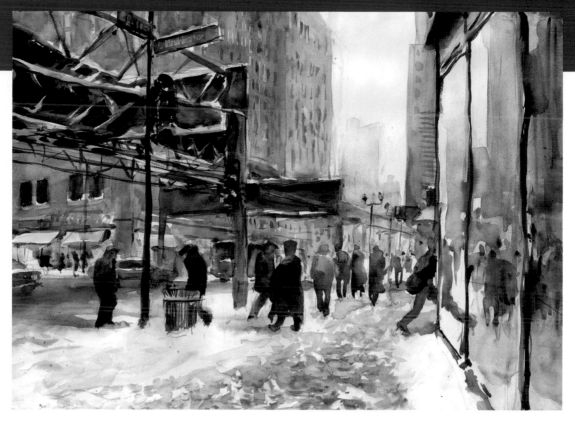

*City Snow* by Gordon France, 20" x 28" (50.8 x 71.1 cm)

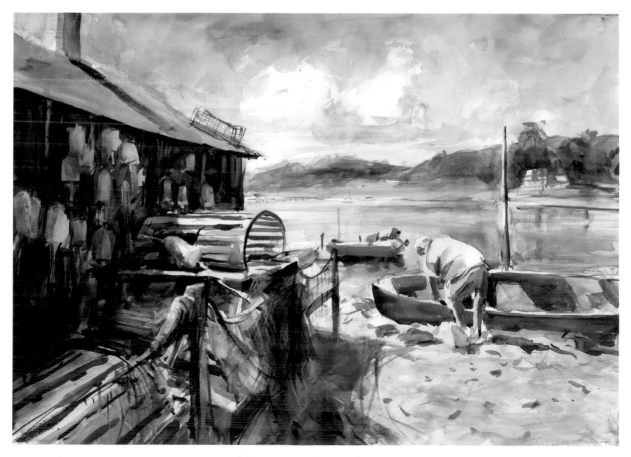

*Cape Neddick Lobster Shack* by Gordon France, 20" x 28" (50.8 x 71.1 cm)

# GLOSSARY

**Abstract art:** Art with a simplified or distorted subject

**Acid-free paper:** Paper with a neutral pH that will not darken markedly with age

**Acrylic paint:** A fast-drying synthetic paint medium made by mixing pigment and acrylic binder with water, forming a permanent clear film when dry

**Alla prima:** A direct form of painting wet into wet, usually made in one session; Italian for "all at once"

**Aerial perspective:** The effect of colors and tones becoming more cool and pale as they recede from the viewer; contrast also diminishes

**Art board:** Artist's quality paper mounted on stiff cardboard

**Background:** The portion of a picture or scene that appears to be farthest away from the viewer

**Binder:** The liquid medium that is mixed with pigment to form paint or pastels

**Bleeding:** The movement or spreading of pigment through a layer of paint or water

**Blocking in:** The initial stage of a painting, when the main areas of color and value are roughly placed

**Broken color:** Color that doesn't completely cover the surface or the color beneath it

**Charcoal:** Carbonized wood made by charring twigs; charcoal is also manufactured in square, compressed sticks

**Color wheel:** A tool used by artists to see the relationships that different colors have with each other, which usually consists of red, red-orange, orange, yellow-orange, yellow, yellow-green, green, blue-green, blue, blue-violet, violet, and red-violet

**Complementary colors:** Any two colors found directly opposite each other on the color wheel; e.g., green and red, or blue and orange. Complements cancel each other out thus lowering the intensity of each other.

**Composition:** Organization of the art elements into a harmonious, unified whole

**Cool colors:** Green, blue, and violet are cool colors. These colors remind us of water, grass, and sky.

**Depth:** The illusion of three dimensions on a two-dimensional artwork

**Dry brush:** The application of minimal paints over a surface, leaving areas of broken color

**Easel:** A stand or structure that supports and displays a painting surface like a canvas or a board

**Fixative:** Thin varnish sprayed onto a painting to protect the surface

**Foreground:** An area of an artwork that is lower on the picture plane and has more detail. It appears to be closer to the viewer.

**Gesso:** An Italian word that means a chalky substance. Gesso has a creamy consistency and is used as a ground to seal a surface before paint is applied.

**Glaze:** A thin, transparent gloss or matte coating applied over a painted surface

**Graded wash:** A wash in which the tones move smoothly from light to dark or from dark to light

**Grisaille:** A monochrome painting in tints and shades of gray (sometimes brown)

**Ground:** Any priming layer between the support and the paint

**Highlights:** The lightest tones in a painting

**Hue:** The name of a color; the property that enables a color to be identified

**Impasto:** A technique of applying a thick layer of paint or texture in a painting, usually spread with a painting knife or a bristle brush

**Intensity:** The brightness of a color; also called saturation

**Intermediate colors:** Six colors created by combining a primary color with a secondary color; also called the tertiary colors. An example is red-orange, made by mixing red (a primary color) with orange (a secondary color). See the color wheel, page 7.

**Lifting out:** Removing paint from the painting support with a brush or sponge to soften or highlight areas

**Linseed oil:** A vegetable drying oil that forms a solid film with oil paint

**Liquin:** A refined oil medium used for transparency

**Mahlstick:** Dowel rod or bamboo stick with a pad at one end, used for steadying an artist's hand and for preventing smudges

**Masking:** Reserving highlights with masking film or fluid, paper, or tape

**Masonite:** A registered trademark for a type of panel sometimes used as a surface for painting

**Matte:** A flat, nonglossy finish or surface

**Medium:** The type of material used to create an artwork (oil, acrylic, watercolor, pastels, etc.); also, the liquid, paste, or gel added to or mixed with paint to modify its consistency

**Modeling:** The use of shading to depict the form of a solid object

**Oil paper:** Textured paper coated with primer, sometimes used for oil pastel work

**Opaque:** Impenetrable by light, not transparent

**Palette:** A board or pad made of wood, glass, paper, ceramic, or plastic on which paint is laid out and mixed; also, the range of colors the artist chooses for a painting

**Pigment:** The colorant used in the manufacturing of paint. Pigments are finely ground and then added to a paint medium.

**Primary colors:** Red, yellow, and blue are primary colors; they cannot be produced by mixing other hues.

**Primer:** A substance that is applied to a surface as a ground to provide a seal between the support and the paint. Gesso is an example of primer.

**Resist:** A material used to preserve highlights or colors; also, the method of preventing paint from coming into contact with an area or surface

**Scumbling:** The technique of dragging a dry layer of color over another color in a deliberately irregular manner

**Secondary colors:** Colors created by mixing two primary colors; orange, green and violet

**Sgraffito:** The technique of scratching into a layer of color with a sharp tool to reveal another color beneath

**Shade:** A color mixed with black

**Support:** The material upon which a painting is made

**Temperature:** Color can create a warm, happy mood, a sad atmosphere, an exciting one, and more; cool colors seem to recede into the distance, and warm colors advance toward the viewer.

**Tint:** A color mixed with white

**Tooth:** The texture of a sheet of paper

**Underpainting:** A tonal sketch blocked in with pigment before finishing a painting

**Value:** The lightness or darkness of a color. White is the lightest value and black is the darkest.

**Varnish:** A protective coating applied over the surface of a painting

**Warm colors:** Red, orange, and yellow are warm colors; these colors remind us of warm things such as the sun or fire.

**Wash:** A thin or transparent layer of paint that is applied to the painting surface

**Wet into wet:** Painting in a new color before the previous one has dried

# RESOURCES

**Ampersand**
1500 E. 4th Street
Austin, TX 78702
Phone: 1-800-822-1939
www.ampersandart.com

**Blick Art Materials**
P.O. Box 1267
Galesburg, IL 61402
Phone: 1-800-723-2787
www.dickblick.com or
www.artmaterials.com

**Colorfin, LLC**
P.O. Box 825
Kutztown, PA 19530
Phone: 1-484-646-9900
www.panpastel.com or
www.sofftart.com

**DecoArt, Inc.**
P.O. Box 386
Stanford, KY 40484
Phone: 1-800-367-3047
www.decoart.com

**Golden Artist Colors, Inc.**
188 Bell Road
New Berlin, NY, 13411
www.goldenpaints.com

**Masterson Art Products, Inc.**
P.O. Box 11301
Phoenix, AZ, 85017
www.mastersonart.com

**Oriental Trading Company, Inc.**
P.O. Box 2308
Omaha, NE 68103-2308
Phone: 1-800-228-2269
www.orientaltrading.com

**Savoir Faire (Sennelier, Rafael, Isabey, Fabriano, Cretacolor, and French School brands)**
40 Leveroni Court
Novato, CA 94949
Phone: 415-884-8090
www.savoirfaire.com

**Strathmore Artist Papers**
1097 Ehlers Rd.
Neenah, WI 54956
www.strathmoreartist.com

**Winsor & Newton**
11 Constitution Avenue
Piscataway, NJ 08854
Phone: 1-800-445-4278
www.winsornewton.com

**Geri Greenman** has taught art for three decades and has had eighteen cover stories with *Arts & Activities* magazine, the nation's leading art education periodical. She is a contributing editor with the magazine as well. Geri was nominated for a Golden Apple, and was a finalist for the International Dolores Kohl Teaching award. She won the Outstanding Achievement Award at two different schools and was listed in *Who's Who Among America's Teachers*. Her award-winning artwork is shown in galleries in and near Chicago, and her poetry has been featured in *ArtsBeat Magazine*.

**Paula Guhin** is a photographer, mixed-media artist, visual arts educator, and writer. Her nonfiction books include *Image Art Workshop* (Creative Publishing international), *Glorious Glue, Art with Adhesives* (J. W. Walch), and *Can We Eat the Art?* (Incentive Publications). Guhin is also a contributing editor at *Arts & Activities Magazine*. She teaches workshops and demonstrates nationally. To learn more or to contact her, visit her blog at http://mixedmediamanic.blogspot.com/.

She lives in Aberdeen, South Dakota, with her husband David, four horses, two dogs, and two fat cats.

# ABOUT THE CONTRIBUTING ARTISTS

**Len Bielefeldt:** From an early age, Len displayed a passion and talent for drawing and painting. His father, a trained artist, encouraged him greatly. Just before his high school graduation, Len's restless spirit and hunger for new experiences resulted in his leaving home. "I went to the bank and got my $400, and headed south." But he never forgot his bigger dream of being an artist.

Len has lived in some of the most divergent and interesting cities in the U.S.: Minneapolis, Seattle, Houston, and Chicago. A tireless adventurer, he has also traveled abroad extensively, experiencing the cultures and scenes of other countries. These travels are illustrated in his work, which shows his understanding and appreciation of the people around him. Len currently lives on a small farm about 40 miles west of Chicago. With one glance into his studio, it is immediately obvious that his life is, first and foremost, focused on his art.

**Signe Bruers:** Of Swedish descent, Signe is a lifelong learner who works in the traditional Norwegian style of Rogaland rosemaling. Besides using oils, Signe also employs glazes on ceramic surfaces.

Seventy-nine years old at the time of this writing, she also worked at the Indian Health Service for "twenty-five years, one month, and three days." She adds, "Then, after I retired, they called me back three times to assist them!"

Daughters Karen and Susan have given her four grandsons and five greats.

**C. M. Cernetisch:** C. M. (Chris) lives on a ranch in rural South Dakota. Her primary medium is pastel, which she says is "delightfully messy, colorful, and makes the most wonderful 'skritchy-scratchy' sound when I'm working!"

Chris often carries a sketchbook in her saddlebags, along with a digital camera. Her paintings have been collected by people from all over the United States and abroad. She is represented by several galleries and is a member of both the Mid-America Pastel Society (MAPS), and the South Dakota Plein Aire Painters.

She and her husband have two kids (the human kind), several horses, dogs, and milking goats.

**Jessica Fine:** Jessica Fine was raised by an antiques dealer who quite literally surrounded her with antiques. Each antique had two hidden histories, its own and that of the hand that shaped it. This awareness, more than anything, shaped her philosophy of the importance of moving just beyond the real in representational art. Her goal is to discover and convey that which is uniquely radiant in each of her subjects.

She has exhibited in eighteen museums around the country, and has been published in *Art in America, American Artist, The Pastel Journal*, and *The Artist's Magazine.*

Ms. Fine has garnered over forty-five awards for her oils and pastels from juried exhibitions around the United States. You may find her work in *Masters of Today* and *Trends*, both published by Masters of Today Magazine, London, United Kingdom.

**Gordon France:** Gordon France began painting full time in 2000 after retiring from the advertising business in Chicago. He has exhibited extensively in the Midwest and on the East Coast. A workshop presenter, Gordon is a member of several art leagues, guilds, and watercolor societies. His paintings hang in private collections in Italy, the United Kingdom, Canada, and throughout the United States.

His website is www.gordonfrance.net

**Jacque France:** Jacque made her public painting debut in March 2005 in a successful two-painter show with her husband, Gordon France, at the La Grange Art League Gallery.

She received her BFA from the School of the Art Institute of Chicago. After graduation and marriage, Jacque taught art to children as an occupational therapist. She soon found herself busy raising her own family, but she continued to paint while developing an antique business that has kept her traveling around the country.

Jacque attended classes at the La Grange, Illinois, Art League for three years and now teaches a popular oil painting class at the Art League Gallery. She is also a member of The Elmhurst Art Guild, Elmhurst, Illinois.

The French Impressionists have been the primary influence in her work, which hangs in many private collections.

See her work at www.landscapepainting.com and www.jacquefrance.com.

**Lenny Fumarolo:** Lenny Fumarolo decided early on in life that he wanted to pursue commercial advertising. He spent 35 years in the industry, many of them as studio director for two major Chicago advertising agencies. Even so, Lenny always had a painting or two in progress in his home studio.

For his watercolor paintings, he prefers Arches 300-lb. cold-press paper and a wide range of Winsor & Newton transparent watercolors.

He paints a wide variety of subject matter, because it keeps him fresh, and works in layers to build up to the darkest darks, using Winsor & Newton masking fluid to protect the white areas throughout his paintings. A tip from Lenny: "I test mixed colors on a scrap piece of watercolor paper first."

His work has been collected privately throughout the country. Accomplishments include being the first American winner of the Mecanorma International Type Design Contest held in Paris, France, and numerous Best of Show awards.

For more information, email Lenny at lafumarolo@sbcglobal.net.

**Carol Weber Green:** Carol Weber Green is a largely self-taught artist who works in many mediums. She is a muralist, jewelry-maker, painter, and more, frequently using such natural materials as feathers and eggshells in her work. A founding member of ArtWorks Gallery, Carol lives in Aberdeen, South Dakota.

**Marge Hall:** Floral portrait artist, teacher, designer—Marge is all that and more. Her award-winning photo-realistic work is bold and dramatic, yet sensitive and intimate.

Over the past 30 years, she has emphasized the importance of "following your own direction" to her students.

View her website at http://MargeHall.com.

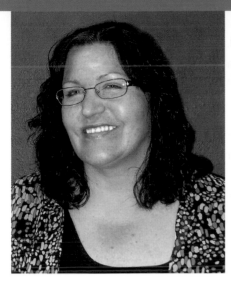

**Brenda Kohlman:** Brenda Kohlman was born and raised in a suburb of Richmond, Indiana. "Art has always been at the forefront of my life," she says. The encouragement she received at home and school reinforced her internal bonfire to become a recognized artist. "My family and friends are the ones feeding sticks into my fire."

Currently Brenda is attending Northern State University, earning a major in fine arts with an emphasis in commercial advertising.

Her work has been exhibited in galleries throughout the Midwest, and is in the permanent collections of the South Dakota School for the Blind and Visually Impaired, MedCenter One Hospital in Bismarck, North Dakota, and the University of South Dakota.

**Anthony Kosar:** Anthony Kosar was the valedictorian of the American Academy of Art in Chicago, Illinois, in 2008, graduating with his bachelor of fine arts degree in illustration.

Anthony has said, "Twisted somewhere between the then and now, visions have plagued me. Art is my only antidote." He enjoys experimenting and working in many mediums and different subject matter, and states, "The moment an artist becomes comfortable in whatever he is doing is the moment he stops growing as an artist."

Anthony is a signature member of the Illinois Watercolor Society. His duality of performing art and visual art has also led him to special effects. He has created make-up, props, and more for numerous plays, commercials, conventions, and films. See his website at www.kosarteffects.com

**Randie Hope LeVan:** Randie Hope LeVan has a passion to capture fond thoughts and memories—even tastes and smells—and suspend them forever in an image. Her images focus on the happiness, kindness, and goodness in life. Her work has been exhibited widely, including a one-woman show at Peck Farm Art in the Barn, Geneva, Illinois, in 2008. Randie was a winner in the West Chicago City Cultural Museum 2009 Banner Competition. *Kashmir Kindness*, included in this book, was exhibited in banner form outside West Chicago Cultural Museum for five months.

She is represented by Six Gables on Purple Hill Fine Art Gallery, Geneva, Illinois, SixGablesArt@aol.com. Her Web site is www.SixGablesArt.com.

**Rebecca Mulvaney:** Rebecca Mulvaney was born in West Virginia and received a BFA in painting from Ohio University. She first used soft pastels as a teenager, while a student of noted portrait artist Dorothy Horne Decker. She began to explore the expressive powers of the pastel line in depicting grasses, trees, and the color and movement of clouds in South Dakota in 1993. Now working in watercolor and oil as well as pastel, Rebecca operates a studio from her home in Saint Joseph, Minnesota. She has also been closely involved with fellow artists and arts organizations to develop awareness and support for the visual arts. Contact her at rebecca@rebeccamulvaney.info and see her Web site, www.rebeccamulvaney.info.

**Lora Schaunaman:** Lora Schaunaman was educated as a commercial artist and spent twenty years as an art instructor for all ages from kindergarteners to senior citizens. For the last ten years she has been the curator of exhibits at the Dacotah Prairie Museum, where she loves designing and fabricating exhibits. Lora also coordinates art programs and gallery shows. Her love for the prairie lands, wildlife, and plants is apparent when she says, "My art has connected me in an intimate way to the things that I care most deeply about."

**Calvin Schultz:** The late Calvin Schultz was an accomplished art educator, painter, sculptor, and muralist. For twenty-five years he designed the Corn Palace friezes in Mitchell, South Dakota. His numerous awards include being named to the South Dakota Hall of Fame. Cal loved people and had a buoyancy of spirit and a great joy in life despite the debilitating effects of polio. He was Paula's dad.

**Daniel Sheldon:** Born in Minnesota, Dan now lives in Cresbard, South Dakota. He has exhibited extensively and has won numerous awards. Working primarily in oils and watercolors, Daniel uses a basic, limited palette, especially when painting en plein. He enjoys common subject matter found within a hundred miles of home. "I am inspired to capture scenes that are rapidly vanishing from our countryside," he says. E-mail him at spitshine58@gmail.com

**George Shipperley:** George has been a resident of Aurora, Illinois, since the 1950s, where he met and married Lois, his wife of 49 years. Together they raised three daughters and now have six grandchildren. The couple owns and operates Henrich Art Gallery and Custom Frame Shop in Aurora.

As an impressionist artist with an emphasis on originality, creativity, and color, George specializes in pastel, acrylic, and oil stick mediums. He is an art instructor, member of the Palette & Chisel Academy in Chicago, and the first awarded signature member of the Oil Pastel Society. Visit his Web site at www.georgeshipperley.com.

**Thomas Trausch:** Because his work is driven by the use of light and color, Tom calls himself an American Impressionist. A master with the Transparent Watercolor Society of America, he has traveled and painted in Europe and the United States. He has also been an international award winner and workshop instructor. He, his artist wife Gale, and their daughter Camille live in rural Woodstock, Illinois. Email Tom at Thomas@trauschfinearts.com. His Web site is www.trauschfinearts.com.

**Kay Wahlgren:** Kay Wahlgren has a BFA with high honors from the University of Illinois. She studied architectural engineering in addition to fine art, which gives her paintings a crisp, realistic look. She has been painting water colors for six years and has won many awards and has shown her work in museums. She currently teaches watercolor at the DuPage Art League in Wheaton, Illinois.

# Index